RotoVision

Rules
can be b
but neve
ignored

roken

er

A RotoVision Book
Published and Distributed
by RotoVision SA
Route Suisse 9
1295-Mies
Switzerland

RotoVision SA
Sales and Production Office
Sheridan House
112–116a Western Road
Hove, East Sussex BN3 1DD, UK
Telephone: +44 (0)1273 72 72 68
Fascimile: +44 (0)1273 72 72 69
Email: sales@rotovision.com
www.rotovision.com

10 9 8 7 6 5 4 3 2 1

ISBN 2-88046-677-6

Commissioned and edited by Zara Emerson
Project managed by Becky Moss
Designed by Vince Frost, Sonya Dyakova
Frost Design, London
www.frostdesign.co.uk

Production and separations by
Provision Pte. Ltd. in Singapore
Telephone: +65 6334 7720
Fascimile: +65 6334 7721

Printed in Singapore

Contents

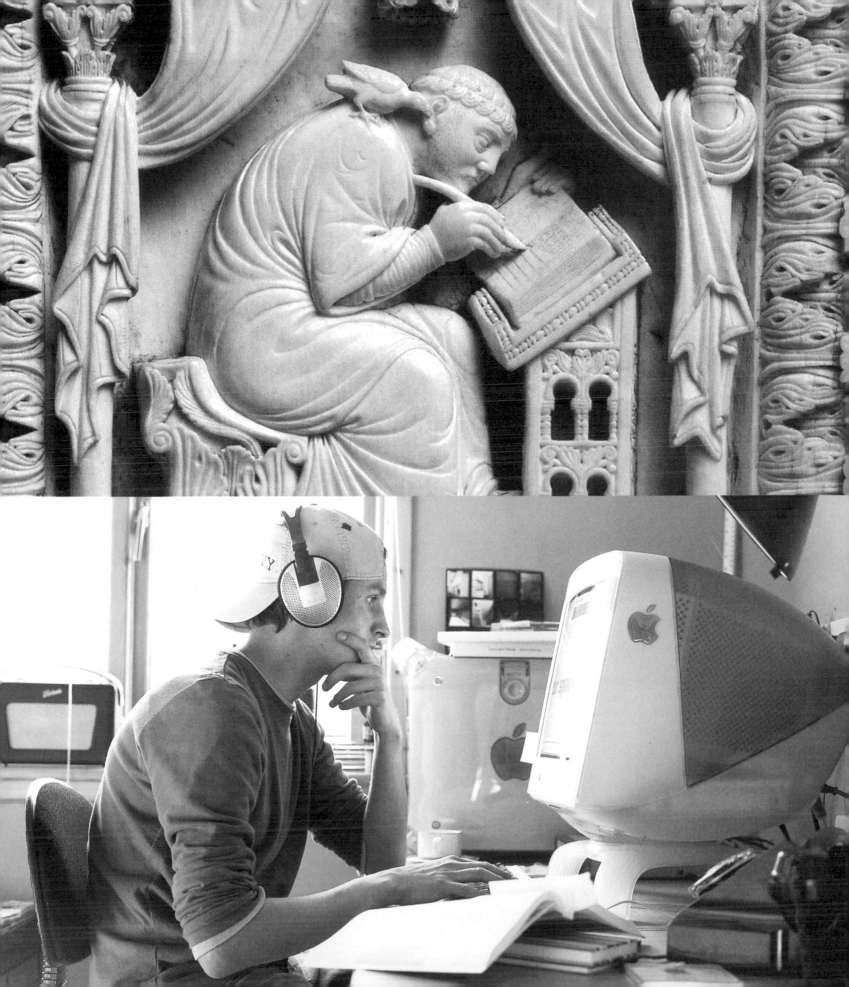

Introduction

It is often said that the purpose of the printed word is to be read. This is a huge understatement. The printing of words is a common activity shared by most members of society and practiced on many levels. Like the written and the spoken word, it is integral to human communication and practiced eclectically.

Prior to digital technology, the design of the printed word had evolved, but very slowly. Printers were the typographers and even when photosetting replaced hot-metal, it was ex-compositors from the printing trade who were drafted in to do the crucial keyboarding. Historically, experience, practical limitations and a lot of common sense regulated typography. It was an activity founded on impiricalism and, to the outsider, shrouded in secrecy. Change within the printing industry was always resisted, although this was entirely voluntary. But as the 20th century approached and the influence of the industrial revolution took hold, previously unwritten rules became an absolute necessity to ensure a workforce, dramatically increasing in numbers and often only semi-literate, could compose type adequately. But it will be clear to anyone looking at the majority of books and magazines printed during the early 20th century, that any sense of 'quality assurance' suggested by the concept of 'rules', was, and is, a fallacy. Clearly, rules alone do not ensure good typography.

Typography has always been a labour-intensive activity – in 1890, printing was the second largest source of employment in London – and in some ways, whilst technological developments have completely changed who does what, where and how, typography is still a time-consuming part of the design process. Of course, today, it doesn't need to be. It is possible with digital technology to pour text into pre-arranged, linked boxes and simply leave it as it falls on its default settings (usually 12-point *Helvetica*!). This is the way the majority of type users – secretaries, students, estate agents etc – 'arrange' type and the technology delivers a perfectly adequate standard for this purpose. As Arthur C Clarke said, 'Any well-developed technology is indistinguishable from magic' and 'magic' rather than 'craft' is the way many users of type imagine typography works.

But this technology offers so much more; a flexibility that not only predates the industrial revolution but also printing from moveable type. For the graphic designer it offers, for the first time, total, independent control of typography. This is a formidable responsibility and perhaps now is an opportune moment to look again at the conventions that evolved during the previous 500 years of printing to discover what might still be applicable today.

New technology brings with it a renewed air of urgency and a natural opportunity and willingness to question accepted parameters. This book is about that process; examining what was accepted 'good' practice from the past and examining its relevance for use in current graphic and electronic methods of communication.

Rules can be broken, but never ignored. This book will explore the process of designing within these formalities, but also provide a justification for their continued relevance. The possibilities offered by digital technologies can then be applied with purpose.

politani etiam tractus extimantur. Ni-
uibus per hyemem ferè totus mons ca-
net:cacumen neqʒ per aestatem uiduatur.
B. P. Quid, quod hyemare tantum
eas meminit Strabo? B. F. At experien
tia ita te docet,usqʒ ipse auctor (quod qui
dem uenia illius dixerim) non deterior.
Quare illud mi pater etiã,atqʒ etiam uide;
ne quid te moueat,si aliqua ex parte huius
nostri de Aetna sermonis cum uetustis scri
ptoribus dissentimus:nihil enim impedit
fuisse tum ea omnia,quae ipsi olim tradi
dere,quorum permãserint plurima in no
stram diem;quaedam se immutauerit;ali
qua etiam surrexerint noua:nam (ut caete
ra omittam); quod cinerosa partim esse
summa cacumina dictauere;eius rei nunc
uestigium nullũ apparet:cinis enim, qui
queat conspici,toto mõte nullus est:neqʒ
id tamen omnibus annis fuit:nam mul
torum testimonio accepimus, qui ui-
dere, annos ab hinc quadraginta tan-

tos ex Aetna cineres euolasse; ut per to-
tam eam insulae partem,quae uersus Pe
lorum iacet,uniuersam oleam abstule-
rint;eos etiam in Italiam uentis feren
tibus latos. Sed (ut ad niues illas redea
mus) addebat idem Vrbanus Kalen-
dis Iuniis ascendente se satis largiter, a-
bundéqʒ ninxisse; tum iterum,qui se-
ptimus fuerit post eum diem, dum
ipse Randatii moraretur,in uniuersam
montanam plagam niues ferè in pedis al
titudinem descendisse:in quo ipso licet
et Pindarum suspicias scite cognomento
usum;qui Aetnam niuium nutricem ap
pellarit. Quo latere subest Catana,me
dia ferè inter ipsam,et cacumen regione
purissimus,et perennis fons erumpit do
rico uocabulo Crana ab incolis appella
ta:caeterum toto monte supra radices nul
lae aquae sunt;nisi quae uel ex niuibus
emanant;cuius quidem rei etiã Theocri
tum teste habemus;in quo dum Galateae
D iii

60 GRYLL GRANGE

CHAPTER X

THE THUNDERSTORM

Si bene calculum ponas, ubique naufragium est.
PETRONIUS ARBITER.

If you consider well the events of life, shipwreck is everywhere.

AFTER luncheon the doctor thought of returning home,
when a rumbling of distant thunder made him pause. They
reascended the Tower, to reconnoitre the elements from the
library. The windows were so arranged as to afford a
panoramic view.

The thunder muttered far off, but there was neither rain
nor visible lightning.

'The storm is at a great distance,' said the doctor, 'and
it seems to be passing away on the verge of the sky.'

But on the opposite horizon appeared a mass of dark-blue
cloud, which rose rapidly, and advanced in the direct line
of the Tower. Before it rolled a lighter but still lurid volume
of vapour, which curled and wreathed like eddying smoke
before the denser blackness of the unbroken cloud.

Simultaneously followed the flashing of lightning, the
rolling of thunder, and a deluge of rain like the bursting
of a waterspout.

They sate some time in silence, watching the storm as it
swept along, with wind, and driving rain, and whirling hail,
bringing for a time almost the darkness of night, through
which the forked lightning poured a scarcely interrupted
blaze.

Suddenly came a long dazzling flash, that seemed to
irradiate the entire circumference of the sky, followed in-
stantaneously by one of those crashing peals of thunder
which always indicate that something very near has been
struck by the lightning.

The doctor turned round to make a remark on the awful
grandeur of the effect, when he observed that his young

THE THUNDERSTORM 61

friend had disappeared. On his return, he said he had been
looking for what had been struck.

'And what was?' said the doctor.

'Nothing in the house,' said his host.

'The Vestals,' thought the doctor; 'these were all his
solicitude.'

But though Mr. Falconer had looked no farther than to
the safety of the seven sisters, his attention was soon drawn
to a tumult below, which seemed to indicate that some
serious mischief had resulted from the lightning; and the
youngest of the sisters, appearing in great trepidation, in-
formed him that one of two horses in a gentleman's carriage
had been struck dead, and that a young lady in the carriage
had been stunned by the passing flash, though how far she
was injured by it could not be immediately known. The
other horse, it appeared, had been prancing in terror, and
had nearly overthrown the carriage; but he had been re-
strained by the vigorous arm of a young farmer, who had
subsequently carried the young lady into the house, where
she was now resting on a couch in the female apartments,
and carefully attended by the sisters.

Mr. Falconer and the doctor descended into the hall,
and were assured that the young lady was doing well, but
that she would be much better for being left some time
longer undisturbed. An elderly gentleman issued from the
female apartments, and the doctor with some amazement
recognised his friend Mr. Gryll, to whom and his niece this
disaster had occurred.

The beauty of the morning had tempted them to a long
drive; and they thought it would be a good opportunity
to gratify at least a portion of the curiosity which the doctor's
description of the Folly and its inhabitants had excited in
them. They had therefore determined on taking a circuit
in which they would pass under the walls of the Tower.
They were almost at the extremity of their longest radius
when the storm burst over them, and were just under the

Page 5 above
This ivory panel was carved for a book cover and is one of a set of three. It depicts St Gregory at his writing desk and being inspired by the Holy Spirit, symbolised by the dove on his shoulder. The panel was made in northern Europe between AD850 and 1000.

Page 5 below
21st century equivalent, complete with audio inspiration.

This page above
Aldus Manutius, *Gli Asolani*. 1505. Manutius learnt the art of printing in Venice and set up his own workshop there in 1494. Manutius had a more efficient letterform cut that would function well at smaller sizes. This enabled him to print books in a smaller format, to be 'more conveniently held in the hand and learned by heart'. Smaller books also meant cheaper books. Manutius was a businessman as well as a scholar–printer. He foresaw, with the increase of literacy, the decline of the large-format book in favour of cheaper and more portable, convenient sizes.
The British Library

This page below
In 1935, when a successful hardback novel was considered a success if it sold 2,000 copies, Allen Lane maintained that a 'comparatively successful' Penguin book would sell 150,000 copies, a 'good' Penguin 250,000 and a best-seller 350,000.

The first ten Penguin books were published 30 July 1935. The state of the publishing trade, and the attitude of the reading public can be judged by Lane's statement in *The Bookseller*, 22 May 1935: 'The great majority of the public are scared of walking through our doors. Their fears are two-fold: firstly of their financial liability [hard-back books of fiction were about 7s 6d] and secondly of displaying their ignorance… the idea of braving an empty bookshop with two or three assistants lying in wait is too much for them.' It was for this reason that Lane initially sold Penguin Books through Woolworths' stores for 6d (2·5p) each.

Classification

Introduction

Classifying type serves to clarify the often subtle differences between typefaces, and helps to explain why such changes occurred. It also helps the designer to make a more appropriate choice of type, since historical and cultural references inherent in a typeface can often provide an important extra dimension to a text.

However, classifying type is no easy matter. *Syntax-Antiqua* (illustrated page 75) is a *sans serif* typeface designed in 1968 by the Swiss typographer Hans Meier. It subtly incorporated the humanistic characteristics of *old style,* in which the dynamic qualities of the pen are still perceptible, in order to achieve a distinctive, and more readable sans serif typeface. It therefore combines two opposing traditions – sans serif, associated with static, upright and independent forms, and old style, with dynamic, angled and flowing strokes.

Such problems of classification are not confined to recent times. Old style fonts, such as *Garamond, Janson and Caslon,* are renowned for the efficiency they bring to the reading experience and so it should not be surprising that, when designing a new text face, these old style fonts should be an appropriate place to start. Famously, in 1860, the Miller & Richard type foundry in Edinburgh produced a typeface, designed by Alexander Phemister, which they described as being '…superior to "old style" types'. They therefore called their new face *Old Style,* which caused great confusion within the printing fraternity who responded by renaming the old style classification, *old face* (by general consensus, the original classification was reinstated). The Americans have a more sensible solution: *old style* for the original group of types and *modernised old style* for new types designed in the old style.

The names of all the basic classes of type (blackletter, old style, transitional, modern and sans serif) are, of necessity, imprecise. There was a concerted effort, by Maximilien Vox in 1954, to introduce a classification which comprised nine groups. This scheme was accepted by the *Association Typographique Internationale* (ATypI) and the British Standards Institute (BSI) who, in 1967, published a revised version (illustrated right). Despite these efforts, there was little interest shown in the scheme and a further revision, planned for 1981, never took place. There is such a large body of published material (from both before and after 1967) that uses the original, simpler classification, that changes seem pointless. For this reason, this book refers to the simpler, time-honoured classification system: blackletter, old style, transitional, modern and sans serif. Of course, the only reason for classification in the first place is to aid study and is not an end in itself.

The historical development of type design has been inseparable from the developments of the tools, equipment and materials used to make and print the type. As it was discovered how to make metal stronger, paper smoother and ink blacker, so the design of typefaces could, in turn, become finer and technically more demanding. As the means of type production and printing became more sophisticated, so type designers felt it appropriate to design typefaces that drew less and less on traditional inspirations, such as hand-written and stone-carved letterforms. Instead, typefaces that demonstrated an ever more rational approach became the 'norm'.

Before the Industrial Revolution in the latter 18th century, there were really only three styles of type design, representing key developments of a slow, but important evolution. These are called *old style, transitional* and *modern.*

However, the very earliest printed books (Gutenberg's 42-line Bible was printed circa 1455) used a type which was designed specifically to simulate the hand-written books that preceded the invention of moveable type. In other words, it was designed to look like a 'book' as recognised at the time and, of course, all books in Europe in the 15th century were what we now call 'manuscripts'. There was already a growing trade in books due largely to the founding of universities in the early Renaissance period (14th century). To meet demand, the production of these hand-written books was organised rather like a production line, where texts might be read aloud and copied simultaneously by numerous scribes. Although we think of these manuscripts as objects of great beauty, many were also, for the most part, highly inaccurate and, of course, very expensive.

Gutenberg's invention not only signalled the beginning of a new craft, but also built upon what was a new age of scholarship. Many of the early printers were scholars first and foremost, and when necessary, experts in their field would be employed to ensure accuracy of interpretation and translation. Great pride is evident in all aspects of these early books – the origination of text, setting and printing the product of a small, combined group of scholars, type-cutters, compositors and printers.[1]

Gutenberg's type, classified as *blackletter*, lasted for only a brief period before old style quickly overtook it, although it remained a traditional letterform in Germany until 1945, and is still seen, occasionally, where 'traditional values' are deemed appropriate.

As printing advanced, so the calligrapher's craft reluctantly disappeared, leaving the crafts of printing and binding free to develop their own conventions.

The Vox classification of types

1 Humanist	Faces derived from Janson type, for example *Centaur* and Italian old style	Centaur
2 Garalde	Faces from *Bembo* and *Garamond* through to *Janson* and *Caslon*. The two above groups cover all kinds of design otherwise called 'old style'	Garamond
3 Transitional	*Fournier, Baskerville, Bulmer* and *Caledonia*	Baskerville
4 Didone	*Bodoni*. To replace 'modern'	Bodoni
5 Slab serif	*Antique* and *Egyptian*	Egyptian
6 Lineal	In place of 'sans serif'; the group is divided into four sections: Grotesque; types of 19th-century origin; Neo-grotesque, recent versions of that mode eg *Univers*; Geometric, Futura, Humanist, Gill Sans.	Akzidenz Grotesk / Univers / Futura / Gill Sans
7 Glyphic	*Albertus*	Albertus
8 Script		Park Avenue
9 Graphic	'Drawn' letters eg *Comic Sans,* but also blackletter faces	Comic Sans

During the next three centuries typeface design evolved slowly. The old style typefaces of *Caslon* and his predecessors were based on the variable thickness of line achieved with a broad-nibbed pen (sideways thin, downwards thick). By the 18th century (the Age of Reason), types were becoming more independent of the written letterform and evolving into rational forms that reflected advances in both skills and manufacturing techniques.

In England during the 18th century, John Baskerville, aware of developments in France, (under the auspices of the *Académie des Sciences)* made significant steps towards a more rational approach to the design of his type, marking a *transitional* period before the decisive steps were taken to drop *all* reference to hand-written forms by Didot in France and, a little later by Bodoni in Italy. The *modern* face is characterised by a severe vertical stress and extreme contrasts of weight between thick and thin lines. Serifs are not bracketed (as would be natural if drawn with a pen or brush) but thin, straight, lines. As such, these types broke all the rules of readability, as both Didot and Bodoni consciously attempted (and achieved) to produce some of the most magnificent books ever printed, designed to be looked at and admired as much as being read.

In stark contrast, the 'mainstream' printer was being pushed in a very different direction, as the mechanical and manufacturing developments that helped create the Industrial Revolution began to take effect. This meant that printing machines were being built that could print much faster, making print cheaper, which offered new opportunities for the use of print. These, in turn, created a greater demand for a much wider range of uses for typefaces. Prior to this, type had been used almost exclusively for the printing of books. New material, much of which was associated with a burgeoning advertising industry, was referred to as *display* types (see Chapter 2). These flamboyant types, influenced in their design by individual, hand-painted or carved lettering on signs or buildings, were designed to compete for the public's attention with other, increasingly loud and exotic typefaces.

Common tactics included designing types that were as complicated or as bizarre as possible. An alternative to this was to create display types by simplifying; taking away much of the detailed refinements required of a text typeface. Later, during the first half of the 20th century, designers began to re-adapt such faces, introducing characteristics that encouraged designers to consider the *sans serif* for a far broader use.

The importance of the sans serif has steadily grown during the 20th century. Its earlier versions were certainly not for the setting of continuous text, although they worked perfectly well for shorter or supporting texts, particularly where a smaller size was required. However, more recently, some type designers have imbued the sans serif form with some of the qualities associated with the more calligraphic old style typefaces in an attempt to establish the sans serif as a contemporary, but also highly readable, typeface (see Chapter 2).

Today, with digital technology, there really is no comparison in the amount of time it takes to design a typeface. Nevertheless, although thousands of new *display* faces have been designed and commercially distributed since the mid-Eighties, the number of new *text* faces remains relatively few. A complete font, of necessity, will include more than 250 characters, and this represents but a fraction of the complete task which might include various weights in roman, italic and small caps, plus numerals (lining and non-lining) ligatures, fractions, diacritics and pi-sorts. In addition, virtually every character pair must be allocated the correct intercharacter space, a huge undertaking which, in all, will usually take more than a year (or perhaps several years) to design. Such a task requires a commitment few are willing or able to undertake or to commission.

Opposite page
An ultra-bold character designed to
maximise its display potential. Part of
a neon display in Piccadilly Circus, London.

This page
Four characters: *Caslon* (old style),
Baskerville (transitional), *Bodoni* (modern)
and *Univers* (sans serif).

The rationalisation of the design of
letterforms can be observed in the angle of
stress: more acute in the earlier old style
character and progressively becoming more
upright towards the modern style. Sans
serif generally continued this emphasis
until the late 20th century.

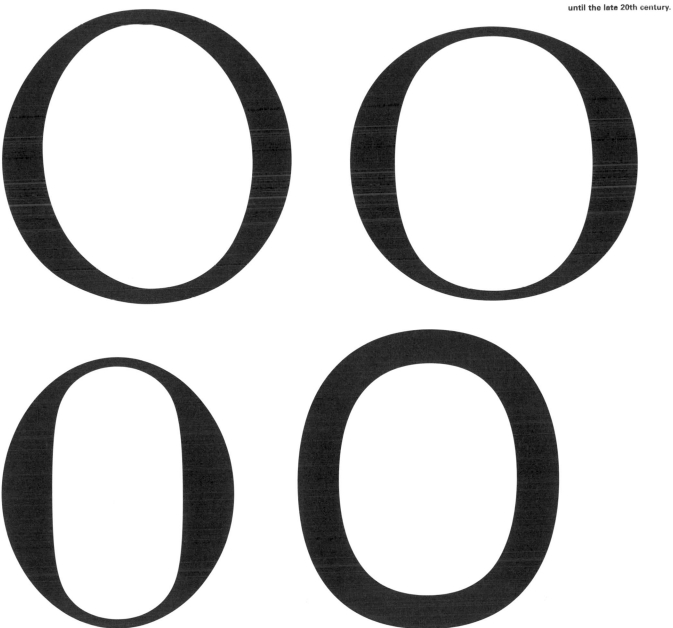

Left column (Prologus):

prouocauit: qui edidōni āciq; trāsla
tionē theodōnois niscuit·asterico et
obelo id est stella et ueru omne opus
distingués:dū aut illucescere facit
que minus ante fuerat:aut supsslua
quæq; iugulat et cōfodit: et maxime
que euangelistarū et apostolorū au
ctoritas promulgauit. In quibus mul
ta de ueteri testamēto legimus que ī
nostris codicibus non habentur: ut
est illud·ex egipto uocaui filiū meū:
quoniā nazareus uocabitur: et ui
debunt in quē cōpunxerūt: et plurima
de ueteri eius fluent aque uiue: z que
nec oculus uidit nec auris audiuit nec
in cor hominis ascendit que prepara
uit diligentibus se: z multa alia que
propriū sintagma desiderant. Inter
rogemus ergo eos ubi hec scripta sūt:
et cū dicere non potuerint·de libris
hebraicis proferam:Primū testimo
niū est in osee·secundū in ysaia·tercīū
ī zacharia·quartū in puerbijs·quintū
eque in ysaia: cp multi ignorāres ap
criphorū deliramēta sectanž: z hibreas
nenias libris autenticis pferūt. Causas
erroris nō est meū exponere. Iudei pru
denti factū dicūt esse cōsilio: ne pto
meus uniž dei cultor etiā apud hebreos
duplici diuinitate cōphēderet: qd
maxime idcirco faciebat quia in plato
nis dogma cadere uidebat. Deniq;
ubicūq; sacratū aliqd scriptura testat
de patre z filio z spiritu sācto aut aliter
interptati sūt aut omnio tacuerūt: ut
et regi satisfacerent: z archanū fidei nō
uulgarent. Et nescio quis pmus auctor
septuaginta cellulas alexandrie menda
cio suo exctruxerit: quibus diuisi eadē
scriptitarent: cū aristeus eiusdē ptolo
mei ypraspistes·z nō multo post tēpore
iosephus nichil tale retulerint: sed in

una basilica congregatos contulisse
scribāt non ypherasse. Aliud ē eni esse
uatem: aliud ē esse interptē. Ibi spiritu
uentura pdicit:hic eruditio et uerborū
copia ea que intelligit transfert. Nisi
forte putādus est tullius oecōomicū
xenofonis z platōis pitāgorā et de
mosthenis pphesonicū afflatus retho
rico spiritu trāstulisse. Aut aliter de ei
isdem libris per septuaginta interptes·
aliter p apostolos spiritus sanctus te
stimonia texuit: ut cp illi tacuerūt hij
scripsisse mētiti sint. Quid igitur?
Damnamus ueteres? Minime:sed post
priorū studia in domo dni quod pos
sumus laboramus. Illi interptati sū
āte aduentū xpi et qd nesciebāt dubijs
ptulere sentenijs: nos post passio
nem eius non tam ppheria cp histori
am scribimus. Aliter enim audita: ali
ter uisa narrantur. Qd meli9 intelligi
mus meli9 et proferim9. Audi igitur
emule: obtrectator ausculta. Non da
mno non reprehendo septuaginta:
sed confidenter cūctis illis apostolos
pfero. Per istos os michi xps sonat
quos ante ppheras inter spiritualia
carismata positos lego: z quibus ultimū
pene gradū interpres tenet. Quid liuo
re torqueris? Quid imperitos aīos cōtra
me cōcitas? Sicubi ī trāslatione tibi ui
deor errare interroga hebreos: diusarū
urbiū magros cōsule. Qd illi habēt de
xpo tui codices nō habent. Aliud ē si
cōtra se postea ab aplis usurpata testi
monia pbauerit: z emēdatiora sunt
exēplaria latina·cp greca: greca cp he
brea. Verū hec cōtra inuidos. Nūc te de
cor desidero carissime: ut cp me tantū op9
libror fecisti z a genesi exordiū capere·orō
nibus iuuer: cp possi eodē spū quo scripti
sūt libri ī latinū eos trāsferre sermonē.

Right page: Genesis

Incipit liber Bresith quē nos Gene
sim dicimus.

In principio creauit deus celū z vn
et terram. Terra autem erat inanis et
uacua:z tenebre erant sup faciē abissi:
et spiritus dni ferebatur super aquas.
Dixitq; deus. Fiat lux. Et facta ē lux.
Et uidit deus lucem cp esset bona: et
diuisit lucem a tenebris·appellauitq;
lucem diem et tenebras nocte. Factū
cp est uespere z mane dies unus. Dixit
quoq; deus. Fiat firmamentū in me
dio aquarū: et diuidat aquas ab a
quis. Et fecit deus firmamentū: diui
sitq; aquas que erant sub firmamen
to ab hijs que erant super firmamen
tum: z factū est ita. Vocauitq; deus
firmamentū celū: z factū est uespere
et mane dies secundus. Dixit uero de
us. Congregentur aque que sub celo
sunt in locum unū et appareat arida.
Et factū est ita. Et uocauit deus ari
dam terram: cōgregationesq; aquar
appellauit maria. Et uidit deus cp es
set bonū· et ait. Germinet terra herbā
uirentem et facientem semen: et lignū
pomiferū faciens fructum iuxta genu
suū: cuius semen in semetipso sit super
terram. Et factū est ita. Et protulit
terra herbam uirentem et facientem se
men iuxta genus suū:lignūq; faciens
fructū et habens unūquodq; sementem secun
dū speciem suā. Et uidit deus cp esset
bonū: et factū est uespere et mane dies
tercius. Dixitq; aut deus. Fiant luminaria
in firmamēto celi z diuidant diem ac
nocte· z sint in signa z tēpora z dies z
annos: ut luceant in firmamēto celi et
illuminēt terrā. Et factū est ita. Fecitq;
deus duo luminaria magna: luminare
maius ut pesset diei et luminare min9
ut pesset nocti: z stellas·z posuit eas in
firmamēto celi ut lucerent sup terrā: et

pessent diei ac nocti: z diuiderent lucem
ac tenebras. Et uidit deus cp esset bonū:
et factū ē uespere et mane dies quartus.
Dixit etiam deus. Producant aque
reptile anime uiuentis et uolatile sup
terram· sub firmamēto celi. Creauitq;
deus cete grandia· et omne animā ui
uentem atq; motabilem quā produxe
rant aque in species suas· z omne uo
latile secundū genus suū. Et uidit de
us cp esset bonū: benedixitq; ei dicens.
Crescite et multiplicamini·et replete a
quas maris: auesq; multiplicentur
super terram. Et factū ē uespere z mane
dies quintus. Dixit quoq; deus. Produ
cat terra animā uiuentem in gene
re suo: iumenta z reptilia· z bestias ter
re secundū species suas. Factūq; ē ita. Et
fecit deus bestias terre iuxta species su
as: iumenta z omne reptile terre in ge
nere suo. Et uidit deus cp esset bonū:
et ait. Faciam9 hominē ad ymaginē z
similitudinē nostrā· z psit piscibus maris
z volatilibus celi· z bestijs uniuerseq; ter
re: omniq; reptili qd mouet ī terra. Et crea
uit deus hominē ad ymaginē et simi
litudinē suā: ad ymaginem dei crea
uit illū: masculū et feminā creauit eos.
Benedixitq; illis deus· et ait. Crescite
et multiplicamini z replete terrā· et
subicite eam: z dominamini piscibus
maris· z uolatilibus celi: z uniuersis
animātibus que mouentur sup terrā.
Dixitq; deus. Ecce dedi uobis omnē
herbam afferentem semen sup terrā·
et uniuersa ligna que habēt ī semetipsis
sementē generis sui: ut sint uobis ī esca·
z cūctis aiantibus terre· omniq; uolucri
celi z uniuersis cp mouentur in terra· et
in quibus ē anima uiuens: ut habeāt ad
uescendū. Et factū est ita. Vidit q; deus
cūcta que fecerat: et erant ualde bona.

Blackletter

'Without help of reed, stylus or pen, but by the marvellous concord, proportion and harmony of punches and types.' A statement printed in the colophon of the *Mainz Catholicon,* 1460, thought by some to have been printed by Johann Gutenberg.

Blackletter is also known as *Gothic, Textura Fraktur* and *Old English.*

Gutenberg's 42-line Bible is the earliest book printed in the Western world to have survived. It was a huge undertaking, consisting of 1,286 pages and published in two volumes. Gutenberg is thought to have printed between 180 and 200 copies, of which 21 complete copies still exist.

The type Gutenberg designed and made for this, the only certified book by him, was described by A F Johnston as, 'An upright and angular letter, characterised by an almost entire absence of curves'. This type was the first to be made in Europe. Although it was largely superseded by type based on Roman inscriptions (see page 16) blackletter has continued to be used, occasionally, throughout Europe ever since. This explains why, particularly in America, this style is referred to as *Old English!*

Gutenberg's blackletter is quite condensed and closely set. With vellum (made from calves skin) and paper probably being the most expensive materials involved in the production process, the tightness of the setting may owe something to the need for economy. Johnston also mentions that the characters are difficult to differentiate; for example, the n is merely two i's and the m three i's placed in contact. However, despite the justified arrangement, the closely spaced characters offer strong, dark lines of text which, because of their immaculate setting, offer a rhythm and balance that has never been surpassed. To help achieve this, Gutenberg appears to have used a multitude of ligatures, as well as up to six or seven alternatives of each character and numerous word contractions.

Johnston's description lends credence to the theory[2] that Gutenberg might have pressed his punches into fine, wet sand rather than into copper matrices. By this more primitive method, only one character could be cast since the sand mould is destroyed in the process. The similarities of the individual parts which make up so many of the characters suggest that Gutenberg might even have cut his punches to represent parts of the characters and then used these, individually or in combinations, to form whole characters.

Because hand-written documents are still associated with exclusivity – documents imbued with basic human values of trust, honesty and tradition – blackletter typefaces tend to be used as newspaper mastheads, legal documents and organically produced foods. However, because of its German origins and Hitler's insistence on its use during the Thirties and Forties as the 'true German' typeface, it can be designed to take on other, more disturbing connotations.

Magere deutsche Schrift

baseline Digital blackletter – resurrection and revolution 13

Digital Blackletter

resurrection and revolution

by Paul Shaw

Blackletter was given a black eye by the Nazis that has only now begun to fade. The Nazis' flip-flop on black-letter – they embraced it when they assumed power, then disavowed it in 1941, at the height of their conquest of Europe, as 'Schwabacher-Jewish letters' – was the final blow to a once-proud type. Earlier, the apostles of modern design and *die neue typografie* had denounced blackletter as historicist, ornamental and, worst of all, nationalist. In a post-war world dominated by Helvetica and Swiss typography – and a fetish for simplicity, clarity and legibility – blackletter types virtually disappeared.

Between 1945 and 1990 there were only three new blackletter typefaces designed in Germany. Fewer than 20 traditional blackletter faces have made the transition from metal to digital type. This vacuum has been met (partly) by the creation of new faces in traditional guise. Sidestepping the thorny issue of Nazism, designers have looked to medieval calligraphy and early typefaces for inspiration. Unfortunately, most of the calligraphically-inspired fonts are quite amateurish. There are some notable exceptions to this sad state of affairs. Linotype's highly visible *Type before Gutenberg* series – which includes Clairvaux by Herbert Maring, Nôtre Dame and San Marco by Karlgeorg Hoefer, and Duc de Berry by Gottfried Pott – and the work of Philip Bouwsma for the Creative Alliance – specifically Cresci Rotunda and Palatino Rotunda – are well-researched and rendered. Burgundica by Gerrit Noordzij is a calligraphic font with a point to make. Noordzij, the godfather of the Dutch type mafia, has been asserting for years that fraktur's origins lie in 15th century Burgundian bâtarde. Burgundica is an attempt to put theory into practice. Its forms – especially the capitals – have been carefully simplified, often exposing their ductus. However, in some cases the letters remain enigmatic to modern eyes. Derived from the same sources as Duc de Berry, Burgundica's asceticism stands in stark contrast to the former's stylization.

Opposite page
Rudolf Koch. *Magere Deutsche Schrift,* **designed 1913–21, was the thin version of the** *Kochschrift.* **This is the front cover of the Gebr. Klingspor type-specimen book, printed 1921.** *St Bride Printing Library*

This page
Blackletter in a contemporary context is a relative rarity. Connotations with the German Nazi Party between 1933 and 1945 have given it a distinctly ominous quality, aspects of which have been utilised on this page from *Baseline,* **the opening page of an article charting the use and abuse of blackletter in the 20th century.** *Designer, Hans Dieter Reichert.*

Old style

'When in doubt use *Caslon.*' Printer's adage.

The advance of printing had been resisted by the scribes, who stood to lose heavily; but, at first gradually, then quickly, the invention of printing from moveable type totally dominated the book trade.

Old style represents the earliest roman typefaces. Roman typefaces consist of two distinct parts; the uppercase, or capitals, which are derived from imperial Roman stone inscriptions, and the lowercase, derived from the hand-written books of Christian scribes in Northern Europe, mainly in France and Germany, and then further refined in Italy.

The translation of roman letters, from hand-written script and stone inscription, to being cut into metal type, began in Italy shortly after Gutenberg's invention of moveable type. The characteristics we associate with old style place the emphasis upon maintaining a distinctive hand-written quality; a modulated line with the width consistently varying with the direction of the line and the whole character set at a distinct angle. These characteristics, most easily recognised in the lowercase letters, reflect the form that is produced by a broad-nibbed pen held in the right hand.

The appearance of books quickly evolved to take account of the printing process and the business of selling. The title page, often carrying the name of the printer (who was also the publisher) and his device, served as a temporary cover for the book until the buyer had the book bound in their chosen style. Italic type was invented in Italy (using a writing style known as *Chancery Script*) initially as an alternative to roman, but, in time, it took on an ancillary function. By the beginning of the 16th century hand-decorating books after they had been printed was no longer felt to be necessary. The art of the printed book had taken over from the calligrapher's manuscript. These books look the way we expect books to look even in the 21st century. The size, the proportions, the appearance of the type, the space between the lines, or the line increment all seem familiar to us.

Despite the many hundreds of text faces designed since 1460, these original old style faces (*Garamond, Plantin, Janson, Caslon* etc.) are still considered to be among the most readable ever designed and therefore, are commonly used in publications where an abundance of continuous text is necessary. The essential humanistic qualities of this type style (a sense of rhythm, strong horizontal stress, with a flowing, easy interaction between characters) are commonly strived for in contemporary typeface design even, occasionally, in *sans serif* (see page 75).

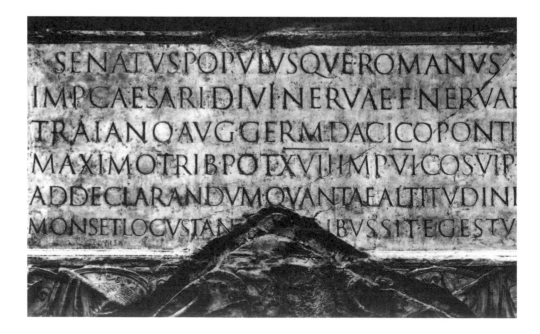

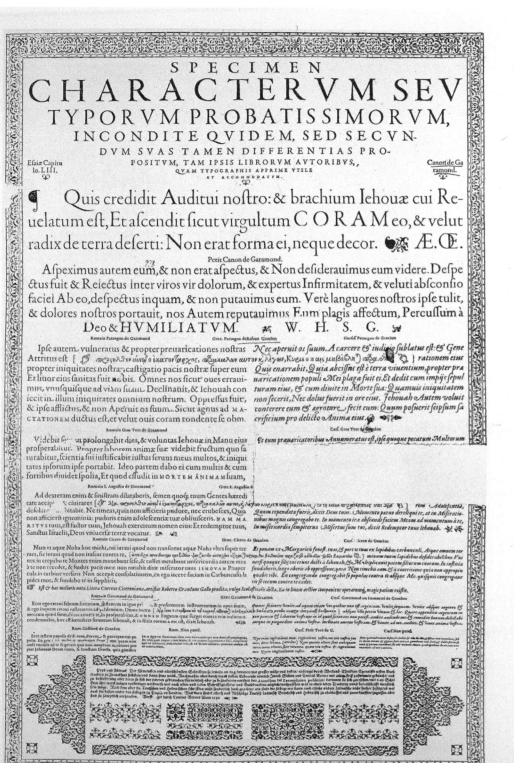

2. KONRAD BERNER, FRANKFURT 1592

This page
Claude Garamond. Garamond trained as
a punch-cutter and was commissioned by
Robert Estienne, a Parisian scholar-printer,
to cut punches for a new series of roman
type. When Garamond died in 1561, his
punches and matrices were bought by
Plantin in Antwerp. In this way Garamond's
roman had become the standard European
type and for 200 years after his death his
types continued to be very popular.

This specimen sheet was originally printed
by the Egenolff-Berner type foundry.
St Bride Printing Library

TYPES A GARAMONT. 1640. (1)				TYPES PAR GRANDJEAN ET ALEXANDRE. 1693. (2)				TYPES PAR LUCE. 1740. (3)				TYPES PAR FIRMIN DIDOT. 1811. (4)				TYPES PAR JACQUEMIN. 1818. (5)				TYPES A LONDRES. 1818. (6)				TYPES PAR M. MARC.n LEGRAND. 1825. (7)			
ROMAIN.		ITALIQUE.		ROMAIN.		ITALIQUE.		ROMAIN.		ITALIQUE.		ROMAIN.		ITALIQUE.		ROMAIN.		ITALIQUE.		ROMAIN.		ITALIQUE.		ROMAIN.		ITALIQUE.	
A	a	A	a	A	a	A	a	A	a	A	a	A	a	A	a	A	a	A	a	A	a	A	a	A	a	A	a
B	b	B	b	B	b	B	b	B	b	B	b	B	b	B	b	B	b	B	b	B	b	B	b	B	b	B	b
C	c	C	c	C	c	C	c	C	c	C	c	C	c	C	c	C	c	C	c	C	c	C	c	C	c	C	c
D	d	D	d	D	d	D	d	D	d	D	d	D	d	D	d	D	d	D	d	D	d	D	d	D	d	D	d
E	e	E	e	E	e	E	e	E	e	E	e	E	e	E	e	E	e	E	e	E	e	E	e	E	e	E	e
F	f	F	f	F	f	F	f	F	f	F	f	F	f	F	f	F	f	F	f	F	f	F	f	F	f	F	f
G	g	G	g	G	g	G	g	G	g	G	g	G	g	G	g	G	g	G	g	G	g	G	g	G	g	G	g
H	h	H	h	H	h	H	h	H	h	H	h	H	h	H	h	H	h	H	h	H	h	H	h	H	h	H	h
I	i	I	i	I	i	I	i	I	i	I	i	I	i	I	i	I	i	I	i	I	i	I	i	I	i	I	i
	j		j	J	j	J	j	J	j	J	j	J	j	J	j	J	j	J	j	J	j	J	j	J	j	J	j
K	k	K	k	K	k	K	k	K	k	K	k	K	k	K	k	K	k	K	k	K	k	K	k	K	k	K	k
L	l	L	l	L	l	L	l	L	l	L	l	L	l	L	l	L	l	L	l	L	l	L	l	L	l	L	l
M	m	M	m	M	m	M	m	M	m	M	m	M	m	M	m	M	m	M	m	M	m	M	m	M	m	M	m
N	n	N	n	N	n	N	n	N	n	N	n	N	n	N	n	N	n	N	n	N	n	N	n	N	n	N	n
O	o	O	o	O	o	O	o	O	o	O	o	O	o	O	o	O	o	O	o	O	o	O	o	O	o	O	o
P	p	P	p	P	p	P	p	P	p	P	p	P	p	P	p	P	p	P	p	P	p	P	p	P	p	P	p
Q	q	Q	q	Q	q	Q	q	Q	q	Q	q	Q	q	Q	q	Q	q	Q	q	Q	q	Q	q	Q	q	Q	q
R	r	R	r	R	r	R	r	R	r	R	r	R	r	R	r	R	r	R	r	R	r	R	r	R	r	R	r
S	s f	S	s f	S	s f	S	s f	S	s f	S	s f	S	s	S	s f	S	s	S	s	S	s	S	s	S	s	S	s
T	t	T	t	T	t	T	t	T	t	T	t	T	t	T	t	T	t	T	t	T	t	T	t	T	t	T	t
	u		u	U	u	U	u	U	u	U	u	U	u	U	u	U	u	U	u	U	u	U	u	U	u	U	u
V	v	V	v	V	v	V	v	V	v	V	v v	V	v	V	v v	V	v	V	v v	V	v	V	v	V	v	V	v
X	x	X	x	X	x	X	x	X	x	X	x	X	x	X	x	X	x	X	x	X	x	X	x	X	x	X	x
Y	y	Y	y	Y	y	Y	y	Y	y	Y	y	Y	y	Y	y	Y	y	Y	y	Y	y	Y	y	Y	y	Y	y
Z	z	Z.	z	Z	z	Z	z	Z	z	Z	z	Z	z	Z	z	Z	z	Z	z	Z	z	Z	z	Z	z	Z	z

327. *Comparative Table of Types used by the French National Printing House from its foundation to 1825*

This page above
This comparative table of roman and italic types was used by the French National Printing House from 1640 to 1825. The letters attributed to Garamond, Grandjean and Luce appear quite irregular when compared to the greater technical perfection of Didot (also see page 24). Perfection, however, does not necessarily mean greater readability.

This page right
William Caslon's first broadside specimen sheet, from which these examples are taken, was issued in 1734. D B Updike explains the popularity of Caslon's type thus: 'While [Caslon] modelled his letters on Dutch types, they were much better; for he introduced into his fonts a quality of interest, a variety of design, and a delicacy of modelling, which few Dutch types possessed. Dutch fonts were monotonous, but Caslon's fonts were not so. His letters, when analysed, especially in the smaller sizes, are not perfect, individually; but in mass their effect is agreeable.' *Caslon* does not have the elegance of Garamond's letters, but their 'defects' are recognised as being typically 'Anglo-Saxon', and as such have come to represent perfectly the 'sturdy English tradition' in typography. The descriptions above each specimen refer to the size of the type. For example, *Great Primer* was a rough equivalant to 18pt and so *Two Lines Great Primer* was double that; 36pt (see also page 80).

Two Lines Great Primer.

Quouſque tandem abutere Catilina, p

Quouſque tandem a-butere, Catilina, pa-

Two Lines Engliſh.

Quouſque tandem abu-tere, Catilina, patientia noſtra? quamdiu nos e-

Quouſque tandem abutere Catilina, patientia noſtra?

Two Lines Pica.

Quouſque tandem abutere, Catilina, patientia noſtra ? qu

Quouſque tandem abutere, Ca-tilina, patientia noſtra? quam-

abcdefgh
BODONI

abcdefgh
TIMES NEW ROMAN

'x' height

abcdefgh
GARAMOND

Promotional material for *Times New Roman,* published by Crowell-Collier & Company in the USA. There was little need to promote *Times New Roman* in the UK since it had been used with great success by *The Times* newspaper prior to its eventual general release. This brochure included explanations of the anatomy of the type and, here, presents comparisons with other fonts.

Fig. 5 • Times New Roman is here compared with Bodoni and Garamond, two of the most popular types in general use. As in the preceding examples, 18-point Times New Roman is shown, in identical enlargement, with 24-point of the others. Notice that Times New Roman is optically equal to the others, yet its compact fitting permits considerable gain in the number of letters per line.

Times New Roman possesses three distinct merits: strength of line, firmness of contours, and economy of space . . . Bodoni is noted for its flat, prominent serifs and dazzling thick and thin strokes…Garamond has stubby, irregular serifs and tall ascenders.

With its angled serifs closely bracketed to the main strokes, Times New Roman may be classified as 'modernized old-face'—coming as it does 400 years after 'oldstyle' Garamond, and 200 years after so-called 'modern' Bodoni.

The actual type used for the above enlargement is printed at the right.

abcdefgh

abcdefgh

abcdefgh

This page
Simon-Pierre Fournier. *Modeles des Caractères de L'Imprimerie,* 1742. *St Bride Printing Library*

Opposite page
John Baskerville set up his own type-foundry with the proceeds of a very successful business manufacturing japanned goods. In 1757 he printed his first book, *Virgil,* **illustrated here. A book of modest proportions, just 180mm tall by 117mm in width. His types were cut for him by John Handy and are more delicate and lighter than the** *Caslon* **characters so popular at the time.**

Transitional

In the last decade of the 17th century, the first conscious revision of old style occurred in France, with the creation of the font for the *Imprimerie Royale.* This departure from old style greatly influenced designers of printing types during the 18th century, the best known of these was John Baskerville. Baskerville was an English amateur printer and typefounder, who is credited with the creation of one of the earliest *transitional* types.

Baskerville had previously been a writing master and engraver (as well as very successfully running a japanning business). With John Handy as his punch cutter, Baskerville produced his first book, *Virgil,* in 1757.

Advances in ink- and paper-making and printing technology, all made by Baskerville himself, enabled him to rationalise the design of his typeface whilst subtly retaining distinctive aspects of hand-written form. *Baskerville* is characterised by an open form (similar to old style) but set at an angle that is closer to vertical and with a greater contrast between the thickness and thinness of line (similar to modern).

The difference between *Baskerville* and its predecessors might seem slight, but at the time his books were considered quite revolutionary and not at all well received. But their rejection was due not only to the type design, but also to the whiteness and smoothness of the paper – which gave the surface a slight 'sheen' – and the opacity and darkness of the ink. These characteristics, consciously and painstakingly devised by Baskerville, when added to the lack of calligraphic 'flow' of the typeface, persuaded some critics to accuse Baskerville's books of potentially causing blindness!

The appearance of Baskerville's books are severe when compared with his contemporaries. They do not incorporate ornament or illustration of any kind, relying, instead, on the precise placement, weight and balance of type on paper. Although deeply unpopular and rejected in England for more than 150 years, it was these characteristics, as much as the design of the type itself, that were to have such an influence upon Didot and Bodoni later. Pierre Simon Fournier, writing in his *Manuel Typographique* (1764–66) said of Baskerville, 'He has spared neither pains nor expense to bring [his types] to utmost pitch of perfection.'

Ni me, quæ Salium, Fortuna inimica tuliffet.
Et fimul his dictis faciem oftentabat, et udo
Turpia membra fimo. Rifit pater optimus olli,
Et clypeum efferri juffit, Didymaonis artes,
Neptuni facro Danais de pofte refixum. 360
Hoc juvenem egregium præftanti munere donat.
Poft ubi confecti curfus, et dona peregit:
Nunc, fi cui virtus animufque in pectore præfens
Adfit, et evinctis attollat brachia palmis.
Sic ait, et geminum pugnæ proponit honorem: 365
Victori velatum auro vittifque juvencum;
Enfem atque infignem galeam, folatia victo.
Nec mora: continuo vaftis cum viribus effert
Ora Dares, magnoque virum fe murmure tollit,
Solus qui Paridem folitus contendere contra: 370
Idemque ad tumulum, quo maximus occubat Hector,
Victorem Buten immani corpore, qui fe
Bebrycia veniens Amyci de gente ferebat,
Perculit, et fulva moribundum extendit arena.
Talis prima Dares caput altum in prœlia tollit, 375
Oftenditque humeros latos, alternaque jactat
Brachia protendens, et verberat ictibus auras.
Quæritur huic alius: nec quifquam ex agmine tanto
Audet adire virum, manibufque inducere cæftus.
Ergo alacris, cunctofque putans excedere palma, 380
Æneæ ftetit ante pedes; nec plura moratus,
Tum læva taurum cornu tenet, atque ita fatur:
Nate Dea, fi nemo audet fe credere pugnæ,
Quæ finis ftandi? quo me decet ufque teneri?
Ducere dona jube. Cuncti fimul ore fremebant 385
Dardanidæ, reddique viro promiffa jubebant.
Hic gravis Entellum dictis caftigat Aceftes,
Proximus ut viridante toro confederat herbæ:
Entelle, heroum quondam fortiffime fruftra,

Tantane

Tantane tam patiens nullo certamine tolli 390
Dona fines? Ubi nunc nobis Deus ille, magifter
Nequidquam memoratus Eryx? ubi fama per omnem
Trinacriam, et fpolia illa tuis pendentia tectis?
Ille fub hæc: Non laudis amor, nec gloria ceffit
Pulfa metu; fed enim gelidus tardante fenecta 395
Sanguis hebet, frigentque effoetæ in corpore vires.
Si mihi, quæ quondam fuerat, quaque improbus ifte
Exultat fidens, fi nunc foret illa juventas;
Haud equidem pretio inductus pulchroque juvenco
Veniffem: nec dona moror. Sic deinde locutus, 400
In medium geminos immani pondere cæftus
Projecit; quibus acer Eryx in prœlia fuetus
Ferre manum, duroque intendere brachia tergo.
Obftupuere animi: tantorum ingentia feptem
Terga boum plumbo infuto ferroque rigebant. 405
Ante omnes ftupet ipfe Dares, longeque recufat;
Magnanimufque Anchifiades et pondus et ipfa
Huc illuc vinclorum immenfa volumina verfat.
Tum fenior tales referebat pectore voces:
Quid, fi quis cæftus ipfius et Herculis arma 410
Vidiffet, triftemque hoc ipfo in litore pugnam?
Hæc germanus Eryx quondam tuus arma gerebat.
Sanguine cernis adhuc fractoque infecta cerebro.
His magnum Alciden contra ftetit: his ego fuetus,
Dum melior vires fanguis dabat, æmula necdum 415
Temporibus geminis canebat fparfa fenectus.
Sed, fi noftra Dares hæc Troius arma recufat,
Idque pio fedet Æneæ, probat auctor Aceftes;
Æquemus pugnas. Erycis tibi terga remitto:
Solve metus, et tu Trojanos exue cæftus. 420
Hæc fatus, duplicem ex humeris rejecit amictum,
Et magnos membrorum artus, magna offa lacertofque
Exuit, atque ingens media confiftit arena.

O 2　　　　Tum

Modern

'I want only magnificence… I don't work for the common reader.' Bodoni

The Didot family in Paris and Giambattista Bodoni in Italy represent the points where typographic design finally rejected *all* aspects of calligraphy. In its place is a rationalist design entirely sympathetic to the resurgent interest at that time in science and all things 'factual'.

Bodoni and Didot were influenced by the results of research carried out in France some 100 years earlier. The *Académie des Sciences* appointed in 1692 a committee of three (made up of mathematicians and scientists rather than printers) to look into the whole process of type design and its manufacture, for use at the Royal Printing Office of Louis XIV. This was an attempt to find solutions largely unburdened by historical precedent, whilst still addressing issues of legibility and economy. The results were the types *Romain du roi*, cut by Philippe Grandjean. These characters were shown constructed on a regular grid to enable others, 'to execute to the smallest detail, the letters we have decided on', using drawing instruments rather than being drawn 'free-hand'. The initial prints (complete with grid and construction lines) were printed from copper plates in 1695 and their impact was dramatic.

Pierre Simon Fournier amazed the printing trade with his two-volume *Manuale Typographique* (1764 and 1766) which assimilated the key characteristics of 'science and economy' initiated in Paris by the *Imprimerie Royale* in 1702. Whilst he did not believe it appropriate to apply mathematical methodology to the design of type, he *was* a profound believer in a rational method of describing the measurement of types. Fournier's point system for describing the measurement of type prepared the way for the later Didot and Anglo-American point systems.

Bodoni and Didot were contemporaries and knew of each other's work. Their mutual influences and the similar nature of their exclusive work (for affluent, often Royal patronage) encouraged them to produce books which would be appreciated as works of art rather than 'mere vehicles of communication'. As Allen Haley notes, 'Bodoni's work was probably the most honoured, and the least read, printing of its time'.[3]

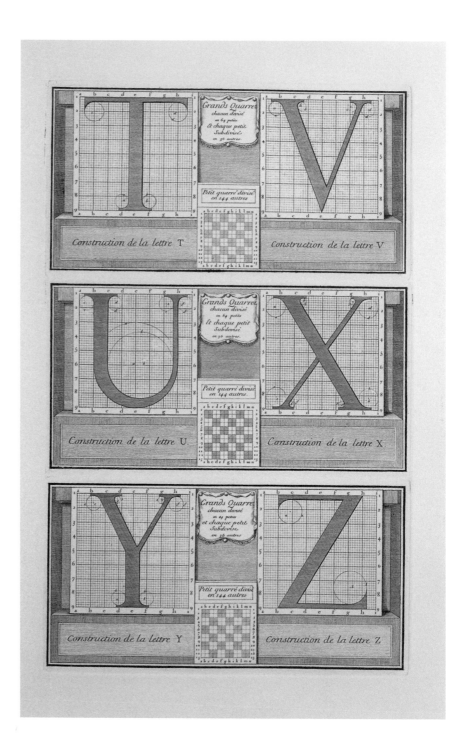

Opposite page
The thin straight serifs of the French *Romain du roi* by Grandjean were the earliest sign of the 'modern' types. Apart from the interest shown by Baskerville, the *Romain du roi* proved too shocking a change for printers to adopt but were later revived by Didot and Bodoni. This style, although never very popular in England, was greatly admired in mainland Europe, especially in France and Italy. For, as Baskerville said when he offered his fonts to the *Académie des Sciences*, 'I do not intend to sell any [of my types] to London printers, as my labours have always been treated with more honour abroad than in my native country'. From D B Updike's *Printing Types*, 1962

This page
François Didot, founder of the Didot family of printers and publishers, opened his bookshop and print workshop in Paris in 1713. The family was active and remained influential for several generations in founding, printing and papermaking. François's eldest son, François-Ambroise, and his two grandsons, Pierre and Firmin, all made substantial contributions. This is the *Specimen des Nouveaux Caractères*. St Bride Printing Library

8 *DEL PURGATORIO*

CANTO II.

Già era 'l Sole all' orizzonte giunto,
 Lo cui meridian cerchio coperchia
 Jerusalèm col suo più alto punto:
E la notte, ch' opposita a lui cerchia,
 Uscia di Gange fuor con le bilance,
 Che le caggion di man, quando soperchia:
Sì che le bianche, e le vermiglie guance,
 Là dov' i' era, della bella Aurora,
 Per troppa etate divenivan rance.
Noi eravam lungh' esso 'l mare ancora,
 Come gente, che pensa suo cammino,
 Che va col cuore, e col corpo dimora:
Ed ecco, qual sorpreso dal mattino,
 Per li grossi vapor, Marte rosseggia,
 Giù nel ponente sopra 'l suol marino;
Cotal m' apparve, sì ancor lo veggia,
 Un lume per lo mar venir sì ratto,
 Che 'l muover suo nessun volar pareggia:

CANTO II. 19 9

Dal qual com' i' un poco ebbi ritratto
 L' occhio, per dimandar lo duca mio,
 Rividil più lucente, e maggior fatto.
Poi d' ogni lato ad esso m' apparìo
 Un non sapea che bianco, e di sotto
 A poco a poco un altro a lui n' uscìo.
Lo mio maestro ancor non fece motto:
 Mentre che i primi bianchi apparser ali,
 Allor, che ben conobbe il galeotto,
Gridò: Fa, fa, che le ginocchia cali:
 Ecco l' Angel di Dio: piega le mani:
 Oma' vedrai di sì fatti ufiziali.
Vedi, che sdegna gli argomenti umani;
 Sì che remo non vuol, nè altro velo,
 Che l' ale sue, tra liti sì lontani.
Vedi, come l' ha dritte verso 'l cielo,
 Trattando l' aer con l' eterne penne,
 Che non si mutan, come mortal pelo.
Poi come più e più verso noi venne
 L' uccel divino, più chiaro appariva:
 Perchè l' occhio da presso nol sostenne:
 Tom. II.

This page
Giambattista Bodoni had the good fortune
to meet influential friends during his stay in
Rome which secured him the post of printer
to the Duke of Parma in 1768. It was not
until 1791 that he was entirely free to
print what and how he chose. This book,
La Divina Commedia by Dante, is a good
example of his mature style. (The title page
of this book is illustrated on page 97.)
St Bride Printing Library

Opposite page
A sale poster, circa 1860–70, printed
letterpress. *The John Hall Collection*

TO BE

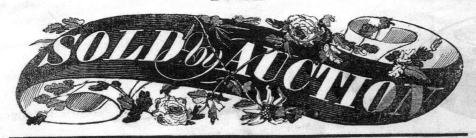

SOLD by AUCTION

BY S. LOVICK,

ON

Friday, Oct. 2nd, at half-past Ten,

THE VALUABLE

Machinery,

AT

LYNG

PAPER & FLOUR MILLS,

COMPRISING AN

EXCELLENT PATENT PAPER MACHINE,

Complete, 52 inches wide, with vat, lifters, stuff chest, lead pipes, pump, water wheel, laying shafts, straps and pullies, dry packing press, with two levers, dry treble press, single ditto, with fine thread screw, brass box, and iron lever, wood scales, with excellent beam, capable of weighing one ton, several $\frac{1}{2}$ cwt. and other weights, boxes with wire, a large quantity of moulds, cask of alum, new hair line, capital drying stove, with 30 feet of six-inch cast iron pipe, and wire guards, shutters round drying room, a quantity of drying poles, cast iron chopping machine, rope and apparatus, wet press and lever, german stove, 80 good trebles, lines and posts, a quantity of laying boards, cutting and other benches, several bow and eel nets, and various other articles.

In Flour Mill.—Pair of excellent french stones, spindle, vat, hopper, and shoe, two oak posts, ditto bridge trees, a quantity of boarding, beam and scales, iron skipper, sack, barrow, sieves, new jumper and apparatus, spur wheel, bevil, nut, laying shafts, meal bins, sack stage, flour cloths, &c.

In Blacksmith's Shop.—Capital pair of bellows, vice and bench, anvil, trough, and a quantity of tools.

ROBERT DAWSON, PRINTER, OPPOSITE ST. MILES'S CHURCH, NORWICH.

Sans serif

(Also known as Grotesque, or Grot, Monoline and Jobbing type.)

'Why two characters, A and a for a single sound a? One character, one sound. Why two alphabets for one word? Why two systems of characters when a single one gives the same results?' Herbert Bayer

The first *sans serifs*, characterised (like Fat Face before them) by an absence of serifs, were a by-product of the popular interest in the exploration of Athens at the end of the18th century and the resulting architectural Classical revival. It was, however, quickly adopted to serve a very different purpose in response to a need for a simple, utilitarian font that could be used in the design and printing of newspaper advertisements, lottery and theatre tickets, programmes and, later, posters. In the printing trade the generic term for such material was 'jobbing' or 'ephemeral' work.

The popularity of the *sans serif* was based upon its 'uncluttered', highly legible (rather than readable) characters, making it ideal where a short, loud statement was required. Haste to respond to huge commercial demands meant that quality of early *sans serif* versions suffered considerably – certainly Vincent Figgins' *Sans*, published in 1832, is such an example. But interestingly, even here, the 'quirkiness' of some of the characters – particularly the s in this case – gave it a raw individuality, and to a public accustomed to highly refined typefaces such a 'mistake' attracted the eye. Perversely, therefore, the face achieved what it was originally designed to do, although not in the way it was intended! The printing trade, conservative at the best of times, and with an eye on its illustrious past, disliked these 'Grotesque' fonts and much of the uncouth work with which they were associated.

Although 19th century in origin, the early geometric, 'minimalistic' characteristics of *sans serif* offered an appropriate starting point for designers after the First World War, who wanted to establish a way of communicating that was capable of reflecting the optimism of a new, modern age in which the social advantages of mechanisation and mass production might be embraced. The mechanistic structure of early sans serifs hindered readability, but this was always considered to be of secondary importance to the idealism and bravado associated with the 'brave new world' syndrome; although some fonts, Paul Renner's *Futura* and, particularly, Eric Gill's *Gill Sans*, went some way to addressing the problem of readability. Twenty-five years later, Adrian Frutiger's sans serif *Univers*, was drawn for optical balance rather than constructed geometrically, and was consciously designed to remain aloof from all 'national' characteristics. It represents an attempt to design a truly utilitarian sans serif that could be used anywhere and for any purpose. To achieve this goal Frutiger designed *Univers* with 21 variations; a huge family of weights and widths with italics which are, in fact, optically adjusted and balanced *slanted* versions of their roman counterparts rather than being calligraphic in origin as was the norm. The 'modernity' of *Univers* was given added credence because it was designed specifically for the photo-typesetting technology.

Since the 1960s there has been a steadily increasing number of sans serifs designed specifically for reading – rather than summoning up the 'spirit of an age' – with distinct calligraphic characteristics making a return. Hans Eduard Meier's *Syntax-Antiqua* in 1989 and Fred Smeijers' *Quadrate* are early examples.

It may appear contradictory, but whilst the invention of a new kind of pen, the ball point, developed for use by pilots during the Second World War, might have encouraged the acceptance of 'monoline' sans serif types in general use. The computer, after an initial flood of display types, so far, appears to be encouraging a resurgence of interest in humanistic old style typographic values of warm, comfortable, and readable types.

This page
Caslon's *Sans*. This sans serif first appeared under the heading 'Two lines of English Egyptian' in a specimen of the London typefounder William Caslon IV in about 1816. It is a monoline – that is, one with strokes of even thickness and its round letters are based upon perfect circles. It is the first known sans serif type.
St Bride Printing Library

Opposite page
Thorowgood & Company, London. Examples of sans serif from the *General Specimen of Printing Types*.
St Bride Printing Library

ABCDEFGHIJKLMNOPQR

STUVWXYZÆŒ

FOURTEEN LINES GROTESQUE.

MINERS

SEVEN LINES GROTESQUE.

BRIDGENORTH
communion

FIVE LINES GROTESQUE.

NORTHUMBERLAND
£2134507.

THOROWGOOD & Co., LONDON.

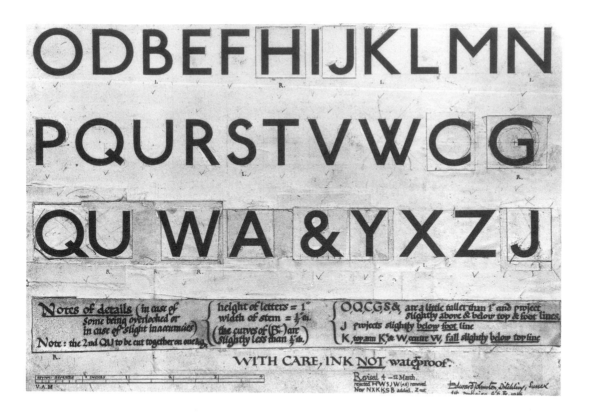

This page above
Edward Johnston was commissioned by Frank Pick to design a typeface for the London Transport's signage system for the Underground (although Johnston always referred to himself as a craftsman, not a designer). It was with the completion of this project that the first large 'corporate image' of modern design was created and the sans serif typeface acquired its dignity. This drawing was made in 1915. Johnston continued to work for London Transport until 1940. *Victoria and Albert Museum*

This page below
Here are two characters from Johnston's Bus Board lettering, circa 1930 (see also page 59). Although laterally compressed, the round forms are still fully curved; they are not U-shaped with flat sides. Johnston insisted that, 'No matter how compressed the letter, a round form should retain its roundness, and not be forced to give up its personality, its readability, and become straight-sided. That would be the old error of blackletter repeated once more'. From a talk to the Double Crown Club by Noel Rooke, 17 May, 1945.

Opposite page
Konrad F Bauer and Walter Baum designed *Folio* between 1957 and 1962. A sans serif family based upon 19th-century examples and on *Fortune*, a Clarendon typeface. Although no relation, Bauer was head of the art department of the Bauer Foundry in Frankfurt from 1928 to 1968.

Folio
breit halbfett

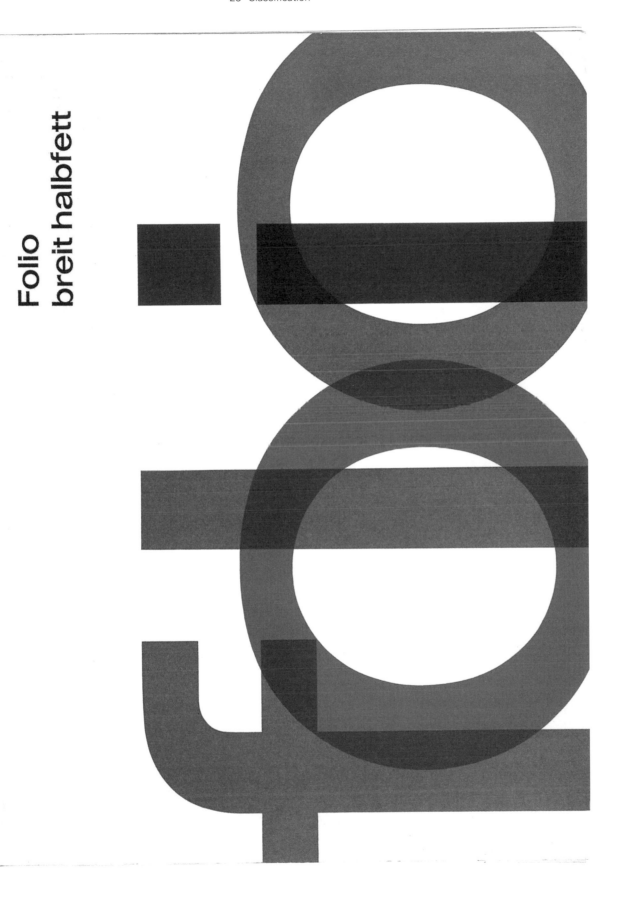

Function

Introduction

Another way of classifying type (other than that described in the previous chapter) is simply to sub-divide everything into just two sections: *text and display*. This sub-division was previously achieved simply by size – anything over 14 point automatically being deemed to be too big for textual use and therefore became display. Now that we have digital technology, this definition is too simplistic. Many typefaces originally designed for a very specific function, such as a signage system or a magazine masthead, have subsequently been made available as complete digital fonts. There is nothing to stop someone from using a display font for setting text – apart from their knowledge of what a text font must be capable of achieving for it to function.

The sub-division of type into text and display serves to emphasise that there are fundamental differences in the way text and display types are used and expected to function. Text type is used for continuous text – cool, quiet and, up to a point, 'invisible'. Supporting texts, such as captions or footnotes, are also considered as textual, although these offer an opportunity for the use of a different size, style (for example, italic), weight, or, perhaps, an alternative typeface, to help the reader differentiate between the various kinds of information.

Display is reserved for titles, headings and sub-headings. Display characters, by their very nature, are designed to shout; draw attention to themselves and to work more independently of each other (also see page 10).

Opposite page
Exclamation mark (or 'screamer'). Wooden type was used to print display characters principally on posters from the mid 18th century onwards.

All the numerals used in this book to signal the beginning of a new section have been taken from prints pulled from wooden characters.

This page
Two pages from the Stephenson Blake & Company specimen book, *Printing Types*, 1924. The presentation of the type demonstrates its function: on the left – text type; and on the right – display.

This type-specimen book, running to 726 pages (and more than 50mm thick) was printed in two (varying) colours, and is typical in both scale and ornamentality of type specimen books during the early 20th century.

Text type

Despite the myriad typefaces available today, those typefaces most appropriate for textual setting fall into a narrow category and, on the whole, follow a traditional pattern. Fonts designed to incorporate old face characteristics are easiest to read, transitional are less easy, and modern and sans serif are hardest to read. Of course, all are, to a point, perfectly legible, and with careful application can be made readable (although some are less efficient than others).

Text-type characters are designed to work in close proximity with each other, providing an uninterrupted visual flow, a dynamic left-to-right momentum, the idea being that the reader's eye is able to skim, without hesitation, along a line of type, recognising the essential shapes of each individual word. Consistency of style must be adhered to if the reader is to feel comfortable. Not surprising then, that the rule for good textual setting is that it should be so predictable, so normal, as to be 'invisible' to the reader (for display type the opposite must apply). The oft repeated truism; 'a type which is read most is read easiest' only serves to emphasise that the appearance of textual setting, once established, must remain predictable. This invites an interesting parallel to the old Shaker adage, '...that which in itself has the highest use, possesses the greatest beauty'. Now that *Helvetica* is the default font on most computers the premise upon which this adage is based has been thoroughly transformed.

Each typeface reflects, to some degree, the era in which it was designed, although it must be mentioned here that all the so-called 'classic' typefaces available for use on computers have been re-drawn for digital use. If a direct comparison were to be made it would be seen that there is often little similarity between the original and its newest version (see right).

This raises the question fundamental to every type revival, regardless of whether it be a revival of a 400-year-old or 30-year-old typeface. 'Perfect' facsimiles of the original never seem to work in quite the same way as the original. It is, invariably, the small 'imperfections' resulting from the combination of original hand-cut type, printing process and paper which make the original results so vibrant and characterful. Although nostalgia has no role to play here, the nature of the printed word, and the fundamental changes that it has undergone – particularly in the last 150 years – *are* a part of understanding the role of type today.

In the 20th century, each change of technology has brought with it new typefaces or the adaptation of older typefaces, some more successful than others. Characteristics commonly required of a readable typeface are openness of form, prominent ascenders and descenders, modelled serifs and a strong directional momentum.

Open letterforms

Those typefaces in which the outside of the o is almost round. This is only appropriate where there is a clear variation in the thickness of the lines, thus making the inside of the o distinctly oval.

Moderate, bracketed serifs

Bracketed serifs are those that curve smoothly into the vertical strokes of the letter.

Left-to-right momentum

To enable the eye to travel swiftly along a line of text, it is important that the key forms of each character feed into the next. In contrast, *Bodoni*, has hairline serifs at right-angles to the vertical strokes of letters, providing less horizontal and more vertical stress. Prominent ascenders, and (to a slightly lesser degree) descenders, are important because they help to define word shapes.

A text face should have all four characteristics but it is certainly possible for a typeface to have perhaps three out of four and still be satisfactory for many aspects of textual setting. The specific choice will depend on a number of factors, such as how efficiently the type fills the page, the required overall 'colour' of the text and those characteristics that best suit the subject matter.

Two Lines Great Primer.

Quousque tandem abutere Catilina, p

Quousque tandem a-butere, Catilina, pa-

Quoufque tandem abutere Catilina, p

Quousque tandem a-butere, Catilina, pa-

Opposite page
A sample of *Caslon*, printed by William Caslon & Son's in 1763, followed by Adobe's version, designed by Carol Twombly and released in 1990. Even allowing, in Caslon's version, for the effects of ink-spread (caused by the pressure inherent in letterpress print process) it is clear that Twombly's version is lighter and yet takes up slightly more space. The space gained has been used to provide more generous counters in an attempt to improve both readability and legibility.

To achieve the appearance of the lower sample the text was tracked by -5 and some interword spaces were reduced. The swash cap q and the swash lowercase f are available in the *Caslon* expert set. The size is described as 'Two lines great primer'. Great Primer was the name given to (approximately) 18pt. 'Two lines' simply means double, so the size of this sample was (and is) 36pt. (Also see page 80.)

This page
The American typographer Bruce Rogers is widely regarded as being the first 'freelance typographer' of the 20th century. He earned his living on both sides of the Atlantic and designed the typeface *Centaur*, based upon one of Janson's types. It was this typeface that Rogers used in this, the *Oxford Lecturn Bible* of 1935.

Display type

'The differences can be expressed as a maxim: text types, when enlarged, can be used for headings; display types, if reduced, cannot be used for text setting.' Walter Tracy, *Letters of Credit*, 1986.

Information, in the form of posters, handbills (fliers), leaflets and other print ephemera, was increasingly in demand from the early 19th century. This was due to effects of the Industrial Revolution, which enabled the 'mass production' of goods and services, all of which needed to be 'sold' to the public. Commercial competition forced business owners to request their printers to find ever more inventive ways of making *their* posters or leaflets more eye-catching than their competitors'. *Display* faces were designed as a response to this need and, as such, the arrival of display faces marked the start of a new purpose for type.

These faces were often given rather derogatory names by a print trade more accustomed to the refinement of texts faces[1]. Fat Face and Grotesques (or Grots for short) were designed to appear as imposing as possible. Egyptians (slab serifs, see opposite page) were developed with characteristic bold, square brackets (replacing the serif) and their mix of boldness and authority made these faces a standard for display work in the latter 19th century.

An influential development in display type was the production of type made from wood (see page 30). Darius Wood was a New York printer who developed a steam-powered router to mass-produce wood type commercially in 1827. In 1834, a pantograph mechanism was added (enabling type to be copied at any size from one master). As a result, a profusion of wooden type became available.

Unlike metal type, wood-type specimen books are quite rare and printed specimens of complete wooden fonts even rarer. The large size of many types meant that it was not uncommon for no more than a single character – perhaps filling an entire page – to represent a whole font. Moreover, wood types were rarely given names, the customer having to order by catalogue number only.

Inevitably, text faces, such as *Century* and *Cheltenham* in the 1920s, were designed to incorporate some of the bold characteristics of display faces. There was another revival of display types in the 1970s (due, in part, to the success of Letraset dry-transfer system) and later still with the development of digital technology.

Display types, regardless of how well crafted they may be, do not, generally, become 'classic' typefaces. They do not become well loved or as comfortable to the reader as a text face might because a display face must have 'novelty' value, which by definition means it must remain ephemeral. During their short lives, display faces may serve their purpose well – just as the rustic 'log', ribbons and 'human' types did and, more recently, as *Bombere*, *Magnificat* and *Stilla* (designed specifically for Letraset Ltd.) did in the 1970s before suffering a sudden demise.

Lettering on buildings and signage are specialisations for which the typographer is better trained than anyone else. It is not enough to pick a typeface, enlarge it, and fix it on a building. Typefaces are generally designed to be read at less than arm's length, and they need modification, or totally remodelling for use outside in sunlight and other weather conditions. We are fortunate to have one of the best motorway signage systems in the world in Britain, designed by Jock Kinneir and Margaret Calvert.

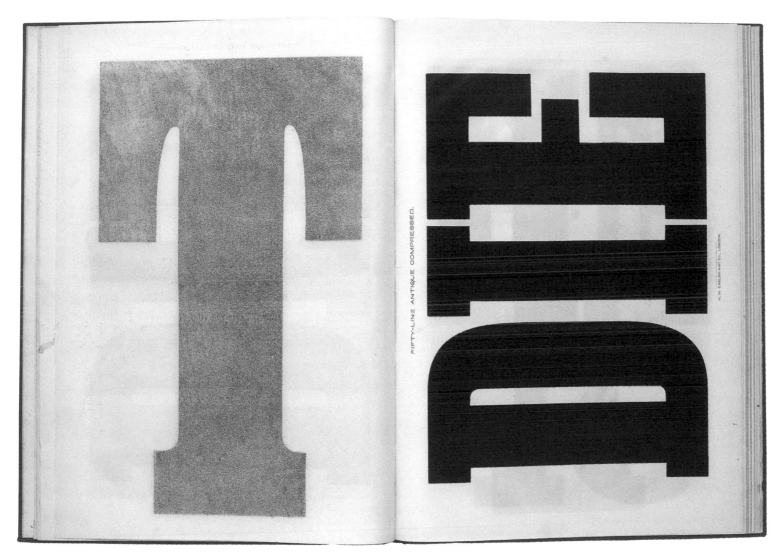

FIFTY-LINE ANTIQUE COMPRESSED.

H. W. CASLON AND CO., LONDON.

Opposite page above
Human 'A'. Seventeenth-century engraved
human figure alphabet. *Paris Royal Library*

Opposite page below
Letraset. The three winning entries
to the Letraset International Typeface
Competition, 1973; *Bombere* by Carla
Bombere Warde, *Magnificat* by F Fredrich
Peter and *Stilla* by François Boltana.

This page
Vincent Figgins, London, 1832. From his
Specimen of Printing Types. The large T
is the result of ink staining seeping through
the paper from the previous page.
St Bride Printing Library

Korte cursussen boekhandel De korte boekhandelscursussen, verdeeld over de clusters *assortiments-cursussen, nieuwe media, managementcursussen* en *commerciële cursussen*, hadden in totaal 130 deelnemers, een gemiddeld aantal van 10 deelnemers per cursus. Het aantal incompany-trainingen voor de boekhandel steeg, en daarmee ook het aantal deelnemers. Alle incompany-cursussen trokken 224 deelnemers.

De cursussen op het terrein van de nieuwe media slaan steeds beter aan. De vaardigheidstraining, bedoeld voor alle medewerkers op de werkvloer, voorziet in een duidelijk toenemende behoefte. Deze training gaat in op de voor de verkoop noodzakelijke technische aspecten van multimedia-computers en -software en oefent de deelnemers in het installeren en demonstreren van cd-roms. Een goede vervolgtraining is de cursus edutainment/infotainment, gericht op inhoudelijke kennis van deze producten. Nu boeken en cd-roms op diverse afdelingen in de boekhandel steeds meer geïntegreerd raken, is aanvullende vakkennis een groeiende noodzaak.

Aan alle boekhandelscursussen samen namen in 1997 547 cursisten deel. Deze teruggang van 11% vergeleken met het vorige verslagjaar komt uitsluitend voor rekening van de korte cursussen met open inschrijving. In het hiervoor aangekondigde meerjarenplan zal de Commissie Vak-opleiding haar beleid ten aanzien van de continuering van boekhandelscursussen en de financiering ervan nadrukkelijk aan de orde stellen. Dit beleid staat in het teken van wat door de KVB als een van haar kerntaken wordt verwoord: 'een bijdrage te leveren aan de ontwikkeling van kennis en vaardigheden van bestaande en toekomstige medewerkers in alle geledingen van de branche en daarmee een bijdrage te leveren aan de kwaliteit van de bedrijfsvoering'. De commissie is hierover ook in gesprek met de NBB, die haar zorg deelt en alle steun geeft om een kentering te bewerkstelligen.

Mystery guest In samenwerking met *Boekblad* en het Centraal Boekhuis heeft de VOB in 1997 ter viering van haar zestigjarig jubileum een uitgebreide speurtocht door de Nederlandse boekhandel op touw gezet, op zoek naar 'de boekhandel van het jaar'. In het hoofdstuk Boekblad wordt verslag gedaan van deze speurtocht naar de meest klantvriendelijke èn deskundige boekhandel.

Boekenuitgeverij *Basiscursus Uitgeverij* De Basiscursus Uitgeverij werd in 1997 herzien en geactualiseerd, met als resultaat een cursus die meer aandacht besteedt aan ontwikkelingen op het terrein van de elektronische media en waarin ook nadrukkelijker wordt ingegaan op de marketing van educatieve en professioneel-wetenschappelijke uitgeverijen.

Voor deze cursus, die in oktober startte, zijn momenteel 140 cursisten ingeschreven. Het examen werd tweemaal afgenomen; van de in totaal 114 kandidaten slaagden er 79 (69%).

This page
Contemporary use of wooden letters. Proof-prints taken from wood letters scanned and printed by offset litho onto both sides of a light-weight paper. The annual report of KVB, designed by Will de l'Ecluse and Mark Diaper at UNA, Amsterdam.

Opposite page
This advertisement, promoting the typeface *Platelet*, appeared in *Emigre* No 31. This typeface was designed by Conor Mangat and draws on the existing characters of Californian license plates. This use of the vernacular was a conscious effort to get away from the 'global aspirations' of the previous generation of 'international' type designers.

plate
s95
let 5

CALIFORNIA CA 93

The Bauhaus finally gets the Cal-Look! Dining heartily on a slice of American car culture, platelet draws from the existing characters of californian license plates to create a whole host of new opportunities for the typographically-minded driver. AVAILABLE IN THREE COMPLEMENTARY FLAVOURS, PLATELET IS NOW AVAILABLE EXCLUSIVELY FROM EMIGRE FONTS. TO order, call 1-800-944-9021.

994

abcdefghijklmnopqrstuvwxyzABCDE
FGHIJKLMNOPQRSTUVWXYZ1234567890
#¶@£ƒ$%*b™!&@?~§.

type and design conor mangat, 1994. grateful thanks go to phil baines, rupert bassett, ravensbourne college, and the square and studio. mr wendy helped a bit too

thin|regular|heavy

Standard Fonts

Introduction
Roman uppercase and lowercase
Numerals (lining and non-lining)
Italics
Punctuation
Weight options

Introduction

A 'family' is a collection of fonts with a common design. A font (previously spelt *fount,* derived from type foundry) is a complete set of letters, numerals, punctuation, signs and symbols. When you buy a font it sometimes includes a comprehensive family of typefaces, or it may be just one, rather restricted, typeface.

Different types are designed for differing purposes and this will certainly be reflected in what you will receive. A *display* font might consist of only a single set of 26 characters, a minimal quantity of punctuation and, perhaps, numerals. A good text font, however, will include roman and italic upper- and lowercase, small caps, numerals, punctuation, diacritics and pi-sorts, and all in a range of, perhaps, four or five weights. In all, over 1,000 characters.

As a rule, a family of typefaces should be used with discretion. Using what is available to good advantage inevitably involves selectivity and restraint, and so, having purchased a wide-ranging font, it should not be assumed that *all* the variations should be used *all* of the time!

However, a document is often made up of a number of interrelated texts. A typical book, journal, brochure or annual report might include running heads, headings, sub-headings, main text, captions, footnotes and folios (page numbers). Although much can be achieved by judicious placement and use of space to help the reader navigate all the differing kinds of information, a surprisingly complex grammar of editorial and typographic rule-governed systems also will often come into play. This often requires the designer to utilise a range of characters from an 'extended' family of type, each of which requires particular and distinctive attention.

Such extended families of type are not new. On page 17 you can see an example of a type-specimen sheet from the 16th century that includes additional character-sets. In the past, because each different *size* of font had to be cut individually, more emphasis tended to be placed upon the range of specific and prescribed sizes; normally in 1pt increments from 6 to 12pt, and then 14,18, 24, 30, 36, 42, 48, 60 and 72pt (also see page 77). The buyer would then have to decide which sizes he could afford to purchase before considering alternative weights and italics (available in the same range of sizes).

With digitised fonts, size is not physically limited. It is now common for text faces to be organised and sold as two separate family sets. The first *standard* family of fonts might consist of roman and italic (upper- and lowercase) and lining (or 'titling') numerals plus punctuation and most accented characters. These will normally be available in a range of three or four weights, such as light, medium, bold and, possibly, extra bold or black.

The second, 'optional' (although no less essential) extended family members – sometimes referred to as the *expert set* – might include small caps, non-lining (or 'text') numerals, ligatures, fractions, pi-sorts and accents. Depending upon the nature of the typeface, the *expert set* might also include swash caps – designed to be used in conjunction with lowercase italics – and, perhaps, decorative elements.

There are no rules as to what, exactly, constitutes a 'complete' font, or what, exactly, you should get even in a standard font. It is not uncommon to find surprising omissions; for example, the standard *Monotype Caslon* set has small caps in medium and semi-bold but not in bold, whilst roman non-lining numerals are only available in bold! It certainly should not be assumed that, for example, fractions, or a full range of pi-sorts and foreign accents will be 'automatically' included. *(Caslon standard and expert fonts, right.)*

All typefaces, regardless of their historical heritage, have, in fact, been redrawn, cut and/or digitised during the 20th century, and if direct comparisons are made, you will see that there is often little resemblance between the original and the typeface on your computer with which it shares its name. Also, each major type-distributor will have their own version of the major, 'classic' typefaces, and again, each version represents an individual 'interpretation' that will be different from another distributor's 'interpretation'. So before you buy you need to decide *which 'Caslon'* you prefer. *(See Original and Adobe versions of Caslon, page 32.)*

'MONOTYPE'
COMPOSITION
FACES

'Monotype' Display Faces
Caractères Gros Corps «Monotype»
«Monotype» Großkegel-Schriften

ABCDEFGHIJKLMNOPQRSTUVWXYZ
abcdefghijklmnopqrstuvwxyz 1234567890
!@£$%^&*()_+={ }:""'"'´` | < > ? ~ [];,.√/¡™#¢∞§¶
•ªº−≠œ∑®†¥¨^øπåß∂ƒ©˙∆˚¬…æ«Ω≈ç√∫~µ≤≥÷

ABCDEFGHIJKLMNOPQRSTUVWXYZ 1234567890
¼½¾⅛⅜⅝⅞⅓⅔ffffiflffiffl
!3$$^&()-—12¢4567890−ŒÝ¨ˆØÞÅŠ.
$¢ÆŽÇ˜,.¡¢Rp∕˚˙Đ

This page above
Two Monotype catalogues – one for text
fonts, the other for display. These were
essential for every graphic design student
prior to phototypesetting in the 1970s.

This page below
Caslon standard and expert fonts.

Roman uppercase and lowercase

In typographic terms, 'roman' has several meanings, but it is generally used to describe upright as distinct from italic characters, regardless of how much 'roman' content there might be ascribed to the font in question.

Roman uppercase characters (capitals) were designed to be read character by character. They are statuesque, upright, with each character designed to function with no interaction with any other character. Since their purpose was to be on permanent display – cut into the stonework of public buildings or monuments – it seems entirely appropriate that roman capitals should have been designed to be read slowly; as if to encourage the contemplation of each character, and then each word, and eventually, the complete statement. The result is a grand gesture, a statement delivered to a submissive but admiring audience (see page 16).

In comparison, reading roman lowercase characters (in conjunction with uppercase) printed onto paper and bound into a book or magazine is, essentially, a private activity. Overall, the forms of lowercase characters are more diverse than their uppercase counterparts, and yet, when placed next to each other, should knit seamlessly together, transferring the emphasis away from the characters and onto the words. The ability of lowercase to become 'invisible' in this way (quite the opposite of uppercase characters) enables the reading process to progress on a private level.

Numerals (lining and non-lining)

There are also upper- and lowercase numerals.

Uppercase numerals, usually called lining, titling, or ranging numerals (because they align with each other in the same way as uppercase characters) are a more recent, 19th-century development. It is normal (and preferable) for lining numerals to be a little shorter in height than the capitals of the same face.

Lining numerals all but took over in the 20th century as type designers, turning to the simpler forms of *sans serif* (and even experimenting with single-case alphabets) preferred the simpler, stronger characteristics of numerals which matched the uppercase (rather than the lowercase) characters.

Lowercase numerals, usually called non-lining, non-ranging, arabic or text numerals, include some with 'ascenders' or 'descenders' and should be used within text in conjunction with other lowercase characters or, perhaps, with small caps. Non-lining numerals are sometimes only available with the 'expert' font, and, occasionally, not available at all!

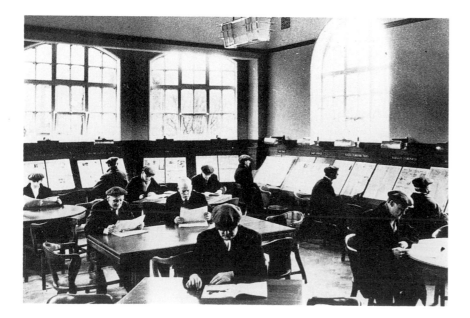

This page left
Even in a full room, the reading of books, magazines and newspapers remains a private and essentially personal experience.

This page above
Caslon non-lining numerals (from the expert font) and *Caslon* lining numerals.

Opposite page
Cover of *Emigre* No. 45, 1998, by Jack Stanffacher. Whilst the surface characteristics of wooden type have been enhanced it is the placement of these forms in relation to the edges of the cover which provides the assertive quality of the numerals. The characters are so big that they lose their original identity as type.

EMIGRE

Emigre • 4475 D Street • Sacramento • CA 95819 • U.S.A.

ADDRESS SERVICE REQUESTED

Bulk Rate
U.S. Postage
P A I D
Denver, CO
Permit No.
489

Italics

The combined use of uppercase and lowercase roman letters has remained a constant for hundreds of years. However, roman and italic were always used quite separately until the 17th century when typographers began to use both in order to differentiate varied information. Typically, but not exclusively, roman might be used for the main text whilst italic might be reserved for supporting material such as footnotes, captions and extended quotations. The custom of combining both in the same text, commonly using italic for emphasis and for foreign words and phrases, became a popular option for editors in the 19th century.

Whilst most romans are (essentially) upright and most italics (generally) slant to the right, this is not the most essential difference between them. A truly italic character, as distinct from a sloped roman, must be 'cursive', which means it reflects the fluidity of handwriting, with the beginnings and endings of each stroke curving into, and away from, each character. This encourages a natural, flowing transition for the eye from one letter to the next. True italics tend to be slightly narrower then their roman counterpart. This is, at least in part, to ensure that the necessary slant does not involve the italic character taking up more horizontal space than its roman equivalent. More recent italics however, have tended to the same character-widths as their roman equivalents.

Standard computer software is capable of distorting letters in many different ways but the 'italicising' command offered, for instance, on the 'measurements' and 'style' menus in QuarkXpress, does not 'automatically' provide a true italic. If you do not have a true set of italic characters in the font you are using, the computer will simply 'slope' the upright strokes of the roman version, even in a typeface which has an 'oblique' rather than an italic. This 'automatic' italicising alters the weight of the vertical and angled strokes whilst the horizontal strokes remains the same. Such mechanical distortions should always be avoided. It is easy to differentiate between a true italic and an electronically slanted version because certain characters – the lowercase italic a for example – will be different from the roman a *(see right)*. *Because fonts may not be linked to the style or measurement menus (or may not be on the computer) it is advisable not to italicise (or 'embolden' in this way.*

Many recent sans serif fonts have been designed with all stroke thicknesses and counters adjusted to provide appropriate balance to a 'slanted' version in preference to a true italic. *Univers* is such an example. These are often described as 'oblique' or 'sloped' – a more accurate description than 'italic'.

Because lowercase letterforms are themselves based upon hand-written forms they easily lend themselves to being adapted to italic. This is not the case with uppercase italic letters which are particularly difficult to set and space satisfactorily.

History and reasoning indicate that the cursive nature of italic lowercase would make it, at the very least, as easy to read as its roman counterpart. However, ease of reading requires conventions, and, over time, the traditional role of italic dictates a supporting role.

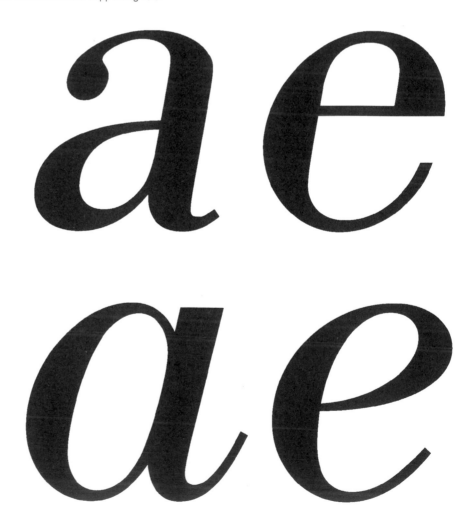

multatuliprijs adviescommissie piet calis, frans de rover en xandra schutte

busken huetprijs

krijgen door het kader waarin Mulisch ze plaatst een onverwachte dimen-

sie. Dat geldt in het bijzonder voor de gebeurtenissen in het Amsterdam

van de jaren zestig, die nu — een kwart eeuw later — door Mulisch gesi-

tueerd worden in een verhaal van mondiaal belang, maar tegelijkertijd

worden bekeken met een scherp oog voor de menselijke komedie die we

dagelijks met elkaar opvoeren. Daarbij komt indirect Mulisch' eigen

optreden indertijd met fraaie zelfspot ● ter sprake. Verder dragen de

lyrische beschrijvingen van culturele lustoorden in Venetië, Rome en

Jeruzalem sterk tot de aantrekkelijkheid van het boek bij.

Dat doen ook de uiterst levensechte dialogen tussen de personages Onno

Quist en Max Delius. Tijdens hun gesprekken ontwerpen ze — soms met

een schijn van ernst, soms uiterst baldadig — allerlei theorieën, die niet

alleen een nieuw licht op sommige vertrouwde verschijnselen lijken te

werpen, maar in de loop van de roman ook met elkaar verbonden worden

tot een visie op de ontwikkeling van de mensheid, die al in vroegere

boeken van Mulisch — in het bijzonder de zaak 40-61 (1962) en de

compositie van de wereld (1980) — terug te vinden is. Daardoor wordt in

deze roman opnieuw op superieure wijze aangetoond dat lachen een vorm

van ernst kan zijn.

Opposite page
Bodoni italicised e and a, followed by a slanted or 'bastardised' e and a offered via the style or measurement menu.

This page
This catalogue of award-winning Dutch culture works from front-to-back and from back-to-front. The use of italic type printed onto translucent paper allows the type on the other side of the page to be seen travelling in the opposite direction. Designed by Anita van de Ven, 1993.

Punctuation

Punctuation, to function effectively, should be used consistently. Such decisions cannot be based upon aesthetic sensitivity, but on grammatical prescription alone. To maintain consistency of application and clarity of style the typographer needs to know what, exactly, each punctuation mark represents and where it should be used.

A normal font will include approximately 20 punctuation signs. These should not to be confused with the diacritics (ä ê ñ õ û etc) legal and commercial logograms (% £ @ # etc) or mathematical symbols (+ = ÷ etc).

Punctuation has a number of functions which can be split into four categories: signs indicating pause; signs which indicate alternatives; signs which indicate omissions; and signs which clarify nuance of expression.

Signs indicating pause (longest first)
Full point (.) closure of sentence
Colon (:) clause arising from preceding clause[1]
Semicolon (;) linked set of clauses
Comma (,) linked clause or word

Other punctuation indicating a pause, but which also has other functions (longest pause first): em dash (—) can function similarly to a colon or to parentheses; en dash (–) has the same functions as an em dash but is less obtrusive among an area of text. Both em and en dashes can also indicate an omission.

Of course, a space of any kind in text is, in itself, a form of punctuation, suggesting as it does, a brief pause between words. It follows that a larger space will suggest a longer pause. It is for this reason that interword spaces, particularly those which include punctuation, should be carefully constructed so that no *additional* space is perceived by the reader.

Signs indicating alternatives or additions
Parenthesis () enclosing author's interpolations. (Plural: parentheses)
Square brackets [] enclosing editor's interventions
Brace } indicating two or more lines form a set
Virgule / or (historically) shilling stroke or forward slash when reciting website addresses
Quote marks ' ' and " " (single and double) opening and closing of a reported utterance

Signs indicating omissions
Apostrophe (') also used to indicate ending of a reported utterance
Ellipsis (…)
Turned comma (')
Double em dash (——) often indicates both an omission *and* a pause

Signs indicating clarification of expression
Exclamation mark (!)
Question mark (?)
Hyphen (-)

Apostrophe
An *apostrophe* signifies an omission: *it's*, for *it is*, or *tho'*, for *though*. It also signifies the possessive branch of the genitive case; John's book. It is also used in Irish names, as in O'Brien but is *not* used in abbreviated Scottish names. The apostrophe also forms the latter part of quotation marks (see also page 46).

Brace
The *brace* is used to connect, for example, two or more sub-titles on different lines within a single, tabulated entry. The brace should always point towards its cross-referred entry.

Square brackets
Square brackets (also called brackets or crochets) are used to separate comments, corrections or explanations from the main body of text in which they appear. When required in a line of uppercase, brackets will need to be lifted to the optical centre of the character.

Colon
A *colon* signifies a pause; a turning point within a clause or sentence. Positioned within a sentence in which the preceding part is complete in sense whilst the following part is a statement or remark arising from it. The colon is also used to introduce a list of points, an example, or a quotation.

Comma
A *comma* separates and defines the adjuncts[2], clauses and phrases within a sentence. It should also follow each adjective except the last. It should not precede or follow a dash, brackets or parentheses. A comma is also used to clarify high numbers – separating each set of three consecutive numbers from the right when there are four or more, although a small space can provide a similar result, as commonly used in telephone numbers.

Ellipsis
An *ellipsis* is made up of three full points each separated by a short space (larger than that normally between characters but smaller than a 'word' space) and signifies the omission of a word. Where ellipsis occur at the end of a sentence a fourth full point should be added, its distance from the final full point of the ellipsis being the same as those within the ellipsis itself.

Em dash
An *em dash* is used in place of a comma or parentheses, offering the author a more dramatic pause where it is necessary for the construction of a sentence to be changed or even halted. It is also used to signify a faltering pause: 'Well — I don't know…' When required in a line of uppercase the em dash will need to be lifted to the optical centre of the characters on either side.

En dash
An *en dash* is used (rather like a virgule) to connect two facts, such as dates (1968–69) or to signify a partnership (Smith–Jones). It is also commonly preferred for use within text replacing the em dash because its shorter length keeps the visual texture of the page more even. If used consistently, and if carefully spaced, this is an acceptable alternative. When required in a line of uppercase the en dash will need to be lifted to the optical centre of the characters on either side.

Opposite page
An apostrophe, brace, square brackets, colon, comma and elipsis. The hyphen, en dash, em dash and double em dash. Note that the hyphen is positioned lower than the en or em dashes. This is not common to *all* typefaces. These are all set in *Caslon*.

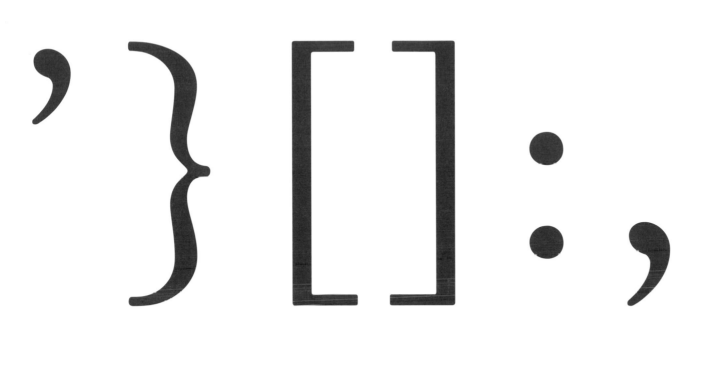

Exclamation mark
An *exclamation mark* is used after words or sentences expressing a striking thought or utterance. It should be placed at the end of the exclamation, whether this occurs at the beginning, middle, or end of the sentence.

It should follow quotation marks when it is not included in the sense of the quotation as in: This is not 'typography'!

It should not be followed by a full point if placed at the end of a sentence, or any other punctuation if in the middle of a sentence except a quotation mark.

Full point
A *full point* signifies the end of a sentence. In all other circumstances it should be omitted where possible if this does not inhibit meaning. For example, do not use after numbers in addresses, or lists of points or the numbering of paragraphs, and do not use after the cap initials of people's names. In all these cases careful spacing arrangements might need to be made to ensure the required sense is maintained but this is preferable in every case to rows of full points.

A *full point* should not be used between numerals. A decimal point should be positioned to separate a whole number from a proportionate number as in: 10·5pt.

Do not use a full point in titles or sub-titles.

Hyphen
A *hyphen* is used to connect. When a word has to be broken at the end of a line a hyphen is used to signify its incompleteness and its connection to the second part of the word at the beginning of the following line. It is also used to connect words that represent a common idea, such as *mind-blowing*.

Where two or more compound[3] words have a common base the latter can be represented in all but the last by a hyphen as in *upper- and lowercase*.

The hyphen is used to separate two syllables[4] of a word where the first ends, and the next begins, with the same letter to indicate that they are pronounced separately, as in *co-operative*, or to clarify meaning, as in *re-mark* (as distinct from *remark*).

Generally, the hyphen should not be used at the end of more than two consecutive lines and must never be placed at the beginning of the second line. Also, avoid using a hyphen at the end of the last line of a page and, in particular, the right-hand (verso) page. When required in a line of uppercase, the hyphen will need to be lifted to align with the optical centre of the adjacent character.

Parentheses
Parentheses, like brackets, are used to separate additional remarks or responses within a text. The key to the practical relationship of brackets and parentheses is consistency. Where a remark in brackets requires a second remark to be isolated, then parentheses should be used and visa versa. If possible, avoid (words [words]). When required in a line of uppercase, parentheses will need to be lifted to align with the optical centre of the adjacent character.

Question mark
A *question mark* should follow each and every question, however short, if a separate answer is required, as in: *What is type made of? How is it defined? Where did it start?* A question mark is not used where no answer is required, as in: *He was asked if he knew the name of the typographer.* It should follow quotation marks when it is not included in the sense of the quotation as in: *You call that 'typography'?*

A *question mark* should not be followed by a full point if placed at the end of a sentence, or any other punctuation if in the middle of a sentence, except a quotation mark.

Quoted speech and quoted texts
The start of a quotation is signified by a raised, turned comma, and its ending by an apostrophe. Used in this way these two signs are called quotation (or quote) marks. Double quotes were introduced to differentiate this role from the other roles these marks play, but, in the interests of simplicity and evenness of visual texture, single quotes are, generally, preferred. The apostrophe at the end of the quote should come before all other punctuation that does not form part of the quote itself.

If a quote includes a quote then this will be signalled with double quotes. A quote within quoted direct speech would appear as; '*He said to me "I think it's wrong"*' she said. A quote within a quote within a quote reverts to single quotation marks etc.

To keep the text area as even in its visual texture as possible, it is preferable not to use quotation marks to signify the title of a book, song etc, or for the name of a typeface or hotel etc. These can be signalled by the use of italic.

It is normal to set a longer quotation or cited text in a different size or even a different style of type. It might also be indented; composed to a line length slightly shorter than the line length used for the main text. In such cases, quote marks are not necessary.

Turned comma
A raised, *turned comma* is used in the abbreviation of the Scotch Mac (M'Donald). It also forms the first half of quotation marks.

Double em dash
A double em dash is used to signify the interruption of a sentence or the omission of a word or part of a word, as in; *He called him a ——*. Rarely needed today and not often included in contemporary fonts, but easily composed by joining two em dashes together.

Virgule
Virgule, also commonly called a forward slash, expresses the choice *either* or *both* terms. For example, and/or and together/apart. This, of course, is not its function when used in email or website addresses.

Other general rules
Punctuation, following bold or italicised words for emphasis, should always return to the style and weight of the general text. In such circumstances, and in particular with parentheses (for example, where italic is used within roman parenthesis) great care needs to be taken over spatial relationships. (Also see page 91.)

**Opposite page
Full points, parentheses and virgules set in *Caslon, Baskerville, Bodoni* and *Univers*.**

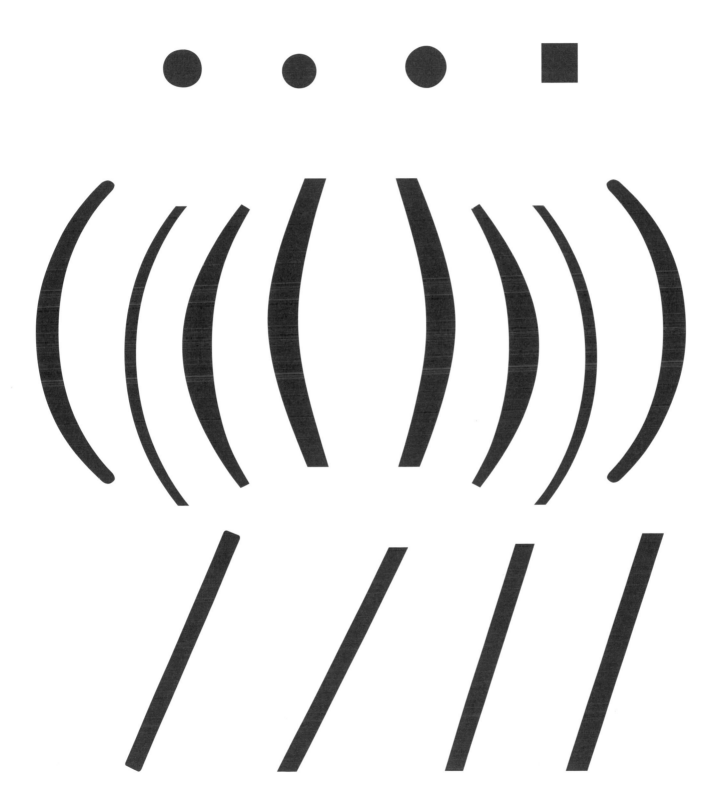

Weight options

Weight can be described in a number of ways but is usually *light, medium, bold* and *extra bold* or *black* and, occasionally, with an additional weight between light and medium (which might be called *demi-light* or *book*) and, occasionally, a *demi-bold* between *medium* and *bold*. These descriptions are arbitrary indications only. There is not a *standard* light, medium or bold. Each typeface offers, instead, the type designer's interpretation of these adjectives with regard to the preconceived functions of the typeface.

Bold face romans are a 19th-century invention by signwriters, and bold italic is even more recent. Nevertheless, font manufacturers have added bold romans and italics to re-cut or digitised versions of 'classic' typefaces, regardless of historical integrity (for example, *Caslon*). Computer software and ease of manufacture has also encouraged font manufacturers and distributors to offer additional weights, such as demi-light and demi-bold. Whilst it is quite common to have a demi-light or book if the medium is considered a little too dark for extended text) these additional weights need to be used with caution. Hierarchy of information – indicating headings, subheadings and text for example – needs to be clearly defined; too subtle a change in weight can appear tentative and such uncertainty will be transferred to the reader.

It is also possible with standard computer software to 'embolden' any weight of any typeface, even a bold face! But the menu on the 'measurements' or 'style' menus in QuarkXpress, for example, does not automatically provide the 'bold' version as drawn by the originator of the typeface. If you do not have a true set of bold characters in the font you are using, the computer will simply 'embolden' the version highlighted on screen. Because fonts may not be linked to the style or measurement menus (or may not be on the computer) it is advisable not to embolden (or italicise) in this way.

When weights are used to signal a new heading or subheading the weight alone should suffice to deliver the emphasis required. If not, always try a heavier weight before considering a larger type size.

Additional weight is normally used for emphasis in titles, headings or sub-headings. They can also be used within text to give emphasis to a word or phrase, but generally this is too disruptive to the page and, of course, the eye can 'see' the emphasis before it is appropriate. It is, therefore, often preferable to use an italic (which is the same weight as the text) in such a situation. Emphasis can also be provided, where practical, by indenting or, for instance, by the use of hung bullet-points. If a bold face *must* be used within a text area then any following punctuation should revert to the weight of the general text.

On a page of text, it is important that the 'tone' of the page is not too dark. A particularly dense-looking page of type will always appear a daunting task to read. As a general rule, the larger the size of text type, the lighter in weight it should be.

Where a short passage of text needs to be reversed out (white type on a printed background) and where the text is a normal text size (between 8 and 12pt) it is best to avoid using a 'light' typeface or one which has particularly thin strokes (such as *Bodoni*) as all lines will appear thinner (making the type appear 'lighter') by the spread of the ink encroaching into the unprinted type area. Using a demi-bold will provide a close, visual equivalent of a medium weight, but since an extended run of reversed-out text (for example, white text on black) is always less readable, a bold face (perhaps with adjustments to tracking values) will often help alleviate this problem.

A bold face will present any colour more effectively than a light face simply because there is more 'face' with which to present the colour.

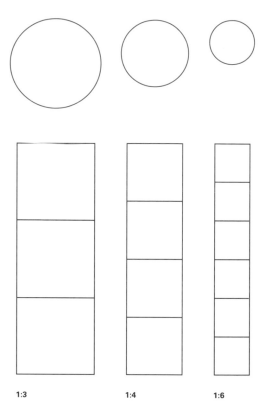

1:3 1:4 1:6

This page below
Helvetica Bold and, right, a 'bastardised' version of *Helvetica Bold*. If you do not have the true bold version of the font you are using then the computer will provide an 'alternative'.

This page above
Ratio of width-to-height using Gerrrit Noordzij's scale, which proposes a standard method with which to express relative weights of typographical character sets. From *Letterletter* by Gerrrit Noordzij.

Opposite page
Using a designated numbering system, Adrian Frutiger arranged the members of the *Univers* family according to width, weight and posture. The *Univers* family has two axes and includes oblique (or slanted) versions of most fonts. The use of numeric variables was successful because there was sufficient uniformity within the family as a whole with their identical x-heights and consistent ascender and descender lengths. The integration of the 21 versions took three years to design and implement. *Univers* was distributed in 1957 by the Paris type foundry Deberny et Peignot.

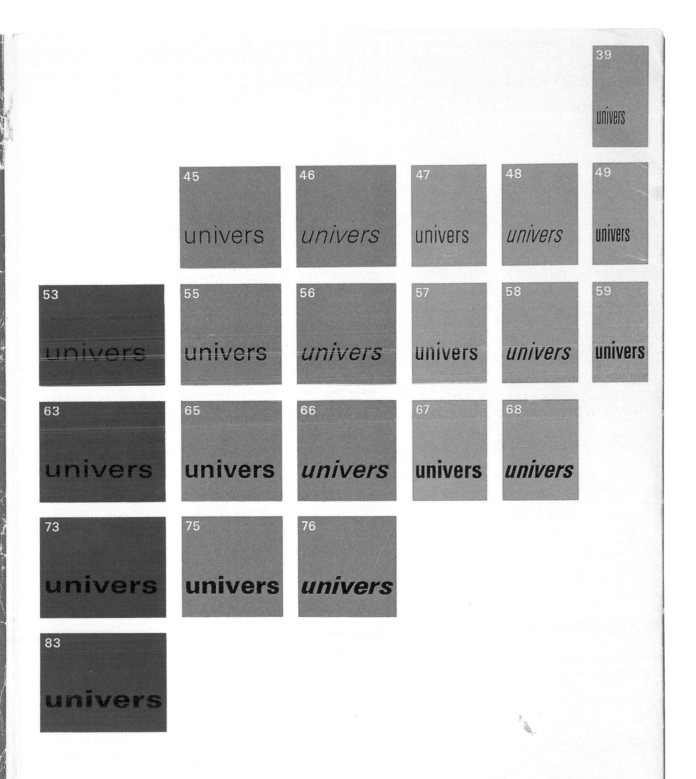

21 variations sur un thème unique

Extended Fonts

Small caps

Small caps are designed to be the same weight as all the other characters within a font and (usually) only slightly taller than the x-height of the lowercase characters. Because they are designed to appear approximately the same size and weight as lowercase characters, the use of small caps allows the text to maintain an even texture even when a large number of 'uppercase characters' are necessary.

Swash caps

Swash caps are a true uppercase italic but their flamboyance severely restricts their use and they are only available with a few (normally old style) typefaces. They work well in conjunction with lowercase italics or as a dropped initial, but are *not* designed to form words only composed of capitals.

Terminal characters

Occasionally, an italic face will include a selection of 'terminal' lowercase letters; a normal italic but with an extended terminal. These are designed to be used only as the last character of a word or, perhaps, at the end of a paragraph.

Ligatures

Ligatures are specially designed pairs and trios of characters which are linked together to form a unity. *Ligature* means laced together. Because the arm of the f reaches into the space of the character ahead of it, certain common sequences, such as ff, fi, fl, ffi and ffl can cause the characters to overlap. Such clashes are ungainly and so ligatures for all of these combinations are available with most text fonts. They are easy to implement either individually via the keyboard or in a large document via the 'find/change' command under the 'edit' menu. (If using this function, take care not to change [cap] Fi combinations by mistake). Less common combinations, such as fb, fh, fj and fk will rarely have ligatures and will have to be dealt with individually.

Some fonts, *Caslon* for instance, have ligatures that are specific to the font; for example, st and ct. It is common for many digitally designed fonts to have a large number of ligatures that play an essential role both in maximising readability and also in providing a distinctive character to the font.

Fractions

Fractions continue in use in spite of the metric system. However, it cannot be assumed that all new fonts will include even a small number of fractions as composites. Fractions can be made with most typesetting software packages such as QuarkXpress, but achieving appropriate weights and sizes of the numerals (which must be lining) with the weight and angle of the bar is very difficult to do with satisfaction. If fractions are required, use a font that has the ones you want in composite form or at least has superior and inferior numerals (see page 54) designed specifically to be 'composed' as fractions.

This page above
The fi ligature set in *Caslon, Baskerville, Bodoni. Univers* does not have an fi ligature. Ligatures available in *Caslon* (standard and expert fonts):
Caslon (standard font): fi and fl
Caslon (expert font): ffi, ffl, ff, st and ct
Caslon Italic (standard font): fi and fl
Caslon Italic (expert font): alternative f, ft, ct, fh, fi, fl, st and k

This page below
Caslon cap, small cap and lowercase m. Note that the line weights of the small cap and the lowercase characters are very similar.

Bottom line: *Caslon* caps reduced to approximately the same size as the small caps. Note that the weight of line of the reduced cap now looks considerably thinner than that of the small cap.

Small caps are designed to be the same weight as all the other characters within a font and only slightly taller than the x-height of the lowercase characters. Reducing the size of uppercase characters to serve the purpose of small caps will provide characters which are considerably lighter in weight.

More about non-lining numerals

Non-lining (or lowercase) numerals have made a welcome comeback in recent years, but despite this, they are often only available in the 'expert' set.

Non-lining numerals are designed to be in visual harmony with lowercase letters, so that 3, 4, 5, 7 and 9 have descenders, 6 and 8 have ascenders and 1, 2 and 0 relate to the lowercase x-height. The zero was often, and, occasionally still is, designed as a circle without modelling to prevent it being confused with the lowercase o. Non-lining numerals are now often included in sans serif fonts.

Diacritics

Although covered here under extended families, diacritics (or at least a selection of them) would normally be available in a standard set.

Diacritics is the generic name for all the characters and punctuation marks required for languages other than standard Anglo-American. In a good font set all of these will be available, although some diacritics – often the Eastern European and Asian ones – are not and must, be constructed from their constituent parts.

Typography deals with language and it is common (and becoming ever more common) for the typographer to have to deal with multilingual and multicultural material. This richness of diversity should be nurtured and protected. It is, after all, cultural diversity that is important, not the similarities. It is essential that diacritics are used whenever appropriate. It is rude and ignorant to assume that such accented characters, specific to a language, do not matter. The fact that Anglo-American mass-circulated material often demonstrates such lazy ineptitude in even misspelling the names of major European and Asian persons and place names is as derogatory to us as it is to them.

Following are the majority of diacritics required (although this in no way purports to be a comprehensive listing). Some of these are hidden in the keyboard, requiring multiple-step commands, but there is also software available that enables you to bring most available characters in a font up on screen for easier access. Many diacritics are available as 'composites' (complete characters with the accent in position) but some will, inevitably, have to be composed, either by combined keyboard commands or negative kerning.

Acute: á é í ó ú Á É Í Ú Ó
Used on vowels in Czech, French, Gaelic, Hungarian, Icelandic, Italian and Spanish among others.

Breve: ă ĕ ğ
An accent used for vowels and consonants a e and g in Malay, Rumanian, Turkish and Vietnamese. Not available in composite form.

Caron: č ě ň ř š ž
An inverted circumflex used on the consonants and vowels c e n r s z. Used in many Eastern European countries. Not available in composite form.

Cedilla: ç Ç
An accent used with consonants in French and Portugese. It is also used on the s, t, and n in some Eastern European countries but these are not available in composite form.

Circumflex: â ê î ô û Â Ê Î Ô Û
An accent used on vowels. Used in French, Portuguese, Rumanian, Turkish and Vietnamese. There is also w and y which are used in Welsh only, but which are not ISO standard.

Grave: à è ì ò ù À È Ì Ò Ù
An accent used on vowels. Used in French, Italian, Portuguese and many other languages.

Guillemets: « » ‹ ›
(Also called chevrons, and angle quotes.) Single and double guillemets are often used as quotation marks in mainland Europe, Asia and Africa. In French and Italian the guillemets almost always point away from the quote, ‹like this› but in German they often point inward towards the quote, ›like this‹.

Overdot: ˙
Used with consonants c, g, and z in Polish and Maltese and with vowels e and I in Lithuanian and Turkish. Not available in composite form.

Ring: å Å
Common in Danish, Norwegian and Swedish. There is also ringed u commonly used in Czech but not an accepted ISO character and therefore not available in composite form. Take care not to confuse the ring for the degree sign (which is larger).

Tilde: ã ñ õ Ã Õ
Used on vowels in Estonian, Greenlandic and Portugese among others. The i, I and H are not available in composite form.

Slashed O: Ø
A basic letter in Danish and Norwegian. Lowercase slashed o not available in composite form.

Umlaut/diaresis: ä ë ï ö ü Ä Ë Ï Ö Ü
Used in many languages including Albanian, Estonian, Finnish, German, Swedish. There is also w and y which are used in Welsh only, but which are not ISO standard. Sometimes used in English typesetting: naïve and Noël Coward for example, to indicate that each of the two vowels is to be pronounced.

Opposite page
Diacritics in common use: acute, breve, caron, circumflex, grave, overdot, ring, tilde, umlaut, guillemets and cedilla.

Pi-sorts

The pi-sorts are the hundreds of additional common characters required for mathematical and scientific publishing but these must be obtained from a special pi-font. However, each standard font will include a number of the most widely used symbols listed here:

dingbats
@ at
© copyright
® registered
™ trademark
° degree (temperature) Also degrees of arc.
space or (principally in America) number as in #5 instead of 5th
¶ paragraph
§ section
& ampersand
″ (double prime) inch. Also seconds of arc
′ (prime) feet. Also minutes of arc
The prime and double prime must not be used for the purpose of quote marks.

currency
£ pound
$ US dollar
¤ euro
¥ yen

mathematical symbols
+ addition
× multiplication
± plus-or-minus
÷ division
· decimal point
= equal
≠ unequal

Five reference ideographs (in order of rule-governed use)
* asterisk. Also used to mark a birth.
† dagger. Also used to mark the year of death or the names of deceased persons.
‡ double dagger. A reference mark.
¶ Pilcrow. Also see *paragraph* among dingbats
§ Section

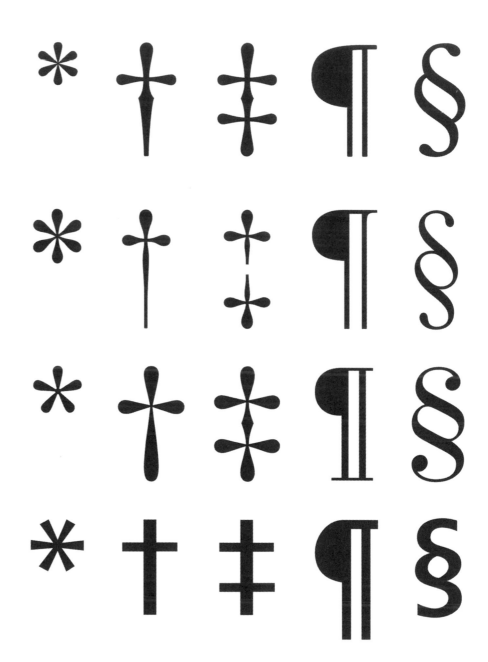

reference[1]

reference[I]

1 2 3 4 5 6 7 8 9 0 –

= ¢ ↑ 4 £ ƒ . – 8) $ ↓ | 0 ¥ 3 5 6 7 9 , -

; ' .. et 2 ↑ 1 (. , . / ɪ ᵇ # ¢ ∞ Ø ¶ ∘

♀ ♂ - ≠ ☞ Σ ᵈ ∫ † ¥ ᵉ ∧ ⁿ π ◄ ◂ š

ʃ ∂ ⁻ᵃ ▼ △ ʳ ᵘ ᵐ Ω ≅ š √ ∫ ~ μ ≤ ≥

÷ / ⌇ ～ ∼ ≋ _ _ ‡ ° .. —

± ❧ · ‰ R G R ⌐⌐⌐⌐⌐ ¹π ►▸

@ § ❦ ♡ ♡ ■ ■ *Luc(as) de groot* ⬸⋯ ⋯⋯ ı

⋯⟩ Ɛ ₵ ◄ 🚲 ᴒ ◄ ► ᵒ ★ Æ £ $ %

∧ ⅇ × () _ + ¢ ¼ 4 £ ƒ → – 8) $ { } ᵒ

¥ 3 5 6 7 9 , - : " ← ¾ ² ½ ¹ (· ‹ › ★

Opposite page above
Five marks of reference. The double bar (two vertical lines) and the fist (a hand with a pointing finger) were fourth and seventh respectively in the rule-governed, standard seven marks of reference, but are no longer included on the ISO standard character list. As marks of reference these seven are too few and too irregular in size and weight. Superior numerals are preferred. *Caslon, Baskerville, Bodoni* and *Univers.*

Opposite page below
Superior numeral (available with the *Caslon* expert set). Rather like small caps, superior numerals (and inferior numerals) have been designed to correspond in weight with the other characters. On the second line, a 'raised' numeral has been obtained using the measurement/style menu and manually reducing the size. Not only does this offer a less effective numeral for its purpose but it is also too light in weight due to the reduction in size.

This page above
The *Sans* expert font by Lucas De Groot with an unusually broad range of pi-sorts included.

This page below
The 'at' sign, set in *Caslon, Baskerville, Bodoni* and *Univers.* Only the *Baskerville* version has the 'a' correctly sitting on the baseline. Compare the following two email addresses, the first set in *Caslon*, the second in *Baskerville*:
david.jury@colch-inst.ac.uk
david.jury@colch-inst.ac.uk

Legibility

Introduction

Legibility and readability are closely related but are not the same. Legibility certainly influences readability, but to understand *how* one influences the other it is necessary to treat them separately.

Until very recently, the only people interested in typography were those involved in its design and application. But in recent years a whole range of disciplines has developed an interest in typography: mathematicians, computer programmers, psychologists and philosophers, have all written extensively in recent times about the nature of letterforms and their arrangement as a representation of the human condition. Psychologists use typography in conjunction with aspects of literacy and comprehension, philosophers examine the role of typography in the representation of language. These (and many others) provide the typographer with valuable insights into the way type functions and its potential to communicate (see also Chapter 12). Various studies in legibility have also been undertaken in some depth at various times during the last 100 years, notably by Sir Cyril Burt[1] Miles Tinker[2] and G W Ovink[3]. These studies provided little that was not already known by practising typographers but the results of their research are valuable if only because they reinforce aspects of good practice and common sense. Herbert Spencer[4] in the late 1960s, also made a sustained programme of research in this field and his published results are all the more accessible for being informed by design (rather than psychological) considerations.

The degree to which a typeface is legible is entirely dependent upon the designer of the typeface (and legibility is not, in every case, the most important criterion) whilst readability is largely the province of the typographer, and all that type requires, finally, is to be readable.

It may appear contradictory, but a highly legible typeface is not always the most readable. One of the most common mistakes students make is to choose a typeface designed specifically for one purpose and use it for something else for which it is wholly unsuitable. Complete fonts have been digitised from type designed for signage, magazine mastheads, telephone directories and corporate logos. All of these might be highly legible but many will often make very poor text faces; *Avante Garde* being a classic example. Text faces are, perhaps, the most conservative of any group, and with good reason. Familiarity is one of the most important conditions for readability and therefore evolution in the design of text type has, naturally, been slow.

Opposite page above
Numeral 1 and other similar, easily mistaken characters. This is particularly problematic with *Univers*.

Opposite page below
***Caslon* and *Univers*. A character displayed at the same set size, followed by the same two characters but with *Univers* reduced so that they appear, approximately, to have the same x-height. Note the contrasting size of the 'eyes' of the two e's.**

1lijtf

ee ee

Character recognition

Legibility is the degree to which individual letters can be distinguished from each other. Such letterforms are designed to present themselves in a clear and concise manner. This does not, necessarily, mean that a highly legible typeface cannot also have distinguishing characteristics – some of the most legible examples, such as Johnston's *Underground*, are also among our most easily recognised faces – but it *does* mean that in the most demanding of environments, their individual forms also remain highly visible. (Also see page 61.)

Generally, the most legible typefaces are those with larger, open or closed inner spaces (counters). This inevitably means a generously large x-height. However, if the x-height is 'over generous' then, as a consequence, the ascenders and descenders will be too short. This not only adversely affects the legibility of individual characters (commonly causing, among others, the h and n, and the i and l to be confused with each other) but also makes the recognition of word-shapes more difficult. (To read efficiently we recognise whole word-shapes rather than individual letters. See also Chapter 6) Colin Banks' redrawing of Johnston's *Underground* typeface for the London Underground illustrates this dilemma. The revised version maximises the size of counters whilst retaining clearly defined ascenders and descenders for optimum word shape. (See page 61.)

Large counters are particularly important in helping to distinguish between some of the most commonly used characters: e, a and s. These lack other distinguishing characteristics (no ascenders or descenders, and all being of a similar width and general shape) *and* they contain similarly sized counters. There is little doubt that, due to frequency of use, the most helpful aid to legibility in any given typeface is the provision of a generous 'eye' for the e and enclosed counter for the a.

But the characters that are most commonly mistaken for each other are i, j, l, and f, t. The l, is also almost identical in many typefaces to the numeral 1, as are the letter O and the zero 0. Relative legibility is also affected by the individual size of letters; for instance, m and w are intrinsically more legible than i or l, simply because they have a larger, more dominant presence.

Of course, problems of legibility are aggravated by intrinsic design features in some typefaces. Typical, well-documented examples are the cap C in *Bodoni, Baskerville,* and *Caslon,* all of which have a distinctive lower serif which can cause them to be confused with the cap G. The cross-barred italic J of *Baskerville, Caslon, Imprint* and *Plantin* are easily confused with the lowercase f, whilst the italic h of *Garamond* tends to be read as b. But, overall, experiments have shown that typefaces *in common use* are, in general, all equally legible under normal reading conditions. These include sans serif as well as serif faces.

The weight of a typeface affects legibility because additional weight inevitably encroaches into the counters. The optimum character stroke-width is about 18% of the character's x-height (almost 5 on the Noordzij scale; see page 48) and erring towards lighter rather than heavier weights (offering more generous counters). Extra heavy (or black) weights often degenerate into comic versions of their original design, and although their forms might appear attractive or even audacious, their overall design will make it difficult to recognise individual characters when attempting to read at speed.

Good typography encourages the desire to read

Good typography encourages the desire to read

This page above
Caslon Italic; characters easily mistaken. Larger open counters ensure that *Univers* does not suffer from the same problem.

This page below
It was Emile Javal in 1878 who first demonstrated that a line of words in which only the upper half is visible is read much more easily than one in which only the lower half is exposed. The predominant shapes that make up the characters of a word can be broken down into four essential categories: vertical lines; curved lines; a mixture of both vertical and curved lines; and oblique lines. It has been concluded that words made up predominantly of vertical lines (eg i, l, m, n, t) or curved lines (eg c, e, o, s) were less easily recognised than words which contained a mixture of both. It follows that characters that contain a mixture of vertical and curved lines (eg b, d, h, p, q) are amongst the most easily recognised.

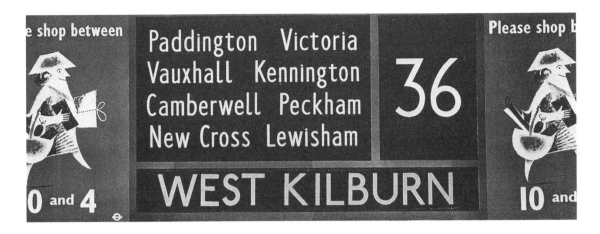

In 1961, London Transport undertook 'scientifically controlled tests'[5] in order to decide which would be more legible for destination displays on their bus fronts: all caps or upper- and lowercase.

All the tests were made using the condensed sans serif designed by Edward Johnston. Tests were designed to assess 'distance legibility' and 'glance legibility'. Glance legibility was tested by placing the observer behind a screen. A shutter would then be opened through which could be seen the bus front. The time it took the observer to see a given place name was recorded.

The results of these (and other related) tests suggested that there was no scientific proof that lowercase was superior to uppercase. Finally, London Transport provided two mock-ups representing a bus top front for a typical London route: one in uppercase and the other in upper- and lowercase. The final destination, in caps, was a 'sensible compromise'. The upper- and lowercase version was finally preferred,'…superior as a typographical design which when tested over a cross-section of the public also met with popular approval.'

On the strength of legibility tests, the London Transport Executive decided to implement new bus-blinds based upon the design shown in the top illustration. The report concluded that '…the dispute which is now brewing as to serif versus sans serif type is so old (and so futile) that we are happy to continue to use the masterly sans of the great Edward Johnston.' (Parentheses, author's original)

This page
A comparison of four road signs.[6]
The lettering compared were:
1 An uppercase, based on
Edward Johnston's sans serif.
2 A serifed uppercase designed by
David Kindersley
3 and 4 A sans serif upper- and lowercase
designed by Jock Kinneir (and already in
use on the [single] British motorway at the
time). The results, assessed largely upon
'distance legibility', suggested that there
was little difference between the top three
examples (the mean reading distances
being 239 feet, 247 feet and 240 feet
respectfully). Not surprisingly, sign number
4, with the smaller type but more generous
margins, was less legible than the others
(212 feet).

Since there was so little difference in
legibility between the different types
of letters it was considered appropriate to
make the choice on aesthetic grounds and
they decided to stick with the Jock Kinneir
signs. Aesthetic grounds also came into
play in the size of margins, since it was
thought that 'a better appearance is
obtained with wider spaces and that this is
desirable' despite an increase of 25% in the
costs of the larger signs. It is interesting to
compare the Kinneir characters with those
designed by Johnston for the London
Underground (right and on page 28).

Opposite page
A direct comparison between Edward
Johnston's original version (left) and
Colin Banks' revised version (right). For
Banks, it was important to respect the
spirit of Johnston rather than to adhere
mechanically to the construction rules
which would have made any further
development of the design impossible.
A reappraisal of Johnston's three
fundamental principles was necessary in
the process of designing New Johnston,
these being:

1 The ratio between the height of
a capital letter and the width of a stroke
could not be greater than 7 to 1.
2 Letters should be made of even strokes
(not varied for optical appearance).
3 A ratio between the height of a capital
letter and x-height of 7 to 4 (providing
prominent ascenders).

The calligraphic content is clearly visible
in the counters of Johnston's g. The Banks
version provides a more rational, less
complex counter.

heightx xheight

Colour and contrast

Whilst black and white provide the highest contrast this does not always provide the most legible solution. Certainly, reversed-out letters (white or yellow on black background) will always appear larger, but where a message or instruction involves a more complicated explanation, this is not always helpful.

However, contrast is an important component of legibility. Some people have defective colour vision which affects their perception of some colours; for example, reducing their ability to differentiate between reds and greens (although not, perhaps, blues and yellows). But whilst colour differentiation might be a problem, most readers will recognise changes in tonal value.

The most effective colour/tonal combinations are those that use white with a second, additional colour: for instance, British road signs using white (sans serif) lettering on a dark-green background; 'hazard warning' signs where black letters are used on a yellow background. Using many colours, particularly where these are similar in hue, inhibits legibility.

Vision impairment

There are many situations affecting legibility, or readability, or both, when it is pertinent for the typographer to recognise that the majority of readers have less than perfect focusing with or without spectacles, and that, for instance, one in twelve males (2,500,000) has defective colour-vision. By 2012, 60% of the British population will be aged 65 to 95.

Different eye conditions create different problems. Very few blind people see nothing at all. A minority can distinguish light but nothing else. Some have no central vision; others no side vision. Some see everything as a vague blur; others see a patchwork of blanks and defined areas. So some people with impaired vision will see well enough to read this book but might have difficulty crossing a road safely. With *The Disability Discrimination Act* of 1995, *inclusive* typographic design has been placed at the forefront of modern environmental design, and typographers (and operators) are now obliged to recognise the diversity of needs their facilities have to meet and to ensure those needs are met.[7]

This page
Black and white can cause glare but reversed letters, when on a dark ground, always look bigger.

Opposite page above
Two destinations are easier to read if placed on two separate lines. For clarity, it is better to use punctuation sparingly and avoid the use of full points at the end of messages. Similarly, abbreviations should be avoided because they can be misinterpreted.

Opposite page below
Top: too great a scanning distance between the message and the arrow. Middle: text and arrow places the visual emphasis towards the left of the sign and therefore confuses the message. Bottom: the preferred solution.

Car Park

Pedestrian Entrance

Car Park, Pedestrian Entrance

Reception

Reception

Reception →

Readability

Introduction

Good typography encourages the desire to read and reduces the effort required to comprehend. Comprehension is the reason for all reading.

Except in the very earliest stages of childhood, we read to learn rather than learn to read. In the development of reading, the attainment of mechanical skills, such as left-to-right progression of perception, accurate return sweeps of the eyes from the end of one line on to the beginning of the next, a sight vocabulary, recognition of words and the functions of accompanying punctuation, are all designed to promote understanding and interpretation of the meanings embodied in printed characters and symbols.

Although these skills are essential to reading and are gained, initially, with great effort, they must, as soon as possible, be relegated to their appropriate place. They must become automatic; the reader should not, normally, be aware of the 'activity' of reading at all, allowing maximum effort to be given to comprehension and interpretation.

We all learn the various reading skills necessary for acquiring differing kinds of information. In addition to the basic mechanics of reading we also learn to adjust our approach to directories, catalogues, indexes, encyclopedias, flyers, junk-mail etc. In general, we learn how to select, and how to respond.

The ability to read quickly and to be able to select in order to use time efficiently depends very much on the order and arrangement of type being 'normal'. Surprises are disruptive to the mechanics of reading.

This 'mechanistic' requirement of reading is something that the typographer needs to understand and be sympathetic towards. But, of course, the role of type is not *always* to be read. Type, in other situations, must be required to communicate, not so much through the meaning of the words, but through the way it appears; utilising colour, size, shape(s), its position and juxtaposition to other, perhaps pictorial or abstract elements.

A book cover, even if it has nothing else but type printed on it, is communicating before a single word has been read. Even within text, the element of surprise, the breaking of conventional rules, might be used to cause an appropriate response.

But the typographer must be aware of the needs and expectations of the reader. Clearly, a dictionary needs to have an absolute order in both arrangement and content. Alternatively, where a publication reflects a questioning attitude to social norms, typographic disharmony; elements aimed at encouraging the reader to question 'norms' might be considered appropriate.

Opposite page above
Legros and Grant's digraphs. Methods employed to save money seem boundless. It was concluded that if just these two character pairs, TH and NG, were designed as single-character logotypes and adopted by the newspapers of Britain and America it would result in a saving of about 3·5% in column length and composing time. The digraphs illustrated are based upon examples reproduced in *The Typographic Scene*, by Walter Tracy. Published by Gordon Fraser, 1988.

Opposite page below left
***Sound-spel*, a proposed alternative method of spelling based entirely upon phonetics. Ed Rondthaler, circa 1976.**

Opposite page below right
A proposed alternative alphabet by Reginald Piggott (circa 1968) called National Roman. An important feature of this design is that all the letters are of a common width. From The *Visible Word*, Herbert Spencer, published by Lund Humphries, 1968.

ᚻᚻ ᚻ Ᏽᚷ ᚷ

ᚻE SAVIᏽ EFFECTED BY REFORMIᏽ ᚻE ALPHABET

Hou tu Grᴕ Wįz.

If lit-el boiz and gerlz wiſ tu be-kᴕm gud and wįz, ᚦe mᴕst du whot iz rįt, and lern sᴕm-ᚦiᴖ nᴗ ev-er-i dɛ.

SPEAKIᴖ OF bɪrd LɪFE ᴦN PƏL-ESTᴦNE, ᴦT ᴣᴦᴑNT ᴦNTEREST ƏNd SURPrᴦSE ᴣƏNY PEOPLE TO KNOƐ

The nature of readability

'His [Plantin's] books do not hinder ones eyes, but rather help them and do them good. Moreover, the characters are so intelligently and carefully elaborated that the letters are neither smaller, larger, nor thicker than reason or pleasure demand.' From an advertisement issued by Plantin's partners, 1482.

Readability has been a subject of consideration ever since writing itself was 'invented' and has certainly been uppermost in the minds of most designers of text type since Gutenberg. But it is only since the late 19th century that readability (usually with little distinction from legibility) has been the subject of 'scientific' research in its own right. 'Scientific' is in inverted commas because it is an adjective that researchers, such as Miles A Tinker et al, have been keen to emphasise in connection with their work. They wished to promote the fact that their approach was objective, whilst at the same time accusing printers of being, 'preoccupied with aesthetics, together with considerations of economy and tradition.'[1] It is a fact that many designers remain ignorant of (or choose to ignore) the results of such research or even view the whole idea of 'readability' with suspicion, perhaps because they fear it might limit their freedom of action. But by understanding what factors are involved in the varying degrees of readability, the designer can make adjustments to ensure type functions efficiently where speed of reading and comprehension are of paramount importance.

Even in work where speed and/or comprehension are not the uppermost consideration, the designer can rationally determine how far reading efficiency can, and should, be reduced for the sake of providing alternative visual narratives.

For 500 years, during which letterpress printing remained the principal method of 'mass' printing, the appearance of type changed relatively little. But during the last fifty years (since the 1950s) influenced by photographic, electronic and digital technologies, the nature of type has changed quite dramatically. And, as the technology has evolved, so have our own aesthetic standards. Our 'typical' experience of type on a daily basis is far broader, in both style and layout, and also in the way it is received: paper, fax, e-mail and world-wide-web.

Surprisingly, no significant research into the effects of new technologies on readability has been attempted in the last 20 years. As Wim Crouwel said recently, 'One of the reasons for the loss of interest [in legibility and readability] is possibly the passing of its apparent relevance. If similar research were carried out today, the odds are that no differences would appear in the perception of legibility and readability any more, as our reading habits have changed so dramatically. While former research was based, primarily, on printed typographic material, we are now used to reading triple-overlaid texts being sent by fax, and reading low-resolution texts from a screen.'[2]

Certainly, the pervasive use of on-screen information and the growing use of abbreviated language, of contractions and other space-saving devices formulated on an ad-hoc basis, suggests a plethora of potential research material. Ironically, it is probably the speed of technological change and the diversity of media currently used to receive texts, that discourages research into the influence upon readability of electronic and digital technologies.

In the meantime, whilst the work of past researchers might not be particularly 'scientific' by today's standards, it is still the best available information we have which specifically relates type, its design variants and its various arrangements, to the act of reading. This research certainly endorses a few good ground-rules. Perhaps more importantly, it also provides the typographer with the opportunity to consider the mechanics of reading in relation to the basic elements and arrangement of typography.

It will be seen that objective research has produced few surprises, but it has provided a wealth of information about factors in typography which can contribute to greater reading efficiency. Such information should certainly inform anyone using type, not only in the design of readable, continuous, textual material, but also when it is intended that individual words or text should be at the very limits of readability, either in layout, technique of printing, use of substrate, or in the circumstances of reading.

There have been two methods consistently used to assess readability. The first is simply to measure the length of time it takes a reader to read a given text. The method normally includes simple comprehension tests to check that the reader did, indeed, read *and* comprehend the text.

A second, more sophisticated method, is to monitor eye movement and blinking. This is far more informative, as it is able to make direct links between type characters and the physical act of reading. With special apparatus it is possible to plot the various positions of the eye as it reads along a line of type, indicating where it stops and for how long. Generally speaking, the number of 'fixation points' (where the eye momentarily stops), the lengths of time spent on 'fixtures', and the number of 'regressions' (when a reader has to go back along a line to double-check) provide a clear indication of how problematic, and therefore how readable, the type is.

A third method, often quoted in research papers relates only to legibility, the earliest recorded experiment of this being in the 1790s by Anisson, Head of the *Imprimerie Nationale*. Anisson had two one-page specimens, one set in 'the *Didot* manner' and the second in 'the *Garamond* manner'. These were read at various distances until the print was no longer distinguishable. The *Garamond* 'was readable several stages after Didot's'.

More recently, parallel enquiries into the meaning and dissemination of language during the 1960s and '70s, particularly in the work of Barthes[3], Derrida[4] and Eco[5], has led to further analysis of the role of the reader in the interpretation of text[6]. As part of these investigations, the 'mechanics' of reading have been re-addressed, but although the methodology applied is more sophisticated, (using adapted cameras attached above computer screens) they are essentially the same as the approach of Birt and Tinker et al. The results of this new analysis is used as the basis for the investigation into the nature of communication (discussed in Chapter 12), although no attempt has been made (certainly on the scale undertaken by Birt or Tinker) to align these findings specifically to the role of type or typographic arrangement in the activities of reading and comprehension.

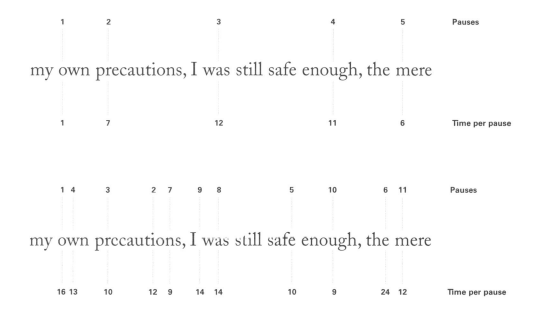

1	2		3		4	5	Pauses

my own precautions, I was still safe enough, the mere

1	7		12		11	6	Time per pause

1 4	3	2 7	9 8	5	10	6 11	Pauses

my own precautions, I was still safe enough, the mere

16 13	10	12 9	14 14	10	9	24 12	Time per pause

This page above
Eye movements of a good (first line) and a poor (second line) adult reader. This diagram shows the location of fixation pauses. Location of the fixations is indicated by the vertical lines. Numbers at the top of these lines show the sequence of the fixations; those at the bottom show the time taken for each fixation in 50ths of a second.

This page below
The Minnesota eye-movement apparatus. From *Bases for Effective Reading* by Miles A Tinker, the Minnesota Press, 1965.

The whole house burnt down? No, not the whole house, but there was nearly a disaster. Somebody found out and managed to put it out, I mean it was a pretty filthy place. **Did you live in this house during your stays in Bolton?** We all lived in. Yes. Which was absolutely horrible. One of the reasons I couldn't take more than about five days was the whole feeding and bathing and lavatory situation. It was so uncivilised. One oughtn't have felt like that. Tom on the other hand was an explorer and he was one of those sort of legendary brave men who was eventually parachuted into New Guinea to organise the opposition to the Japanese in that part of the world during the war. He had trained at Sandhurst. He was a very, very strange mixture. The son of an ecclesiatic who went to Sandhurst and trained and who always saw the funny side of things. While Tom was at Sandhurst he would have seen how ridiculous the whole thing was but nevertheless he would have gone through it. **Do you think Tom was a Socialist?** Oh very much so. All his writing discloses absolute hatred of the establishment. There are plenty of young men and women with potential guts and brains in Oxford. For heavens sake use them. Oxford needs a wider sense of values, a new vision and a direct personal knowledge. Go to Alaska, go to the Gold Coast, go to Hell, anywhere different and exciting and new. Go for six months and live in the country, not on the country. Spend nights in the East End, be aware of homosexuals, stowaways, realise how little a man or woman can live on, fight occasionally – not for your life, but with fists for your pride. Go without enough to eat every day for a fortnight. Do not be content to see something wrong; do something about it, put it right. **Tom Harrisson,** *Letter to Oxford,* The Hate Press, 1933.

and his great belief was that people, the general public, were being drastically misled by politicians and by the press. He was out to disprove that. I mean people's attitudes to big events like the, what's the word, when the king discarded the throne, the. . .

NIB (top right, large)

Anti-establishmentarian
New Guinea
Socialism
Sandhurst
Impossible missions
Pennies from Heaven

Tom, however, was the man of action, the anthropologist with the note-book. Not for Tom the eighteenth-century house on Blackheath. Mass Observation was really the product of three minds, each seeking from it something different, each contributing to it a different technique. Besides Tom, its founders were Charles Madge and Humphrey Jennings. To Charles Madge, who was now married to Kathleen Raine and lived in a beautiful eighteenth-century house at Blackheath, Mass Observation was a new kind of poetry; it was chiefly he who collected the 'reports' sent in each month by voluntary observers all over the country; who would choose out a description of five minutes in a country bus by a working girl, and hold it up for all the world to see, to savour the poetic overtones in those few casual words. Underneath, I believe, Charles was an empirical Marxist who wanted to understand the motives of individuals and equate them with his own beliefs. ¶ To Humphrey Jennings it was an extension of his surrealist vision of industrial England; the cotton workers of Bolton were the descendants of Stephenson and Watt, the dwellers in Blake's dark satanic mills reborn into a world of greyhound racing and Marks & Spencer. He had filmed them, and now he was to fix their irrational behaviour in another medium; it was his '1937ness' as André Masson had recorded his '1933ness'. His interest was intense but not long-lived. Julian Trevelyan, *Indigo Days,* pages 81-82, McGibbon & Kee, 1957.

but rather the working-class house in Worktown, anonymous, and like those on either side of it. He complained to me at the time that he could not really sleep unless he could feel through the wall the people next door going to bed; could not work unless the radio was turned on full blast. One of my duties was to keep Tom went out for his material to the pubs, to the dogs, to the dance halls. He sent a band of willing workers flying round making reports on anything, from the contents of a chemist's shop window to an account of a service in a spiritualist church. *'Bring back a list of hymns and any other dope you can get hold of, and try to pinch a copy of the sermon,'* he would say as he sent us out on our mission. For Tom had an almost hypnotic power over those who he worked with; he would ask the most impossible things of us *'All observers will record conversations in public lavatories at flowthirds'.* (Tom Harrisson). and we would willingly do them. **Julian Trevelyan,** *Indigo Days,* page 83, McGibbon & Kee, 1957

a portable gramophone going as he liked so have a good background of noise as his work. He had a weakness for George Formby and a record we played again and again was *Chinese Laundry Blues.* **Wandrew Wyatt,** *Into The Dangerous World,* pages 24-25 Weidenfeld & Nicholson, 1953.

Timothy Green *The Adventurers,* page 120, Michael Joseph Ltd. 1970.

'Letter to Oxford' is a 25,000 word attack against university society of the 1930's. It was published, according to the fly-leaf, by The Hate Press and Tom Harrisson's introduction announced, 'publishers are notoriously slow; also afraid. This is a quick (and unafraid) pamphlet. I consider it imperative that it be published immediately; for this reason, and because I have no money at all of my own, I have issued a private subscription to cover printing'. ¶ According to Timothy Green ('The Adventurers' page 112) Harrisson was enormously pleased with the controversy in Oxford that his pamphlets had caused. He enjoyed causing a fuss: 'All my publications are petrol devices for rolling and stimulating my ego'. Later in Bolton when the money got low he would use his writing skills to raise money to keep Mass Observers in fish and chips. He would happily write articles with such lurid titles as 'Public hotpitels' for the Daily Mirror accompanied by a photograph of himself peering through a keyhole, note-book in hand. No wonder the scientific establishment of the day wanted little to do with Mass Observation.

Tom was very aware of not sticking to one social class and he would say 'Lets go posh' you know, what would rich parents do with their children, ah yes, dancing classes. So he found a place where they taught dancing, which in those days would be a parallel to discos and things now I suppose. Places like the Hammersmith Palais, and there were big dance halls where people would go. . . it was a social necessity to be able to cope with that. So I went off there duly obeying Tom's orders and found exactly what he had suspected, these little dolls being taught by someone who had clearly based himself on Rudolph Valentino or George Raft. . . the slick hairdo and huge quantity of Brylcreem. And there are these little dolls being put through their paces. **What are they doing with their fingers? Beating time?** No, I think there was one particular dance which involved an action, could it have been the Chestnut Tree? **What was the dance?** There was the Lambeth Walk wasn't there? There is something about. . . where you actually had to make a gesture with your hands with one finger raised. ¶ Tom knew what I would find and um, in a way I knew what I would find and I think I thought it was hardly necessary to do it. It was more of a journalistic feature. Certainly nothing to do with anthropology. Together we did a feature called 'The Birth of The Dance' which I think was published in Picture Post and Tom was involved in that. He was mad about dance lyrics: He would read huge meanings into words like 'Pennies from Heaven' and rightly I think. . . **What are the hidden meanings in Pennies from Heaven?** (laughter) Oh don't ask me, I. . . (laughter). . . you have got to know all the other words. I suppose you could say that attitudes are expressed in the lyrics of pop music aren't they, particularly the attitudes of disenchantment and disapproval, and cynicism. I've just remembered the title, 'Underneath the Spreading Chestnut Tree'.

HE CAN (bottom, large)

Long time ago a million years BC
The best things in life were absolutely free
But no-one appreciated a sky that was always blue
And no one congratulated a moon that was always new
So it was planned that they would vanish now and then
And you must pay before you get them back again;
That's what storms were made for
And you shouldn't be afraid for
Every time it rains, it rains pennies from heaven
Don't you know each cloud contains pennies from heaven
You'll find your fortune falling All over town
Be sure your umbrella is upside down
Trade them for a package of sunshine and flowers
If you want the things you love you must have showers
So when you hear it thunder don't run under a tree
There'll be pennies from heaven for you and me.

Words per line

The full width of a column or length of a single line of type is called the 'measure'. For readability, the width of a line is less important than the number of characters it contains. Somewhere between 54 to 80 characters and spaces has been found to be the most conducive to efficient 'long distance' reading. At an average of five characters and one interword space per word in English, this means an approximate average of nine to twelve words per line.

Therefore, eleven words (about 55 characters and ten spaces) set in 9pt *Univers Light*, would give an approximate measure of 105mm (or 25 picas).

Opposite page
In Darkest England **is a document comprising a boxed set of 21 loose sheets printed principally letterpress. The subject is Mass Observation, an anthropological study undertaken in Bolton and Blackpool, Lancashire between 1937 and 1939, the focus being the observers' observations of their fellow observers. Complex relationships and differing memories of the same events were explored typographically. Providing form for the complex interrelationships was as important as the content itself. The type becomes smaller as the recorded memories become further removed from the original record. As the type becomes smaller, so the line length becomes shorter.**
David Jury, 1998.

This page
Anthony Froshaug. A typographic exercise which incorporates long lines of text with relish; ***Gloria in excelcis Deo set terra par hominibus bonae boluntatis,* 1948.**

The appropriate number of characters per line will vary, depending upon the subject matter and the expectations of the reader. For example, a scientific text, which might include longer words, would be more suited to a slightly wider measure – this would also lower the frequency of line-break hyphenations. The text of this book averages 47 to 49 characters per line. Because the majority of readers will already have, at least, some knowledge of typography it was assumed that most readers were unlikely to start at the beginning and read, in normal order, to the end. The text, therefore, has been arranged to suit shorter periods of reading with one-line spaces separating paragraphs to help define the topics under discussion.

The width of a measure might also reflect the length of the text and the commitment expected of the reader. A wider measure (within optimum guidelines) offering fewer word-breaks and the opportunity for a more even setting, suggests an efficient use of the reader's energy appropriate for a longer read. Shorter measures offer a more staccato reading experience, providing a sense of urgency, enabling the reader to scan quickly down the page; an appropriate reading experience for newspapers But even with newspapers, the relation between tempo of reading and column-width (measure) is reflected in their formats: broadsheet being wider than tabloid.

The readability of a wider measure will be dramatically improved by the use of additional leading. It provides stronger definition to the line of text so helping to keep the reader's eye on the line and also enabling the reader to track back to the beginning of the next line of text.

It has been hypothesised that lines that are of equal length (justified) might better signal the end of a line to the reader's peripheral vision and also provide a natural rhythm to the act of reading. Such perceived advantages must, however, be weighted against the negative effects that justifying text has upon interword spacing. In fact, experiments comparing reading performances that were applied to justified and ranged-left settings concluded no significant differences in either speed of reading or comprehension.[7]

Uppercase and lowercase

As early as 1914, it was reported that material set in roman lowercase was read faster than similar material set in uppercase. When these experiments were repeated by Tinker and Paterson in 1928 they found that all-cap text was read up to 11·8% slower than lowercase. In 1955, experiments involving longer reading periods, at 5 and 10 minutes, were undertaken, (again by Tinker) which indicated up to 19% slower reading rate. But when the length of reading time was increased to 20 minutes the speed of reading improved to 13·9%, suggesting, perhaps, that with more practice the difference between reading times of upper- and lowercase might not be quite so significant. Nevertheless, it remains that continuous uppercase setting generally retards the speed of reading more significantly than any other typographic factor.

The explanation for the poor readability of uppercase is that the images tend to be perceived, *letter by letter* and the words recognised as a result. On the other hand, *words* set in lowercase are more easily recognised than the individual lowercase characters. The reason this makes such a profound difference is that reading in word-units is the most important characteristic of the mature reader. Distinctive word-shapes contribute substantially to easier, and therefore faster, reading, and these are more distinctive when set in lowercase than in uppercase. Few words in lowercase are exactly the same shape; whilst all words in capitals are varying lengths of a rectangle. The word 'typography', for example, has a distinctive shape when set in roman, italic or bold face lowercase which is distinctly lacking in the all uppercase TYPOGRAPHY where the letters are in horizontal alignment. In eye-movement tests, these visual characteristics of uppercase mean that there tends to be far more fixation points required because the eye has fewer clear, distinctive features as it scans the line of characters.

The fact that type set in all uppercase takes up approximately 40–50% more printing area also affects fixation points, because the number of words perceived within each fixation is reduced. Also, additional space required by uppercase characters means that the mechanics of reading – for example, the necessity of finding the beginnings of many more lines – increases reading time.

However, it has been argued that all uppercase setting can, if carefully arranged, be as economical with space as lowercase because it allows smaller type sizes to be used. For instance, tests involving the design of labels have shown that where a small amount of *very* small type is required, perhaps due to a lack of space, uppercase characters are more easily recognised than lowercase.

how much is expendable

abcdefghijklmnopqrstuvwxyz

An inquiry which has just been held at Brighton once more illustrates the kind of leading strings in which local municipalities are kept. An inspector of the local Government Board has been holding a kind of public inquest on the proposal of the Brighton corporation to borrow 55,000l. This enterprising public body in its desire to increase the attractions of the great sussex watering-place has resolved to buy an estate on the inland side of the town to be formed into a public park. The scheme seems to have met with much opposition; but it has been adopted by the corporation, who wish to borrow money to complete the purchase But though the whole sum it requires is not equivalent to

Opposite page above
The more distinctive outline offered by lowercase compared with uppercase.

Opposite page below
Wim Crouwel's *New Alphabet*, designed in response to the introduction of the first generation of electronic typesetting devices in 1967 which were making traditional fonts illegible. *New Alphabet* was originally intended to be no more than an experiment which might encourage debate. Designed to optimise the limited nature of technology at the time, each character is based on a simple grid and each takes up the same amount of space.

This page above
An experimental alphabet designed by Brian Coe to determine the extent to which each lowercase letter can be eliminated before recognition is impossible. This alphabet was reproduced in *The Visible Word*, Herbert Spencer, published by Lund Humphries, 1968.

This page below
A proposed new kind of type by Andrew Tuer in the 1880s in which 'tailed letters, projecting above and below the line, have been docked' to provide maximum type size 'where economy of space is an objective'. From *The Visible Word*, Herbert Spencer, published by Lund Humphries, 1968.

11 22 33 44 55 66 77 88 99 00

Sans serif, isolated	7 4 1 6 9 0 3 2 8 5
Old style, isolated	7 4 6 0 1 9 3 5 2 8
Sans serif, groups	7 1 4 0 2 9 8 5 6 3
Old style, groups	8 7 6 1 9 4 0 5 3 2

Italics

Italics take longer to read – caps or lowercase – in all probability because they are traditionally narrower, containing smaller, and therefore less defined counters than roman. This problem is made worse, of course, in smaller sizes. Italics, therefore, tend to be used sparingly, limited to the few occasions when added emphasis is desired, a foreign-language word or phrase is used, or for a brief heading in textual material. If reading efficiency is essential, it might be wiser not to use italics for quotes, especially if these take up whole paragraphs or pages.

Bold faces

Like italics, bold faces are frequently used as a means of emphasis. As one might suppose, bold faces have greater visibility, and in some cases greater *legibility* than light or medium roman or italic faces, and if a face is chosen which has been designed with open counters, then there is no reason why it should not be as *readable* as a medium-weight face. Young children, on the whole, prefer bolder faces as long as the characters are presented with plenty of space. However, mature readers are generally put off by overly dark pages of text and so, if a bold face is to be used for text, additional space in the form of leading and subtle use of tracking will, in part, alleviate this. Also, a heavier face will take up more space causing more line-sweeps which inevitably makes the reading process less efficient.

Numerals

As lowercase characters are more readable than uppercase, it might be assumed that non-lining (old style) arabic numerals (1234567890) are more readable than lining numerals (1234567890). However, in normal reading situations, and in mathematical situations, research has shown there was little difference between the two. However, the non-lining (arabic) numerals harmonise with extensive (upper- and lowercase) text, whilst lining numerals tend to be too conspicuous. But in tabulated work – for instance, timetables and financial reports – lining numerals can provide a helpful aid to horizontal and vertical scanning of information.

Because numerals, both lining and non-lining, are perceived digit by digit, they are far slower to read than words. Tests have proved that a seven-digit number will require up to five fixation pauses. (The same would apply, for example, to chemical formula.) However, arithmetical problems set in arabic numerals, were read faster and with fewer fixations than when the numbers were spelt out in words.

Roman numerals; I, II, III, IV etc, are just as legible as arabic numerals, but, at higher numbers their unfamiliarity and complexity makes them difficult for the average reader to decipher.

Punctuation

Punctuation marks are intrinsically small and, therefore, particularly prone to a loss of identity in poor printing conditions or where the typeface itself is printed at a particularly small size. The most repeated problem is in distinguishing between the comma and the full point. It has been recommended (not by a typographer!) that the full point should be 30% and the comma 55% of the x-height, to alleviate this problem (Herbert Spencer, *The Visible Word*).

A more recent phenomenon has been the quote marks (turned comma and apostrophe) of recent typefaces. The clear '69'-shaped quote marks (see page 75) have often been replaced with less distinctive wedge shapes which at normal reading sizes are virtually indistinguishable.

Opposite page above
Univers and *Caslon* numerals.

Opposite page below
Employing the 'distance method' Tinker determined the perceptibility of 10pt numerals in sans serif and in old style type. The order of perceptibility from most to least legible are as shown.

This page
Type as sound and as image. A blend of words and pictures by Ann and Paul Rand. This children's book, *Sparkle and Spin*, described as 'a book about words', was first published in 1957 and re-issued in 1991 by Harry N Abrams Incorporated, New York.

Words are "Yes I will"
and "No I won't,"
but they are polite too
like please and thank you.

Other factors

Two other factors affect readability of textual information: the size of typeface and choosing between sans or serif typefaces.

Size

Optimum type sizes vary dramatically for children as they grow older, and grow more proficient in the mechanics of reading. In the earliest stages, when they are striving to recognise individual characters or groups of characters, sizes as large as 24pt are used. But as the child's reading skills advance, so the need to recognise word shapes (rather than their constituent letters) becomes more important and so smaller type is preferred. By the age of 12, the preferred size-range is much the same as an adult's.

Attempts to establish an optimal size of type for adults with normal eyesight have been made, but an optimal size is difficult to determine because the question is so closely related to tracking, kerning and leading. (All these spatial factors are discussed in Chapter 9.) However, reliable investigations show that the common type sizes (given as 9 to 12 point) are of equal readability, whilst 10pt is the 'preferred' size. As sizes increase above 12pt, reading becomes progressively slower for the same reason that larger sizes are helpful to younger children – the word shape takes second place to individual characters.

age	type size	characters per line
under 7	24	30
7 to 8	18	38
8 to 9	16	45
9 to 10	14	52
10 to 12	12	58
over 12	11	60

Sans serif or serif?

Few books are set in sans serif. The general consensus is that whilst sans serif (and slab serifs) generally have a high legibility factor, they have a relatively low readability factor because they are less efficient at projecting word recognition. In other words, the characters tend to have poor left-to-right momentum, tending to stand independently of each other (rather like uppercase characters). The predominance of larger x-heights in sans serifs, resulting in short ascenders and descenders, also tends to cause less efficient definition of word shapes.

Sans serif typefaces, such as Roger Excoffon's *Antique Olive* (1966) Hans Eduard Mieier's *Syntax* (1968) and Fred Smeijers' *Quadraat* (1989, also available in a serif version) have attempted to address this problem with considerable success.

This page above
Size of type in relation to children's reading ability. This table was reproduced in Sir Cyril Birt's 'A psychological study of typography', 1956. Type specimens used for the experiments were in *Caslon*. Birt reiterates that '…particularly with older children, a type might err by being too large as well as too small…we would add that, for the very young (aged 9 or below) the words should be well spaced out – with an em-space as a minimum instead of an en-space as a maximum; and thin spaces should not be used in books intended for children'.

This page above
A book written and designed for ten-year-olds and above. The only concession to a younger readership is the more generous leading and the line illustrations that appear at the beginning of each chapter. *This is White Boots* by Noel Streatfield, published by Harper Collins, 2001.

Opposite page above and centre
***Antique Olive* by Roger Excoffon and *Syntax* by Hans Eduard Meier.**

Opposite page below
***Caslon, Baskerville, Bodoni* and *Univers*; turned commas and apostrophes.**

ABCDEFGHIJKLMN
OPQRSTUVWXYZ
abcdefghijklmnopq
rstuvwxyz 1234567890.,:;''

ABCDEFGHIJKLMN
OPQRSTUVWXYZ
abcdefghijklmnopq
rstuvwxyz 1234567890.,:;''

' 9 ' 9 ' 9 ' 9 '

Measurement

Introduction

A standard system of measurement for typography was not put into practice until the 18th century. Before then, type was not produced in uniform, interchangeable sizes. This meant that type characters, cast in different foundries, were mutually incompatible. Instead, names were given to approximate type sizes (see page 80). Only the 'pica' as a term for type size remains in common use today.

Pierre Fournier, in 1737, had devised a method of measurement by dividing an arbitrary inch into 12 'lines', each of which were then subdivided into 6 'points'. In 1785, another Frenchman, François-Ambroise Didot, settled on a standard – the D or 'Didot point' – by relating this to the then official French measure, the *pied de roi*. This made type and paper measurement compatible for the first time. But not for long. By 1799, French revolutionary reform had resulted in the adoption of the metric system. An attempt to adjust the Didot point system to the metric system was abandoned in 1815, so it was fixed at 0·376mm; this is still used in mainland Europe today.

The Anglo-American system is different, and is based on the division of one inch into 72 parts, again called points. But, unfortunately, not the same 'point' as that in the Didot point system. Most recently, it was thought that there might be a gradual move towards the metrification of typographic measurements, but the advent of the computer (and more specifically, the 'MacIntosh') as a design tool has established the 'new' international standard of measurement as the Anglo-American, the so-called imperial or foot/inch system.

Another general measurement specific to type is the *pica*. It represents 12 points (exactly 1/6 inch or approximately 4·2 mm) and was used to describe the measurement of, for instance, the length of a line of type. Therefore, a line of 24 picas (24x12) would be 288pts, 4 inches or about 102 mm in length. The pica is the *broad* unit of typographical measurement, the point the *fine* unit. However, computers can be set up to use picas, millimetres or inches, and, not surprisingly, most people today choose to use millimetres for general measurements. Type remains, for the time being, in points.

4pt 5pt 6pt 7pt 8pt 9pt 10pt 11pt 12pt 14pt 18pt 24pt 36pt

48pt 60pt 72pt

84pt 96pt

104pt

A standard system of measurement for typography was not put into practice until the 18th century.

A standard system of measurement for typography was not put into practice until the 18th century.

Opposite page
A type gauge, used as an aid in drawing typographic layouts and in establishing the size of a printed typeface.

This page above
The traditional range of sizes available prior to phototypesetting. Sizes over 72pt were quite rare.

This page below
Univers Light **and** ***Park Avenue*** **are set with the same type size and same leading values (36/38pt).**

Type measurement

The size of type is described in *points*. This is determined by the number of points in the height of the *body* of the typeface, which should not be confused with the height of the visible, printed area of the typeface itself.

These measurements and descriptions were formulated when type was made in metal for letterpress; a method used for more than 500 years. It is tempting to argue that, with digitisation, a certain amount of rationalisation should be brought into the measurement of type; and 'body size' might appear to be a prime example. Prior to phototypesetting and then digitisation, the body of a piece of metal type could be held in the hand, clearly recognised as a physical part of the type (right). However, the 'body', as such, no longer exists and is quite meaningless with digitised type [1]. But, by retaining 'body' size it does maintain the inclusion of a small space at the top and bottom of a face so that when set solid (no extra interline spacing) the descenders do not touch the ascenders of the line below (see page 81). Similarly, very fine spaces separate letter from letter horizontally.

Although all typefaces sit on a common baseline, the x-height and the lengths of ascenders and descenders will vary. This, effectively, changes the optical size of a typeface. A 12pt typeface with a large x-height (and corresponding shorter ascenders and descenders) will appear larger than a 12pt typeface with a small x-height (with longer ascenders and descenders, see page opposite).

The x-height optically determines the amount of extra interline (or the baseline-to-baseline) spacing required. The larger the x-height, the more interline spacing there needs to be. These relatively minor characteristics have a dramatic effect on the visual appearance of a typeface and also, therefore, on legibility when set as continuous text (see page 95).

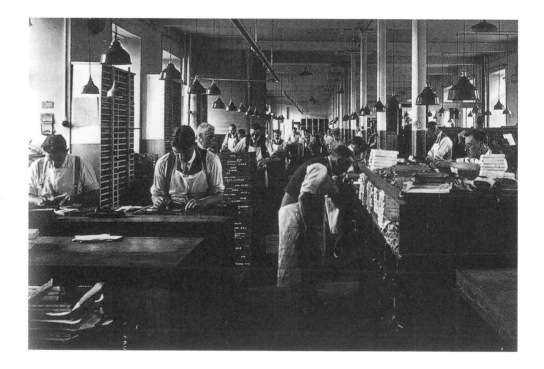

Opposite page above
Metal type. The notch is to indicate to the compositor which way up the character is.

Opposite page below
The Monotype Department of the Oxford University Press, 1925. *Photograph courtesy of the OUP Archive.*

This page above
Caslon Medium and *Univers 55:* Body height the same (100pt) but the x-height is different. *Univers,* with the larger x-height, appears larger. The larger x-height leaves less space within the body area for ascenders and descenders and so, with *Univers,* these must be shorter.

This page below
Caslon, Baskerville, Bodoni and *Univers*; a comparison of x-heights.

Horizontal measurement

The set-em is so called because it is roughly the width of a cap M; and like the character M, the size of the set-em (often reduced to *em*) will always be proportionate to the size of the typeface in use at any one time. The *set*-em should not be confused with the *pica*-em, which has a constant value of 12 points.

The em (set-em) is now an important element of measurement for the computer. In QuarkXpress, the em is divided into 200 units, each of which, in turn, can be divided by 20. This offers manual adjustments of 1/20,000 em, expressed in the measurement panel as 0·005. Automatic adjustments are expressed in increments of 10 or –10 (10/200 em).

This refined measuring facility is used for describing kerning values (the adjustment of individual space between characters and words) and for describing tracking values (the adjustment of the spaces between characters and words in a line or in a whole text).

Control over spatial relationships between characters, punctuation and words has never been so comprehensive. Letterpress compositors had only five divisions of the em from which required combinations of spacing material could be made: the en (or *nut*) as 1/2 width of a set-em; the thick as 1/3; the mid as 1/4; the thin as 1/5; and the hair as 1/12. In comparison, a potential 20,000 divisions is more than adequate!

The length of a full line of type is still often described as the 'measure', which, in turn, expresses the column-width.

Vertical measurement

Leading (pronounced ledding) refers to the additional space optically placed between lines of type. The term comes from the fact that strips of lead were used for this purpose with letterpress technology (see this page below). Not surprisingly, computers do not recognise this additional space as separate, physical matter, and so when it describes any interline space, it describes the vertical distance from baseline to baseline. For instance, if you have 10-point type and add 2-point leading, it describes the vertical increment as 12-point leading. This would be explained verbally, or in writing as 10 on 12 point (or 10/12pt). If the vertical increment has *no* additional interline spacing – for example, described by the computer as 10-point type with 10-point leading, (or 10/10pt) – the term *used* is *set solid*.

Unless specified, the QuarkXpress default ('Auto') value for leading is 20% of whatever (body) size of type is being used. So, 10pt type will always have 2pt leading (10/12) regardless of what typeface is being used. The use of leading, however, should always be a conscious decision based on the characteristics of the typeface, its size, and the line length and *never* left on 'Auto'.

One of the earliest attempts to introduce a British point system was made by the Caslon Foundry in 1886. Before this, approximate 'sizes' of type were described by names rather than by measurement. The following table lists some of these names and their approximate size in points.

Minikin	3·5
Brilliant	4
Diamond	4·5
Pearl	5
Ruby	5·5
Nonpareil	6
Minion	7
Brevier	8
Bourgeois	9
Long Primer	10
Small Pica	11
Pica	12
English	14
2-line Minion	14
2-line Brevier	16
Great Primer	18
and so on…	

A standard system of measurement for typography was not put into practice until the 18th century. Before then, type was not produced in uniform, interchangeable sizes. This meant that type characters, cast in different foundries, were mutually incompatible. Instead, names were given to approximate type sizes. Only the 'pica' as

A standard system of measurement for typography was not put into practice until the 18th century. Before then, type was not produced in uniform, interchangeable sizes. This meant that type characters, cast in different foundries, were mutually incompatible. Instead, names were given to

hxp hxp
yxb yxb

Opposite page left
'Automatic' leading is set on the
computer at a constant 20%, regardless
of which typeface is in use. *Caslon*
and *Univers*.

Opposite page right
A strip of lead being inserted between lines
of metal type to provide additional white
space between the lines of printed text.
Leads are cast in different thicknesses,
which are always described in points and
normally available in 1, 1·5, 2, 3, 4, 6, 8 and
12pt. They can be bought in long lengths
and cut in the workshop (the metal is
quite soft) or can be cut to measure by
the foundry.

This page above
The effect of differing size of x-height
upon the appearance of interline space.
A comparison of *Caslon* and *Univers*.
These lines are set solid.

This page below left
The size of the set-em (often reduced to
em) will always be proportionate to the
size of the typeface in use at any one time.
The set-em should not be confused with
the pica-em, which has a constant (width)
value of 12pts.

This page below right
The divisions of an em prior to digitisation.
A third, half (an en), quarter, fifth and
twelfth of an em.

Typography

Typography

Typography

Typography

Manipulating Space

Introduction

The type designer consciously designs the inner 'spaces' whilst drawing the actual letterforms; the aim is to create a visual equilibrium between the two. When setting characters and words the key to creating a readable text is to ensure an even, visual texture. To achieve this, the spaces within the type *and* the spaces around it need to remain in visual equilibrium. The setting of text should be persuasive; no hesitations, no unintentional pauses or stutters. It must consistently and fluently maintain the same rhythm to ensure that the reader's eye does not wander from the line.

To achieve this, the constituent lines of text should be uniformly close but never touching. This, and the amount of leading, are two of the most important keys in establishing the tonal (colour) value of the text area. Once established, the same spatial relationships between characters and words must be maintained throughout.

There are no 'optimum' values for letter- or word-spacing. Judgement concerning the final tonal value of the text will depend on the subject, the intended audience, and, occasionally, the conditions in which the text will be used. Achieving tonal value depends on five factors; the typeface, the space *within* words, the space *between* words, the space between *lines* and the space *around* text. Such considerations (in relation to size and weight of type, paper colour, surface and weight) are, in essence, what typography *is*.

Space within words

'By good spacing I mean, quite simply, that each letter should appear to be exactly in the centre between its neighbours. To me this is the only criterion.' David Kindersley, 1966

Lowercase
Space within text is necessary to group characters together so that no intercharacter space can be confused with a word space. Although this section is called *space within words,* in fact the only space the *reader* should register is that between the words. Intercharacter spacing, if done correctly, will be entirely 'invisible'.

Another word for intercharacter spacing is kerning; a term derived from the stone-cutters ability to achieve the perfect *lock* or *joining together* of two cut stones. In letters, kerning is done to achieve perfect, even, visual spacing between *all* the characters; both upper- and lowercase roman and italic, small caps, numerals, punctuation and pi-sorts.

The need to adjust the space between lowercase characters is, essentially, a problem created by digital technology. Previously, with letterpress technology the set of character-punches for *each size* of font had to be individually cut and so spatial values relating to changes of scale, such as adjustments to weight, inner spaces, and shoulders (also called side-bearings) – to provide space on either side of the character – could be addressed at source.

Opposite page
Christopher Plantin is perhaps the most famous of the 16th-century printer-publishers. This book, *A Choice of Emblems,* was printed in 1586. Plantin was a Frenchman who moved to Antwerp in 1555 where he set up a press that remained in business for almost 300 years.

No haulting verſe hee writes, but matcheth former times,
No*Cherillus, he can abide, nor Poëttes patched rimes.
What volumes hath hee writte, that reſt among his frendes,
Which needes no other praiſe at all, eche worke it ſelfe comendes.
So, that hee famous liues, at home, and farre, and neare;
For thoſe that liue in other landes, of SIDNEYS giftes doe heare.
And ſuche as Muſes ſerue, in darkenes meere doe dwell;
If that they haue not ſeene his workes, they doe ſo farre excell.
Wherefore, for to extoll his name in what I might,
This Embleme lo, I did preſent, vnto this woorthie Knight.
Who, did the ſame refuſe, as not his proper due:
And at the firſt, his ſentence was, it did belonge to you.
Wherefore, lo, fame with trompe, that mountes vnto the ſkye:
And, farre aboue the higheſt ſpire, from pole, to pole dothe flye.
Heere houereth at your will, with pen adorn'd with baies:
Which for you bothe, ſhee hath prepar'd, vnto your endleſſe praiſe.
The laurell leafe for you, for him, the goulden pen;
The honours that the Muſes giue, vnto the rareſt men.
Wherefore, proceede I praye, vnto your laſting fame;
For writinges laſt when wee bee gonne, and doe preſerue our name.
And whilſt wee tarrye heere, no treaſure can procure,
The palme that waites vpon the pen, which euer doth indure.
Two thouſand yeares, and more, HOMERVS wrat his booke;
And yet, the ſame doth ſtill remayne, and keepes his former looke.
Wheare Ægypte ſpires bee gonne, and ROME doth ruine feele,
Yet, both begonne ſince he was borne, thus time doth turne the wheele.
Yea, thoughe ſome Monarche greate ſome worke ſhould take in hand,
Of marble, or of Adamant, that manie worldes ſhoulde ſtande,
Yet, ſhould one only man, with labour of the braine,
Bequeathe the world a monument, that longer ſhoulde remaine.
And when that marble waules, with force of time ſhould waſte;
It ſhould indure from age, to age, and yet no age ſhould taſte.
Oh happie you therfore, who ſpend your bleſſed daies
In ſeruing GOD, your Prince, your lande, vnto your endleſſe praiſe.
And daily doe proceede, with trauaile of the minde,
To make you famous heere, and eeke, to leaue a fame behinde.
Which is the cheefeſt thinge, the greateſt Prince can haue,
For, fame doth triumphe ouer deathe, when corpes are cloſ'd in graue.
Euen ſo, your worthie workes, when you in peace ſhall ſleepe,
Shall make reporte of your deſertes, and DIERS name ſhall keepe.
Whome, I doe reuerence ſtill, as one of PALLAS peares:
And praye the Lorde, with ioyfull dayes for to prolonge your yeares.

b 3

*Horat. lib. 2.
Epiſt. 1. ad Au-
guſtum.

Homerus vixit, poſt
Romam conditam,
ſed natus ante, Aul.
Gell. lib. 17. cap. 21.

Sed Plinius ſecũdus,
qui ante Gellium,
tempore Veſpaſiani
Imperatoris vixit:
De Homeri ætate,
lib. 7. ca. 16. Natur.
Hiſtor. ſic ſcribit:
*Iam verò antè annos
propè mille, vates ille
Homerus non ceſſauit,*
&c. Et Cornelius
Nepos primo Chro-
nicorum antè Ro-
mam, Homerum
vixiſſe ſcribit.

De Pyramidum æ-
tate, incertum, Plin.
Natural. hiſt. lib. 36.
cap. 12. tamen quaſ-
dam poſt Homerum
conditas, probabile.
De his, Herodotus.

Animus

66 quasi-cursive Roman Capitals have been designed to match. This practice has, however, been carried to excess; the slope of Italics and their cursiveness have been much overdone. In the absence of punch cutters with any personal sensibility as letter designers, with punch cutting almost entirely done by machine, the obvious remedy is a much more nearly upright & non-cursive Italic, & for Capitals the ordinary upright Roman. Even with a nearly upright Italic, the mere presence of the Italic a e f and g alters the whole character of a page, & with a slight narrowness as well as a slight slope, the effect is quite different from that of a page of Lower-case. ¶ The common practice of using Italics to emphasize single words should be abandoned in favour of the use of the ordinary Lower-case with spaces between the letters (letter-spaced). The proper use of Italics is for quotations & foot-notes, & for books in which it is or seems desirable to use a lighter & less formal style of letter. In a book printed in Italics upright Capitals may well be used, but if sloping Capitals be used they should only be used as initials—they go well enough with Italic Lower-case, but they do not go with one another.

¶ We have, then, the three alphabets, & these are

the printer's main outfit; all other sorts of letters 67 are in the nature of fancy letters, useful in inverse proportion to the importance and quantity of his output. The more serious the class of book he prints, the wider the public to whom he appeals, so much the more solemn and impersonal and normal will be & should be his typography. But he will not call that book serious which is merely widely bought, & he will not call that a wide appeal which is made simply to a mob of forcibly educated proletarians. A serious book is one which is good in itself according to standards of goodness set by infallible authority, and a wide appeal is one made to intelligent people of all times and nations.

¶ The invention of printing and the breakdown of the medieval world happened at the same time; and that breakdown, tho' hastened by corruption in the Church, was chiefly caused by the recrudescence of a commercialism which had not had a proper chance since the time of the Romans. The invention of double-entry book-keeping also happened about the same time, and though, as with modern mechanical invention, the work was done by men of brains rather than men of business, it was the latter who gained the chief advantage.
e2

This page
Eric Gill's book, *An Essay on Typography*, begins, 'The conflict between industrialism and ancient methods of handicraftsmen which resulted in the muddle of the 19th century is now coming to its term. 'But tho' industrialism has now won an almost complete victory, the handicrafts are not killed and they cannot be quite killed because they meet an inherent, indestructible, permanent need in human nature.' *St Bride Printing Library*

Opposite page
Anthony Froshaug. *Ulm*: journal published by the Hochschule für Gestaltung, Ulm, 1958. This is a large-format publication in three languages. The depth of the column is determined by the 'longest' language.

The typeface is *Akzidenz Grotesk*. Froshaug is renowned for his consistent use of *Gill Sans* and the five issues of *Ulm* that Froshaug designed are therefore quite different in feel from his other work (also see pages 69, 109 and 135). *St Bride Printing Library*

ulm 4

Vierteljahresbericht
der Hochschule für Gestaltung, Ulm
April 1959

Preis pro Nummer DM 1.–/SFr 1.–/ÖS 7.50
Jahresabonnement DM 4.–/SFr 4.–/ÖS 30
portofrei

Quarterly bulletin
of the Hochschule für Gestaltung, Ulm
April 1959

Price per issue 2s6d/$ 0.50
Yearly subscription 10s/$ 2.00 postpaid

Bulletin trimestriel
de la Hochschule für Gestaltung, Ulm
Avril 1959

Prix du numéro 125 frs/L175
Abonnement annuel 500 frs/L700 port payé

Anthony Fröshaug

Visuelle Methodik

Visual Methodology

Méthodologie visuelle

1. Aufgabenstellung

Die ersten Aufgaben, die in der Grundlehre der HfG innerhalb des Faches Visuelle Methodik gestellt werden, haben zu berücksichtigen, daß die Studierenden eine unterschiedliche Vorbildung besitzen und daß kaum methodologische Vorkenntnisse vorausgesetzt werden können. Auch beherrschen sie die Darstellungstechniken nicht in gleicher Weise.

Daher werden am Anfang Aufgaben gestellt, die nicht nur die Darstellungsfertigkeiten entwickeln, sondern auch ohne besondere methodologische Voraussetzungen zu lösen sind. Die Studierenden sollen dazu angeleitet werden, diese Aufgaben nicht nur intuitiv zu bearbeiten, sondern, soweit wie möglich, systematisch an sie heranzugehen und sich auf diese Weise einige methodologische Kenntnisse anzueignen. Schließlich sollen die Aufgaben in einem thematischen Zusammenhang mit der späteren Arbeit in den Abteilungen stehen.

Es empfiehlt sich, Aufgaben zu wählen, die eine übersehbare Anzahl von Lösungen besitzen. Eine solche Aufgabe ist zum Beispiel die Darstellung von Kommunikationsverhältnissen durch zwei- oder dreidimensionale Graphe. Unter einem Graph versteht man ein System von Punkten und Verbindungslinien zwischen diesen Punkten (1.1).

Gleichzeitig läßt sich auf diese Weise experimentell untersuchen, ob sich für die Gestaltung von Informationsträgern Prinzipien entwickeln lassen, deren Anwendung die Informationsvermittlung optimalisiert: ein Problem, das für alle Abteilungen der HfG in gleicher Weise von Bedeutung ist.

1. Problems set

In the foundation course at the HfG, the first problems set in the subject of visual methodology have to take into consideration the facts that the previous education of the students varies; that hardly any basic methodological knowledge can be presupposed; and also that their command of representation by means of technical drawing is uneven.

For these reasons, at the beginning of the school year problems were set, which not only develop skill in technical drawing but which are also soluble without previous specialised knowledge of methodology. In this way an attempt is made to guide students to have, as far as possible, a systematic approach — rather than merely to work intuitively; thus to acquire some knowledge of method. Finally, the problems must be related in theme to the work which the students will carry out later on in the various departments of the Hochschule.

It is advisable to choose problems which have a clearly visible number of solutions. An example of this sort of problem is the representation of communication relationships by means of two- and three-dimensional graphs. A graph is understood as a system composed of points and connections between such points (1.1).

Simultaneously, one can in this way make an experimental investigation into the design of sign vehicles, to discover whether certain principles can be developed whose application will lead to an optimal transmission of information: a problem which is of equal significance for all departments of the HfG.

1. Enoncé des problèmes

Les premiers problèmes posés en méthodologie visuelle, une des branches du cours fondamental de la HfG, doivent s'adapter à la formation antérieure très inégale des étudiants; on ne peut exiger d'eux des notions méthodologiques préalables. Par ailleurs, ils ne maîtrisent pas de manière uniforme les techniques de représentation.

On commence donc par poser des problèmes qui développent l'habileté à représenter, sans exiger pour autant des bases méthodologiques. Il faut amener les étudiants à ne pas se contenter d'aborder les problèmes par l'intuition seule, mais, dans la mesure du possible, à les étudier systématiquement afin d'acquérir ainsi quelques connaissances méthodologiques. En outre, les thèmes des problèmes doivent se rattacher aux travaux ultérieurs des différentes sections.

Il vaut mieux choisir des problèmes ayant un nombre limité de solutions. Représenter des réseaux de communication par des graphes à deux ou trois dimensions constitue un exemple de ce genre de problèmes. Par graphe, on entend un système de points et de lignes reliant ces points les uns aux autres (1.1).

En même temps, on peut, par ce moyen, vérifier expérimentalement s'il est possible de déduire des principes pour la représentation de porteurs d'information dont l'application permettrait un transfert optimal d'information. Ce problème intéresse également toutes les sections de la HfG.

(1.1)

Today, type designers set the spatial values *(the fit)* for all the common character combinations at what is called the optimal size range; usually considered to span 10 to 14pt. The exact number of character combinations (or character pairs) specially kerned depends entirely on the whim of the type designer. Some will, effectively, design every possible combination; an immense task. Just taking one character, the cap A; this must fit with all other capitals (including another A) on both sides. It must fit every lowercase character, again, on both sides (for example McAllister); it must fit with small capitals; align optically in the margin at the left and at the right (for justified setting); and, occasionally, it must fit with italic lowercase – in all, perhaps, more than 2,000 pairs. Others take the view that either a well-designed font needs less attention to spacing, and/or, that a certain amount of 'quirkiness' in spacing values adds interest to a typeface. Clearly, the space between letters is designed to be very much a part of the 'character' of the typeface, and its integrity, on the whole, should be protected. For this reason you should not, normally, letterspace lowercase letters. If you do not like the overall spatial characteristics of a typeface it is probably better to select another typeface.

However, when a size of type is required from outside the optimum size range, (generally smaller than 10pt or larger than 14pt) the intercharacter spaces will need to be adjusted. This is because when you choose, for instance, 6pt, the typeface will be 'reduced' by the computer from its optimum size. This reduction includes (by the same ratio) the spaces between the characters. Therefore, a typeface designed with close-fitting characters will certainly appear too close – or even touching – when reduced. This situation will, generally, be made worse by the print process.

To remedy this, it is necessary to open (loosen) the type by universally adding small amounts of space between all of the characters. This is done by utilising the computer 'tracking' facility. How much space is required depends very much upon the typeface and, most importantly, the original fit. As a general rule, the type should fit firmly together, ensuring the reader can still see the whole of each letter; they should be close but not touching.

If a typeface is enlarged beyond the 'optimum size range' (above approximately 14pt) then the opposite occurs; the intercharacter spaces are too large. In this case, tracking values need to be reduced.

Unfortunately, assessing fine adjustments on screen is frustrated by the poor resolution of many monitor screens. When the resolution is as coarse as 72 dpi (dots per inch) trying to establish the *exact* location of, for example, an apostrophe, is virtually impossible without magnification. At 400% (maximum magnification) things become much clearer, but then, essential comparisons cannot be made across the text. A certain amount of guesswork is inevitable until you have had the experience of seeing proofs from film-output or have seen the final result of commercial offset-lithographic technology.

'Print-outs' are often not a great help either. Judging the amount of space between characters, particularly at small sizes, can be difficult if print-outs are from ink-jet or (to a lesser degree) laser printers. This technology, which offers a much higher resolution than that of your monitor, tends to be adversely affected by the poor performance of paper and inks. Even if photo-quality paper is being used, a certain amount of 'bleed' from the printed area makes the spaces appear smaller (and the type appear heavier) than it will appear if it is eventually to be printed by offset-lithography.

In his book *Letters of Credit,* Walter Tracy describes the process of allocating space to each side of a character. Although written for type designers, it provides an insight into the nature of letterforms and how they function. In the roman alphabet, both upper- and lowercase characters are formed of straight or round strokes or a combination of them.

Letters with a straight upright stroke: BDEFHIJKLMNPRTU bdhijklmnpqru
Letters with a round stroke: CDGOPQ bcdeopq
Triangular letters: AVWXY vwxy
Odd characters: STZ afgstz

The basis for the spacing of uppercase is the H. The width between the uprights can be measured and half of that amount allocated to each side of the character. Four Hs are then positioned at an appropriate distance apart. When set in a row their eight uprights should be equal distances apart. This will work best when the uprights are bolder and, therefore, the open counters narrow. In lighter weights, the crossbar plays a more prominent role between the two uprights, visually pulling them together. Because of this, the side-spaces need to be reduced until they appear equal to the interior spaces. Also, a sans serif H will require a little less side-space than a serif. When the four Hs look harmonious the distance between them is measured and half the amount allocated to each side of H and all other uppercase characters which have straight, vertical strokes.

The next letter to deal with is O. This is placed between two pairs of correctly spaced Hs, and the spaces on each side of it are reduced or increased until all five characters are in balance. The space is then measured. The amount belonging to the H is subtracted and the remainder is, therefore, the amount due to O. But a further test is required. A second O is positioned using the side-spacing previously arrived at and placed side-by-side between the two pairs of Hs, thus, HHOOHH. Further revisions may be necessary, but when complete, the 'standard' spacing for the two key capitals has been achieved. It is now possible to space the other characters by taking note of the groups of letters listed earlier and spacing them as indicated above. However, this is only a formula, and as such should be used as a guide only.

The same method is used for the fitting of lowercase characters, the standards being the n and o. (Fournier suggested the m; but since this is so often designed with narrower internal spaces than those in n, h and u, the n seems a better choice for the standard.)

HHHH

dAd aBc cCc aDe aEc aFc eGb aIa dJa aKd aLd bMa

dNd aPe eQe aRd dTd aUb dVd dWd dXd dYd cZc

S must be spaced visually, between standards

a Same as H
b Slightly less than A
c About half of A
d Minimum space
e Same as O

ABEbE ECc FEDAd AEeF CBhB CIAiA AjAJ CDkD CLAlA ABmC CPEpE EqA

ArD BuB DVDvD DWDwD DyD

afgstz must be spaced visually, between standards

A Same as left side of n
B Same as right side of n
C Slightly more than left side of n
D Minimum space
E Same as o
F Slightly less than o

Ligatures

If ligatures are incorporated into the text, great care needs to be taken when increasing or decreasing tracking values. The 'spaces' between the ligatured characters are not, of course, affected by alterations caused by a change in tracking values. If the spaces between 'ligatured' characters look either too large or too small in relation to the other (tracked) intercharacter spaces, you have a choice of either replacing the ligatures with standard characters or making further adjustments to the tracking value.

Uppercase

Unlike lowercase, uppercase characters must *always*, and under all circumstances, be individually letterspaced. To achieve effective letterspacing of capitals in good classical inscriptions and later in manuscripts, the space values ranged from 5% to 100% of the 'body' size. Tschichold recommends a minimum of 20%.[1] The spacing needs to be varied between each pair of characters to achieve the appearance of even spacing. Such letterspacing must be evident but should not be intrusive.

Uppercase characters are designed to be read letter by letter, and space plays an important role in making this process as efficient as possible. Unlike lowercase, letterspacing with caps is essential, regardless of size. So, small caps also need to be *individually* letterspaced. The practice of adding an equal amount of letterspace (tracking) when setting caps (and particularly prevalent in the setting of small caps) is not, usually, an adequate substitute. Optically even spacing demands the use of spaces which vary according to the printed shapes of each individual character pair.

Certain character pairs, such as LA, tend to serve as the starting point by requiring the smallest kerning value, whilst HI, or any other character-pairing that offers adjacent verticals, suggest the largest kerning value. It should be self-evident that spacing between words set entirely in uppercase or small caps will need to be wider than those between words set in lowercase.

Letterspacing can be wide if the text consists of only a few words. However, if it runs to more than one line, the interline spaces must remain wider (by a significant amount) than the intercharacter (or interword) spaces.

Uppercase and lowercase combined

If a typeface has been properly kerned it should not be necessary to adjust the spaces between upper- and lowercase. However, certain character pairs – for example, Te, Ta, To, Pe, Pa, Po, and We, Wa, Wo etc – should always be checked. Occasionally, fonts offer composites of some of these.

-50 -10 -10 -10

THE NATURE AND SCALE OF THE WORK
For what kind of setting are we designing? Is it a large work? How is it to be used? Is it for a Bible, a work of reference, or a novel? If the work is a lectern Bible the reader will be standing and his eyes will be at a considerable distance from the page: each period of reading is likely to be a short one. On the other hand if the work is a pocket dictionary or other book of reference it will either be consulted for brief periods or be pored over; if it is a novel it may be read quickly, perhaps in a single evening: an easily readable measure is therefore imperative.

Opposite page
When a ligature is used the adjustment of intercharacter spacing must be done in conjunction with the fixed 'spaces' between the characters that make up a ligature. The top example shows correct spacing, the bottom one is inconsistent.

This page above
Punctuation can cause text to appear particularly 'gappy' if left unadjusted. In spite of everything the typographer should attempt to present text as evenly as possible.

This page below
Detail from Geoffrey Dowding's *Finer Points in the Spacing and Arrangement of Type*. Actual size. (Also see page 93.)

Punctuation

Full points and commas will often need to be pulled closer to certain characters, typically r, v, w, and y. But with letterspaced caps, it is important also not to position full points and commas too close, particularly with F, P, T and V.

The lowercase italic f when used in combinations, such as, with *f' f? f! f) f]* and the lowercase italic j *j)* and *j]* will often need kerning.

Dashes need to be separated from the words to which they relate by a small space; enough to avoid the dash inadvertently joining the words on either side of it together, but not so large as to suggest that the dash is 'floating'. The amount of space required will also vary depending on the shape of adjoining characters (see this page right). Hyphens, sometimes, also have to be fine-tuned to fit in the exact optical centre between adjoining characters.

Exclamation and question marks function better if separated from the final word because they refer to the whole exclamation or whole question rather than the *word*. It used to be common for this space to be word space but this amount tends to isolate the punctuation mark. Generally, 20/200 (or kerned +20) is sufficient, although this will vary depending on the form of the previous character. Similarly, colons and semi-colons need to be separated from the previous word, but generally not by so much.

Numerals

When spacing numerals, the type designer will often *tabulate* rather than *kern* (eg set them to fit beneath each other as in columns). This means that the digit 1 (one) for instance, although slimmer in form than any other numeral, is assigned the same amount of space (set-width) so that it will align vertically with columns of numerals. All numeral combinations usually need to be spatially adjusted. Generally, grouped numerals require a little more space than might be necessary for normal lowercase characters. This is because numerals are read more slowly than letters since they often have to be read individually. It is common practice, even for short lists of numbers (such as telephone numbers) to divide the number into even shorter groups, such as 000 0000 0000.

yes–maybe

yes – maybe

yes – maybe

This page
The position of the em (or en) dash.
Top; 'standard' setting. Middle; with +30
units of space on each side. Bottom; in
addition, the em dash has been lowered
to be at the optical centre of the x-height.
The vertical placement of the hyphen, en
and dashes can vary even in the same font,
(see page 45).

Opposite page
Character combinations which
regularly cause problems, and, below,
appropriate adjustments.

f f? (f) [f] (j) [j]

f f? (f) [f] (j) [j]

f' f? (f) [f] (j) [j]

Space between words

The sole reason for spaces between words is to help the reader to recognise individual word shapes. The space should be the minimum to fulfil this task, commonly stated as the width of an i.

Close, consistent word spacing will make it easier for the eye to smoothly skip along a line of text with minimum pauses. Visually, a page of text should appear as an orderly series of thin, horizontal, evenly textured lines, separated by channels of clear space. If the setting is loose, there is a tendency for the texture of these lines to appear uneven, fractured, and, in the worst cases, broken. Persistent use of over-large word spaces (particularly if these become wider than the interline spaces) can align with spaces in other lines to create white, vertical 'rivers' through the text. Comprehension will certainly be impaired if the type cannot keep the reader's eye on the line, and a tightly spaced line will greatly help. There should be a sharp contrast between the line of text and the interline spaces, allowing each to provide strength and support to the other.

Similarly, space before and after uppercase characters can be reduced, and, if required, the same applies to parentheses and brackets. The shape of some lowercase characters, such as the v, w and y, also offer the opportunity to reduce word spacing where they begin or end a word. The size of the x-height also influences the amount of word space required. The larger the x-height the larger the counters. This means that the spaces separating words also need to be larger to ensure the word shapes are clearly defined.

Every effort needs to be made to maintain consistency, especially in demanding circumstances; for example, where punctuation occurs, or where a roman text includes italics or involves a large number of people's names with initials or clusters of numerals; all of these need to be dealt with in such a way that they blend, inconspicuously, into the the page of text.

Punctuation
Word spaces, preceding or following punctuation, should be optically adjusted to appear to be of the same value as a standard word space.

If a standard word space is inserted after a full point or a comma then, optically, this produces a space up to 50% wider than that of other word spaces within a line of type. This is because these punctuation marks carry space *above* them, which, when added to the adjacent standard word spaces, combines to create a visually larger space. Some argue that the 'additional' space after a comma and full point serves as a 'pause signal' for the reader. But this is unnecessary (and visually disruptive) since the pause signal is provided by the punctuation mark itself.

The word space should be reduced to take account of the space above the comma or full point. The aim must be to provide an overall space which is the optical equivalent of a standard word space. Spaces between words, regardless of punctuation, should maintain an even *optical* value equivalent to that of a standard word space.

Similarly, quote marks (turned comma and apostrophe, singly or paired) carry space *beneath* them. Consequently, spaces before the turned comma and after the apostrophe should be reduced to the optical equivalent of a standard word space. Single rather than double quotes will make it easier to maintain constant optical word spaces.

The colon and semi-colon, and also parenthesis will benefit from a reduction in the word spaces immediately adjacent to them. Question and exclamation marks, generally, do not require an adjustment to the following word space.

The type designer consciously designs the inner 'spaces' whilst drawing the actual letterforms. The aim is to create a visual equilibrium between the two.

The type designer consciously designs the inner spaces whilst drawing the actual letterforms The aim is to create a visual equilibrium between the two.

THE SETTING OF TEXT MATTER

columns especially when the matter consists of very short paragraphs, e.g. in conversational passages. This effect is exaggerated when the measure is a narrow one. When indention is called for then the first line[1] of the *commencing* paragraph should be set full out. This treatment gives the page a strong and clean beginning. It will be found much easier to design a satisfactory chapter or other heading over a full line than over the weak and unshapely beginning which an indention, however slight, would give. Similarly, the first line of a paragraph immediately below a sub-heading should be set full out. Of course in books with running heads the indention of the text paragraphs makes it almost certain that on several of the pages a new paragraph will commence the page and give the weak shape just referred to. This is unfortunate, but short of re-writing the text at those points such contingencies appear to be unavoidable.

The use of well-designed paragraph marks, either set flush or overhanging the text, should be considered as an alternative means of marking the beginnings of paragraphs.

Perfecting. In the finest bookwork the pages of text are printed in such a manner that the lines on a recto page back up exactly those printed on the reverse or verso side. This care in setting & printing, nullified when extra space is inserted between paragraphs (for there is some show-through even on reasonably good paper), adds to the beauty & clarity of the pages by heightening the contrast between the lines & their interlinear whiting. Students engaged in the production of books, booklets & pamphlets would do well to bear this in mind, so arranging the whiting of subheadings, for instance, that line-for-line backing is possible.[2]

The first word or words of the opening (*in bookwork*). Various treatments of the opening word, or words, of the first paragraph may be used. For instance, they can be set in letter-spaced capitals provided these are of the

[1]See notes on page 22 for the treatment of paragraphs opening with a quotation.
[2]In this book, for example, the spacing allowed for headings is based on the unit of the text line plus its leading.

Opposite page
Uniformity is one of the most important factors of readability. Word spaces can only be at a constant value if set ranged left. When text is justified, the varied word spaces should not be noticeable.

This page
Geoffrey Dowding's slim volume, *Finer Points in the Spacing and Arrangement of Type* was described as a 'primer for students of typography'. It was written and designed by Dowding and published by Wace and Company in 1954. The book is a lucid and particularly persuasive argument, as well as a paradigm of even, justified setting. Opposite the preface of the first edition, Dowding offers a quote from Stanley Morison which sets the tone of the book: 'Typography today does not so much need inspiration or revival as investigation' (taken from Morison's *First Principles of Typography*, 1951).

Space between lines

'There is more danger of making reading hard by crowding the lines, than by crowding the words.' Edward Johnston. *Writing and Illuminating and Lettering*, 1906.

Text setting

The space between the lines of text aids the focused vision of the reader to sweep back, right to left at an acute angle, from the end of a line to the beginning of the next. If there is insufficient interline spacing, the text will not provide the means for the horizontal action essential for efficient reading. The importance of this particular function is emphasised if the length of the line is longer than normal because the eye has further to travel and at a more acute angle, in order to find the beginning of the next line. Therefore, the longer the lines, the wider the interline spacing that is required. If successful, this will prevent inadvertent *skipping* or missing of lines or *re-reading* of lines just completed!

The space between lines will appear wider (with or without leading) if the typeface used has a smaller x-height, and narrower if the typeface has a larger x-height (see opposite and page 80).

The size of the x-height will, therefore, influence any decision concerning the use of leading. A typeface such as *Caslon* – which has a smaller x-height – will look, and be, extremely readable, with considerably less leading than a typeface such as *Univers* which has a large x-height. The style of the face will also influence leading. A serifed face, such as *Caslon*, provides a horizontal emphasis, predominantly along the baseline and the top of the x-height, that is missing with a sans serif. In fact, many sans serif faces have a distinctively upright stature which, to be made readable should be tightly set and generously leaded. More Humanistic sans serifs, such as *Syntax*, (illustrated page 75) do not suffer to the same extent.

This is not a problem that is isolated to sans serifs. Certainly, modern and even transitional typefaces, to varying degrees, need judicious leading if the necessary horizontal stress is to overcome the vertical emphasis inherent in the type style.

With these, and most other typefaces, the heavier versions require more leading than the light versions. The modern typeface, *Bodoni Bold*, for example, will comfortably carry leading equal to its body height.

The computer default setting for leading is normally 20% of the body height regardless of the size, weight or style of typeface used. This should always be overridden with an *appropriate* amount of leading to be decided by the typographer.

Display setting

Whilst working with type at a larger scale the interline spacing (leading) often needs additional consideration.

Where lines of uppercase are being used there is the option of drawing the line together since there are not ascenders or descenders to crash into each other. This is called negative leading. However, if the caps are widely letterspaced, care should be taken to ensure that horizontal action is maintained by making the the interline space larger than the interword spaces.

If the display setting includes a mixture of uppercase lines and lowercase lines (or all lowercase) the interline spaces will need adjustments if they are required to be optically the same. For example, a line of lowercase *with* descenders above a line of uppercase will appear closer together (because of the descenders) than a line of lowercase *without* descenders.

Comparative translations—set in VERE DIGNUM—to celebrate Christmas 2001 | Phil Baines & Catherine Dixon Phil Baines studio, Lowfield, 49B King's Road, Willesden Green, London NW10 2BP (07973) 359579 studio@philbaines.co.uk

A Christmas card designed by Catherine and Phil Baines in 2001, using negative leading values. The forms of this typeface, *Vere Dingum,* are loosely based upon examples found in Ravenna and Canterbury. Rhythms are given emphasis by the close, vertical proximity of the repeated characters and words.

This page above
Book cover designed by Peter Krans for the Kulturamt, Stuttgart, 1998. Overlapping characters printed silver and fluorescent orange.

This page below
Caslon Medium and *Univers 55:* Body height the same (14pt) but the x-height is different. *Univers,* with the larger x-height appears larger. The larger x-height leaves less space within the body area for ascenders and descenders, and so, with *Univers,* these must be shorter.

Univers 45 and Caslon Medium set solid: Body height the same (14pt) but the x-height is different. Univers, with the larger x-height appears larger. The larger x-height leaves less space within the body area, for ascenders and descenders, and so, with Univers, these must be shorter. Optically, this means that Univers appears to have less space between lines (shown here in blue)

Caslon Medium and Univers 45 set solid: Body height the same (14pt) but the x-height is different. Univers, with the larger x-height appears larger. The larger x-height leaves less space within the body area, for ascenders and descenders, and so, with Univers, these must be shorter. Optically, this means that Caslon appears to have more space between its lines (shown here in blue)

Space around text

The spaces around text are called margins. As the intercharacter, interword and interline spacing all locks the type in place, so the margins lock the text itself in place within the page.

There are, of course, more pragmatic reasons for margins. As we have seen (in the chapter on legibility) there is an optimum size of type (around 9 or 10pt) which needs to be set in lines averaging ten words per line. There is a minimum size of document that can be held in the hand with any comfort. The difference between the two – the area of text and the edges of the document – are the margins. Margins do not have a *direct* influence on readability and therefore, as Paterson and Tinker concluded, 'since margins are not essential [from the point of view of readability] and since they add greatly to costs, it is clear they must be justified, if justified at all, solely in terms of aesthetics'. Tests concluded that the margins could be as little as 1/4 inch for the head, foredge and tail and 3/4 inch for the paired spine margin (backs). But such proportions are not particularly inviting and it is generally acknowledged that the text *is* looked at to assess 'readability' before purchase. In fact, at many publishers, the textual appearance is considered as crucial to the sale of the book as the design of the cover.[2]

Any document must be designed as a whole if it is to work as a whole. Coherence is essential and margins play a major role by establishing a framework that isolates the text area from the environment beyond the book or magazine. Margins should enhance the text by providing, in their varying proportions, the right amount of support for its placement on the page.

In books, the proportion of text area to margin area is roughly half and half. That any page might consist of 50% white space is, perhaps, surprising. But even during a period of severe paper shortage, such as that imposed during the Second World War, the economic regulations only went as far as to stipulate a type area of 'not less that 58%' of the page area. Magazines often use tighter margins but disguise this by rarely utilising the whole text area and by the judicious placement of images; factors which are used to vary the pace of each article and the publication as a whole.

Medieval manuscript books show a surprising conformity in proportions of margins-to-text area. Gutenberg later used similar proportions and these have persisted, to a large degree, in bookwork to the present day. Generally, the rule is that the width of the head margin should be half that of the tail, whilst the paired back margin (across the spine) should equal the width of the foredge margin (see page 102), the aim being that when the book is open the foredge margins should be the same width as the combined spine margin. (The generous foredge margins have been justified by stating that the fingers and thumbs of the reader need to hold the book without impeding the reading. In fact, common sense tells you that the readers, other than the youngest children, are not clumsy enough to be consciously impeded by their own fingers.)

These proportions are designed to draw the facing two pages together and lift the text upward into a visually stable location. The paired narrow back margins optically combine to form a channel between the two pages of the same width, or a little less than each of the foredge margins. The head is less than the tail margin because the eye generally sees the optical centre of a page rather higher than the *actual* centre (see this page right).

A generously leaded text will look quite comfortable with smaller margins whilst a text with less leading will look better with more generous margins. Similarly, the use of a lighter typeface will look comfortable with smaller margins whilst a heavier typeface will require wider margins. Generous space *within* the text area appears to compensate for the lack of space *outside* the text area (margins) and visa versa.

Margins contribute greatly to the comfort and pleasure of reading; providing a calm environment in which the text can function to the full. But they are rarely *just* space. Chapter headings, sub-headings, running heads, folios, illustrations and captions, footnotes and reference material are often positioned in the 'margins', and for this reason, a portion of the margin area is often represented in the grid specifically to carry supporting material.

This page
The physical centre and the optical centre of a square.

Opposite page
Giambattista Bodoni. Title page of
***La Divina Commedia of Dante.* (A double page spread is illustrated on page 24)**

LA

DIVINA

COMMEDIA

DI

DANTE

ALLIGHIERI

TOMO II.

PARMA

NEL REGAL PALAZZO

MDCCXCVI

CO' TIPI BODONIANI

CHARLES HALE # The Integration of Photo and Type

The photographs on pages 15–18 are by the author

In a well-designed book the printed page is an harmonious yet significant organisation of letters; of groups of letters as words; of spaces between words; of spaces between lines of words, and of spaces between lines of words as a mass and the edges of the page. The well-designed printed page is above all significant as one of a number of other similar but not identical pages – significant in itself seen alone, and also as one of a significant collection of pages.

Its significance lies first in its being an expressive visual counterpart of the writer's message; secondly of its having beauty in itself apart from the literary content of its words; thirdly of its being an efficient functional vehicle for conveying those thoughts and feelings expressed as literature; fourthly, of its being, when occasion arises, a powerfully integrated combination of typographic and illustrative expression. The well-designed printed page is where the two arts of the writer and the designer meet.

So much for the visual presentation of the literary content of a book *per se*. In an *illustrated* book the three arts of literature, typographic design, and illustration combine: the last not being, as with typography, so much a continuation of the author's work in another medium – continuing, as it were, where the author left off and being wholly contained within the æsthetic framework of the literature – but being rather in the nature of a supplementary contribution expressed in a different medium, added on and worked into the whole with such taste and gentleness that the author's purpose in writing the book receives additional impetus. Here both typographer and illustrator play a subservient role to that of the writer.

It is necessary that both typographer and illustrator should arrive at a personal attitude which will enable them to transpose the writer's finished literary work into a visual key. It is here, where the writer produces the *fait accompli* of sentences, paragraphs, and chapters that the designer's work of creating an adequate and sensitive visual presentation of them, begins. The illustrator's work consists of supplementing the visual presentation of the designer – again strictly within the æsthetic framework predetermined by the writer. Therefore, the illustration has to conform to (1) the illustrator's personal æsthetic; (2) the writer's æsthetic; and (3) the æsthetic and technical demands of the designer.

From the illustrator's point of view, whether graphic or photographic, the matter is one of personal interpretation freely exercised within certain technical limitations. Not often is the illustrator in a position from which he can view the finished book as the designer visualises it and feel that he is an essential contributing factor. That he should so feel himself is necessary if his work is to reach that peak of consonance and relevancy which must be the least of its achievements.

Of the two categories of books, namely: books meant primarily to be read and books meant primarily to be looked at, here the latter is our main concern. I mean the book which is primarily a designer's product, and which therefore appeals first to the eye and conveys a large proportion of its message visually before the reader is led to investigate further into the territory of illustration and from there into the copy. For this is the medium in which typographic designer, writer, and illustrator can work together on an almost equal footing.

Of necessity such a book must begin as an Idea. Upon this Idea the book is based, and around and about the Idea it is developed. From the Idea each artist expands creatively in his own way, guided throughout by a designer who himself is fully aware of the potentialities of both literature and illustration. It is the designer who determines finally how much of the space at his disposal shall be relegated to illustration and how much to copy. It is his job to see the book as a unity, as an harmonious organism of word-masses and image-masses before anything is written or drawn or photographed. In this way writers and artists become craftsmen and clearly defined objectives and a strong sense of purpose give added momentum to the expression of their feelings.

As with the graphic artist, the photographer's work ends with the production of his prints: that is, the photographic part of it ends, but by no means the presentation of his work, and it is upon the presentation of photographs that so much of their eloquence depends. Like the drawing, the photograph can be said to speak for itself, and this is what it usually has to do, receiving little help from its spatial setting. Too often it is looked upon as being a static area of image to be insulated from the rest of the book by borders of white space or (conveniently) bled off the page. What lies above, below, or to either side of it is thought to have little influence upon it. So it is placed somewhere on the page, just where is determined either by technical expediency or by the dictates of a reigning 'style'. This view – that the photograph is a *dead* mass – must prevent it from ever becoming an integral part of the well-designed page.

When the designer is handed a finished photograph, it is left to him so to order his type areas that his page becomes a dynamic abstract composition whose 'mood' is in harmony with (*a*) the photograph; (*b*) the literary subject; (*c*) the rest of the book; and (*d*) his own feelings and aims. Assuming that

must change continually, otherwise it falls into decay. So, for example, centrally placed typography can lose its power of speech. Every generation has the duty to find form freshly, and the continuation of the status quo is by definition something to be avoided.'

Martens possesses sufficient discipline to keep his work as an artist, like his work as a designer, on the move. His cut-paper pieces may belong to the past, but now he goes to work on his 'printings' with the same systematic pleasure in research. These latter certainly contributed to the award given for Oase (which is published by the SUN). Within a constant format, each issue has another design, a changing canvas with different colours and typefaces, even doing without its own masthead, and of which one number (about the interior) came uncut. And further, with this award, the jury (Joost Swarte, Victor Levie and Hugues Boekraad) seals the historic association that twenty years ago was made between a left publisher, a possessed editor and a sensitive designer.

Koosje Sierman
(First published in NRC-HANDELSBLAD, 30 11 1993).

Karel Martens: meticulous and personal
Judges' Report, H.N. Werkman Prize 1993

Martens's designs are always tuned to a particular content, aimed at a particular category of users. He designs for readers, thinking beings who need to be neither entertained nor lectured. He practises information design without being distant. His designs are modest, personal and meticulous. This care is a trait of the person, of the way he works and the finished design. Martens avoids expansive gestures (though he is not at all shy of strong contrasts or a restrained rhyth-micity). He hesitates and doubts, considers and rejects, until his decision and its consequences are fully thought through. The result is lucid, reasoned and thoroughly evolved designs. Rational *and* personal. Because design solutions always have to be tuned to a given content, the route to a systematic design methodology is blocked off. Underlying his designs there is no system of thought, but rather the desire to bring a singular content to a form of its own within the framework of the grid which lies on his desk as it does on anyone else's. Martens will grasp chance circumstances with both hands and he is happy to play little jokes like leaving the edges of Oase 34, which was devoted to interiors, uncut. Everything can serve in the creation of a form that goes against the current idiom of magazine design in the segment in which Oase finds itself (De Gids, Kunst & Museumjournaal, Tirade etc.).

He has learned this experimenting attitude from the early modernists. Despite his admiration for the wholly rational-ized design methodology of late modernism, he deploys this attitude against its all too uniform imagery. In so doing, he also serves other values besides productivity and efficiency. Slowly but surely Martens has lost interest in standardiza-tion. To him, graphic design remains a labour-intensive craft. This experimental character is not something that is shouted from the rooftops. It is not a matter of conspicuous infractions of commonly accepted codes, nor of Utopian innovation. The experiment as a romantic attitude is alien to him, as is any pretension to avant-gardism. It is more a matter of the unassuming, inconspicuous desire to experiment of a craftsman who takes pleasure in his work and creates joy in a piece which transcends routine. Martens's experimenta-tion is low-key. It concentrates on the materials with which he works, the letters and punches, the paper and the inks, formats and rasters, and the forms of the genre concerned. To him, the tactile quality of the design when executed is no less important than the visual. Compare the little games he plays with cover paper coated on one side: if possible, it is the rough side that he likes to have printed. He has always had something of the hobbyist about him, in spite of his professionalism. To him, design is never just working to order, it is an activity he adores.

His experiments, then, are by way of being tryouts. They spring from a playfulness which does not advertise itself but is the product of the pleasure of doing. He tries something new in every issue of Oase, and looking at the issues that have appeared so far we see that he makes as many ingredients variable as possible. It is a game that is played for a stake. This playful pleasure puts into perspective the undiminished moralism which spices his designs, and thwarts his scrupulous design ethic.

His designs are sparing (not too much white) and economical. Here again he reveals himself as a descendant of modernism. But it is not the historical imagery of modernism that he puts on the stage, he shares its intrinsic engagement and some of its design precepts. In the seventies, particularly in the covers for the SUN-schriften, his work contained quotations from Bauhaus typography, as in the expressive use of thick rules, but formal references to his models have since become rarer. Martens has always avoided the use of diagonals. He had no need of them to give his anaxial ordering schemes an air of mobility.

The text is not sanctified, it is treated as a vehicle of information and knowledge. Nor is it parachuted into a spectacle. In Martens's hands, image and text are complementary. And if text runs through into a photo, this is the consequence of an organizational problem, not of a desire for form. Such a solution is reasoned. It is often founded on careful observation of an image, not on the desire to degrade the text into ornament. Martens's design is subservient to textual interchange and appeals not to the reader's visual curiosity but to his powers of judgement. An aversion to theatricality leads to sober design. Martens the designer is no actor, making other people's texts vanish into the echo of his broadly projected voice. It is not his person but his attitude and professionalism that remain recognizable in the product.

There was a time when a preference for rectilinearity occasionally produced a lack of agility, when moralism led to immaculate sobriety, as in the design practised by the Shakers. This is the very area in which we can now see a process of evolution in Martens's recent work. The treatment of pictorial matter has become more varied, bolder, without succumbing to the temptation of a baroque lust for decora-tion. A superficial film of Calvinism cannot be polished away, but nor does it stand in the way of brisk flamboyance and even colourfulness. (A sophisticated sense of colour, incid-

maar in het professionalisme schuilt zeker een gevaar. De wereld deugt hoe dan ook niet en de dingen moeten voortdurend veranderen, anders komt het tot verval. Zo kon bijvoorbeeld het centraal op de as van de pagina typografe-ren zijn zeggingskracht verliezen. Iedere generatie heeft de plicht opnieuw zijn vorm te vinden en de continuering van de status quo is per definitie iets dat vermeden moet worden.'

Martens bezit voldoende discipline als kunstenaar om ook zijn toegepaste werk beweeglijk te houden. Zijn papieren snijsels mogen dan tot het verleden behoren, hij zijn druklust van nú gaat hij met dezelfde systematische onderzoekslust te werk. Dat laatste heeft zeker bijgedragen tot de bekroning van het bij de SUN ondergebrachte Oase dat, binnen een vast formaat, per nummer een andere vormgeving, een wisselend stramien een veranderlijke kleurstelling of lettertype heeft, dat niet eens een eigen logo bezit en waarvan één aflevering (over het interieur) onopengesneden kwam.

Maar bovendien bezegelt de jury (Joost Swarte, Victor Levie, Hugues Boekraad) met deze bekroning het historisch verbond dat twintig jaar geleden gesloten werd tussen een linkse uitgeverij, een bezeten redacteur en een gevoelig ontwerper.

Koosje Sierman
(Eerder gepubliceerd in NRC-HANDELSBLAD, 30 11 1993).

Karel Martens: zorgvuldig en persoonlijk
Juryrapport H.N. Werkmanprijs 1993

Martens' ontwerpen zijn steeds afgestemd op een specifie-ke inhoud, gericht op een specifieke categorie van gebruikers. Hij ontwerpt voor lezers, denkende wezens die niet vermaakt hoeven te worden noch te worden beleerd. Hij bezit iets informatie-vormgeving maar zonder afstande-lijkheid. Zijn ontwerpen zijn bescheiden, persoonlijk en zorgvuldig.

Deze zorgvuldigheid is een eigenschap van de persoon, van zijn werkwijze én van het gerealiseerde ontwerp. Martens vermijdt het grote gebaar (al schuwt hij sterke contrasten en beheerste ritmering geenszins). Hij aarzelt en twijfelt, overweegt en verwerpt, tot zijn beslissing in haar consequen-ties doordacht is. Heldere, beredeneerde en doorwerkte ontwerpen zijn het gevolg.

Rationeel én persoonlijk. Doordat ontwerp-oplossingen telkens weer op een gegeven inhoud worden afgestemd, is de weg naar een systematische ontwerpmethodiek geblokkeerd. Geen systeemdenken ligt aan zijn ontwerpen ten grondslag, eerder het streven om in het kader van het stramien dat natuurlijk ook op zijn werktafel ligt, een singuliere inhoud tot een eigen vorm te brengen. Toevals-gegevens grijpt Martens met beide handen aan en geintjes zoals het onopengesneden laten van Oase-aflevering 34 gewijd aan Het interieur gaat hij niet uit de weg. Alles kan dienen om een vorm te creëren die haaks staat op het gang-bare idioom van de tijdschriftvormgeving in het segment waarin Oase zich ophoudt (De Gids, Kunst & Museumjournaal, Tirade etc.).

Deze experimenterende houding neemt hij van het vroege modernisme over. Ondanks zijn bewondering voor de doorge-rationaliseerde ontwerpmethodiek van het late modernisme, zet hij die houding in tegen de al te uniforme beeldtaal daarvan. Daarmee dient hij ook andere waarden dan pro-duktiviteit en efficiëntie. Martens is gaandeweg steeds minder geïnteresseerd geraakt in standaardisering. Bij hem blijft grafisch ontwerpen arbeidsintensief handwerk. Dit experimentele karakter wordt overigens niet van de daken geschreeuwd. Het gaat niet om opzichtige verbrekingen van gangbare codes noch om utopisch aangehauchte vernieuwing. Het experiment als romantische houding is hem vreemd, evenzeer een avantgardistische pretentie. Het gaat eerder om de bescheiden, onopvallende experimenteerlust van een ambachtsman die plezier in zijn vak houdt en vreugde schept in een werkstuk dat aan routine ontkomt. Martens' experiment is low key. Het richt zich op de materialen waarmee hij werkt, op de letters en stempels, op het papier en de inkten, op formaten en rasters, en op de vormen van het betreffende genre. De tactiele kwaliteit van het uitgevoerde ontwerp is voor hem niet minder belangrijk dan de visuele. Vergelijk de spelletjes die hij speelt met eenzijdig gestreken omslagpapier, waarvan hij het liefst de ruwe kant laat bedrukken. Iets van de knutselaar heeft hij ondanks zijn professionaliteit altijd behouden. Ontwerpen is voor hem nooit alleen arbeid in opdracht, maar een bezigheid waaraan hij verknocht is. Zijn experimenten dragen dus vaak het karakter van pro-beersels. Ze komen voort uit een speelsheid die niet met zichzelf te koop loopt, maar voortkomt uit het plezier van het doen. In elk nummer van Oase probeert hij iets nieuws, en de tot dusver verschenen afleveringen overziend, stellen we vast dat hij zo veel mogelijk ingrediënten variabel maakt. Het is een spel dat om inzet gespeeld wordt. Dit speelse ple-zier relativeert het onverflauwde moralisme dat zijn ontwer-pen kruidt, en doorkruist zijn scrupuleuze ontwerpethiek. Zijn ontwerpen zijn zuinig (niet te veel wit) en economisch.

Ook daarin toont hij zich een nazaat van het modernisme. Maar niet de historische beeldtaal daarvan ensceneert hij, hij deelt daarvan het inhoudelijk engagement en enkele ontwerpuitgangspunten. Kwamen in zijn werk van de jaren zeventig, met name in de omslagen voor de SUN-schriften, nog citaten voor uit de Bauhaus-typografie, zoals het expressieve gebruik van balken, formele verwijzingen naar zijn voorbeelden zijn sindsdien schaarser geworden. Het gebruik van diagonalen heeft Martens altijd vermeden. Hij had ze niet nodig om zijn anaxiale ordeningsschema's een air van beweeglijkheid te geven.

De tekst wordt niet gesacraliseerd, maar behandeld als voertuig van mededeling en kennis. Evenmin wordt de tekst geparachuteerd in een spektakel. Beeld en tekst worden door Martens nevenschikkend behandeld. En als tekst doorloopt in een foto, is dat het gevolg van een organisatie-probleem, niet van vormlust. Zo'n oplossing is beredeneerd. Ze berust vaak op het secuur bekijken van een beeld, niet op het verlangen om de tekst te degraderen tot ornament. Martens' vormgeving staat in dienst van tekstuele informatieoverdracht en komt niet tegemoet aan Schaulust maar aan het oordeelsvermogen van de lezer.

Afkeer van theatraliteit leidt tot sobere vormgeving. De ontwerper Martens is geen acteur die andermans teksten laat verdwijnen in de galm van zijn breed uithalende stem. Niet zijn persoon maar zijn houding en vakmanschap blijven herkenbaar in het product.

Voorkeur voor rechtlijnigheid leidde vroeger wel eens tot ge-ringe wendbaarheid, moralisme tot kraakheldere soberheid zoals in de vormgeving van de Shakers. Juist op dit punt zien we een evolutie in Martens' recente werk. De beeldbehan-deling is gevarieerder, gedurfder geworden, zonder voor de verleiding van een barokke sierlust te bezwijken. Een zweem van calvinisme valt niet weg te poetsen, maar het staat

133|134

Opposite page
Typographica was founded, edited and designed by Herbert Spencer. It became one of the most distinctive and respected international publications of the post-war years. It is important not only for its editorial content, but also because it played such an influential role in pioneering a modernist vision into British culture and, of course, graphic design in particular (1949).

This page
This book, designed by the Dutch graphic designer Karel Martins has used particularly small margins, and on the foredge virtually no margin at all. The book is perfect bound with each page being printed one side only and folded at the foredge. This provides additional bulk but also, and more importantly here, provides the control required on the foredge (remembering the close proximity of the text) that would not be possible if it were necessary for the book to be trimmed in the normal way. *Printed Matter \Drukwerk*. Published by Hyphen Press, London, 1996.

Manipulating Type

The appearance of letters had evolved with our written languages but was formalised in a sudden and rather dramatic way with the invention of printing. The arrangement of letters and where they are placed onto paper was also formalised. Subsequent technologies offering technical and/or economic improvements in printing and typesetting met the same requirements as these long-standing traditions.

The existence of well established traditions suggests that we prefer continuity; we like best what we already know. Continuity makes us feel comfortable and reassured. It would be gratifying to imagine that an intrinsic 'rightness' in classical (symmetric) aesthetics is the reason they are so firmly established in our culture. However, it is more likely that the reason symmetry is still prevalent is simply because we prefer that with which we feel comfortable, and we feel most comfortable with that which we know. The first printer-scholars were very much a part of the Renaissance, and it is *their* influences – the aesthetics of ancient Greece and Rome – which, surprisingly, still dominate the way the majority of books appear today.

However, the 20th century has seen this tradition severely tested. During the last 150 years, typographic control, for so long the mainstay of the printer's craft, has steadily been eroded. The 'craft' became an industry as typesetting and printing machines became faster and, economically, more efficient. The huge increase in printed, mass-circulation material, also led to the expansion of the advertising industry, which quickly recognised the limitations inherent in the printer's adherence to tradition. Printers, were still (but only just) holding on to an apprentice/journeyman system, which considered the rigorous defence of tradition as a means of upholding standards.

But commercial organisations increasingly required their promotional material to be novel and distinctive (although they would rarely venture as far as the unique). Not surprisingly, the burgeoning advertising industry, frustrated by the predictability of the printer's work, began to train their own typographers. These came to be known as commercial artists from which commercial art studios, eventually, grew a separate, *graphic* designer, who specialised in designing the whole, ever expanding, plethora of printed material which all large, increasingly international companies required to communicate across the world.

'Form follows function'; a primary axiom of the Modernist movement (not to be confused with the type classification of the same name!) is simply another way of saying that traditionalism is irrelevant. More than that, they considered it to be lazy. Function alone should govern how type is made to work. Moholy-Nagy, a prominent figure at the Bauhaus, listed what he considered to be the three primary considerations of the typographer:

1 *Clarity* is of overriding importance.
2 *Communication* should not be constrained by previous styles of presentation or preconceived aesthetic ideas.
3 *Integrity*: Letters and words should not be forced into arbitrary shapes.
These three 'primary' considerations need to be elaborated upon within a wider context.

1 *Clarity* requires consistency, and consistency establishes a pattern. As readers, we learn to anticipate and expect pattern to provide order as we generally do in life. A change, therefore, requires justification. The introduction of a change in the size of type or the amount of spacing, or for instance, the isolated use of uppercase, small caps or italic, signals the existence of a visual hierarchy. The function of such a 'system' should be to clarify meaning, or the structure of the text. In all these aspects, there is a rich vein of inspired common sense in the traditional applications of typography. However, typographers must maintain an open mind and take inspiration from *wherever* it originates. There can be nothing so boring as knowing how the solution will look before the question has been asked.

2 *Communication.* Certainly, every problem of communication requires its own solution. Communication occurs on two levels: implicit and explicit. Explicit communication occurs through the content of the words themselves. Implicit communication takes place through the manner in which explicit information is communicated; the choice of typefaces, their size and juxtaposition, the use of colour, texture, choice of surface and weight and, on screen, sound and movement. The explicit message should, in every way, be reinforced by the means (implicitly) created for its successful communication. The necessity of understanding and using what the reader expects, and the extent to which inherent conventions might be extended, is very much a *creative* role in the process of explicit communication.

3 *Integrity* comes from respect based on sound knowledge. Type is designed to be used within certain practical parameters. Outside these parameters it requires very careful adjustments to be made if it is to function properly. But function it can. In demanding circumstances: when used particularly large or small; when squeezed into narrow columns or into arbitrary shapes. When wrapped around an image or a three-dimensional object, type can still appear integral, integrated, and unforced. But to achieve this will inevitably require an extensive amount of time and effort.

This page above
An uppercase *Caslon* regular O
in its original state and expanded 200%

This page below
Metal type. 'Theories are elastic –
expandable and compressible; but types
have set dimensions and, in some cases,
refuse to budge.' Theodore Low De Vinne,
The Practice of Typography: Correct
***Composition,* published by The Century**
Co. New York, 1902.

Grid structure

The grid provides a rational basis upon which a set of recognisable and repeatable conventions can be arranged, enabling the reader to navigate the printed page. It also allows any number of individuals to collaborate on a longer or more complex project. The grid increases efficiency. These same practical aids are also the cause of the grid's reputation for inhibiting the freedom of the typographer to make individual choices. However, such complaints usually come from typographers having to work within a grid system that is not of their making! As a device, the grid is as simple or as complex, confining or liberating, as the originator needs it to be.

The grid structure of any spine-bound document is always devised as a double-page-spread (a typical pair of facing pages). Traditionally, the grid structure of a book was based upon the principles of Greek aesthetics incorporating the series of 'golden' ratios, principles which were rediscovered during the Renaissance. The ratio (1:1·618) helped establish the facing pairs of text areas plus margins at the head, foot, spine and foredge. The geometrically constructed grid structure has the advantage of requiring no calculations, the text areas being derived solely from the shape of the pages themselves. This also means that the proportion of text area to page area remained constant regardless of page size or its shape (see this page above).

The general visual appearance of the page resulting from this methodology is still much in evidence in contemporary book publishing, particularly where a single, continuous text (fiction, for instance) is the subject. Margins today are slightly smaller but, essentially, the relationship of spatial proportions remain the same (see page 96).

The influence and popularity of magazines, both in appearance and in the way they are used, can be seen in the growing market for random access books, designed and published to be looked at and dipped into, rather than read from beginning to end (in that order). Technology has made it so much easier (and cheaper) to present more complex and varied material in print that, offered the option, many authors accept the opportunity. In such documents, it is generally preferred that supporting material is accessible simultaneously with the main text. A grid structure, therefore, often needs to be designed which can accommodate far more flexibility than the traditional, single column of text per page. Each document certainly requires a grid structure to be designed that is specific to its purpose.

One of the key purposes of the grid is, of course, to carry texts. The requirements of the text – choice of typeface, size, weight, kerning and tracking – need to be addressed in conjunction with the grid design. Neither can be planned in isolation from the other.

A modern, basic grid structure, typically arranged in conjunction with the dimensions of the outer margins, subdivides the page into a number of smaller modules (or fields) which are separated by narrow intervals. The number of modules and their size will be determined by the nature of the text and images. If the document carries text only, the structure might be simpler, with the modules predominantly in the shape of columns. If the content is a more complicated mixture – for instance, including photographs, illustrations, diagrams, charts plus captions and references – then the grid might need to be broken into many more, smaller modules (see this page below).

Essentially, the grid provides the underlying structure upon which the various aspects of the document can be presented in a coherent and consistent manner. It is not necessary (or desirable) to use all of the modules all of the time. A consequence of the consistent application of textual and other material is that the effects of 'see-through' in fact reinforce the coherence of the document as a whole.

Opposite page
The establishment of text areas in relation to format. The top example is a geometrical structure that requires no measurements and is based upon the Golden Section. Point A, where the diagonals intersect, is one third of the way down and across the text block and the page (Jan Tschichold, 1955, after Villard de Honnecourt, circa 1280). The bottom example offers an approach favoured by the Swiss International Style typographers (modernists). The grid is arranged in conjunction with the dimensions of the outer margins and subdivided into three columns, which, of course, might be subdivided into six or twelve for additional flexibility. (See Spencer's *Penrose Annual*, page 104.)

This page
Graphic Design in Swiss Industry was the third in a series of books from ABC Publishers, Zurich, in 1965. The series represents very clearly the development of technical aesthetics as the structural basis of visual information. The aim is objectivity regarding information relating to the product or the service. The inference is that this is not selling, but informing. It has a four-column grid. The majority of the images take up two columns. The text is presented in three languages, each occupying a column of its own. All the margins and the space between the columns are the same (10mm) except for the back margins (which are approximately 20mm). Designed by Walter Bangerter; author, Hans Neuburg.

extraordinary output but, increasingly, able to cope with page make-up. Setting in metal is already on the decline; but it would be unrealistic to write off metal type completely. It will be used for a long time yet, though in an increasingly narrower field.

Enormous increases in the output of filmed text will positively demand a corresponding increase in the speed of other processes, leading eventually to almost total automation. It may therefore be expected that the present moves toward automatic processing of one kind and another in the plate-making side will be sharply stepped up. The entry of newspapers into the web offset litho area has, in fact, provided the basis for great changes, which would not have occurred if lithographic printing had remained only a small segment of the industry. It is not merely that newspaper production provides fertile soil for new automation ideas, but since many newspaper printers are former letterpress men, they welcome readily anything which takes the mystery out of lithographic printing. What they would like, and what is in the offing, is a system which will automatically process the lithographic plate completely, right up to the press. Cutting, binding, packing and delivery methods – indeed all ancillary processes – will be automated as far as possible because no one stage of mass-production can be allowed to hold up the continuous flow. Mass production implies that an identical product is being manufactured in large quantities. An elaborate and expensive plant is justified only if there is a regular flow of this kind of work. Such a flow can be provided if the plant is part of a large publishing complex which markets extensive reference works, popular periodicals or newspapers or both. Independent printers may have to decide what kind of plant they can afford to run. If they have the capital and decide on a large automated plant they may well have an assured flow of work (in normal economic conditions) because the publisher of books in large editions and of popular periodicals, who has no captive plant, will have to use their services to keep his costs down in a competitive market. He will not be able to afford to give his work to the medium-sized printer working with traditional methods. Here a cautionary note. Many printed products are not manufactured in large quantities. As long as the need remains for the multifarious items of printing used in a free society, there will be a small printer to satisfy it. The medium-sized printer will more and more have to make up his mind where he stands. If he has a profitable speciality or his own captive work, he can probably carry on, but if he is in direct competition with both large and small printers he will have to analyze his position more exactly. Structural change in the industry will no doubt proceed erratically, but the closing down of uneconomic plants, mergers, re-deployment and all the other manifestations will continue, and it may eventually become

128

The Harris-Intertype Fototronic disc, above, and the Photon/Lumitype disc, right.

possible to draw a very clear line between printing 'industry' and 'trade'; the first based on technicians and mass-production for general consumption; the second on craftsmen and bespoke work. For some time the conventional surplus equipment thrust on to the market by both tendencies – the move to new techniques by the bigger firms and the gradual shrinkage of the middle-ground – could hold up any substantial technical changes in the 'trade' section. If good conventional equipment is going comparatively cheap and a labour force is accustomed to its use, the temptation will be to carry on as before, particularly if competitive prices can still be quoted. This cannot go on for ever, but much equipment is so well made that, unless there are innovations so remarkably advantageous economically that few would dare to ignore them, we can expect to see in ten years time jobbing printers working in much the same way as today.

The most radical so far of the changes in printing techniques can now be considered: the move from metal type to photosetting. Photosetting is nothing new and the first machines taken up commercially were not greatly different from the hot-metal machines on which they were based; they used similar keyboards but with a film 'matrix' – a negative character – instead of the indented character in a piece of metal. The next stage has consisted of electronically-controlled systems employing keyboards which produce punched tape for the operation of high-speed photo units carrying a whole 'fount' of negative characters on plates, disks, grids, revolving drums and the like (even an 'hour glass' in the PhotoTextSetter). At least six mechanisms of this kind, some in specially

129

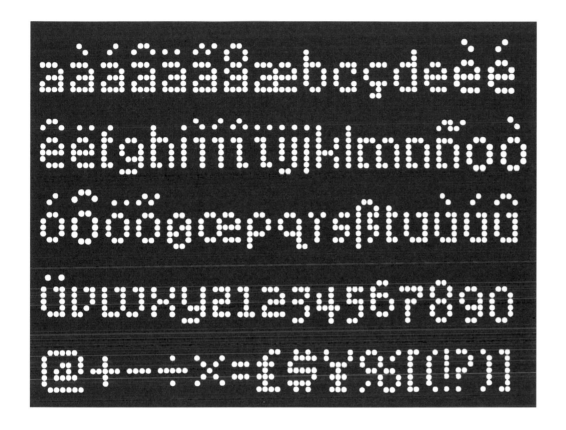

Opposite page
The Penrose Annual (number 62) 1956, designed by Herbert Spencer using *Times New Roman* and a three-column grid.

This page above
A sketch proposal for a grid-based system capable of carrying multilingual public information, specifically in airports, termini, and motorway gantries. This is a variant-width alpha-mosaic character-set based on columns of nine on/off light-emitting diodes. Shown here are the fifty lowercase characters with which to cover at least ten European languages. Also shown are ten non-lining numerals and ten pi-sorts. Typographical engineering project by Clive Chizlett.

This page below
New Alphabet, designed by Wim Crouwel. It was in 1967 when the first electronic typesetting devices were appearing on the market, that Crouwel 'saw the horrible type coming out of those first-generation machines'. His answer was a single alphabet (eg not upper- and lowercase) something already explored by Herbert Bayer, Jan Tschichold and Kurt Schwitters. To avoid the jagged edges that distort curved lines composed with cathode-ray tubes, he used a grid of horizontal and vertical lines. This also had the advantage of characters remaining the same regardless of size. All characters are of common width. (The full alphabet is illustrated on page 70.)

Textual layout

Symmetrical setting appears deceptively simple; commonly consisting of only a central axis with surrounding margins. Viewed as a double-page-spread, the central axis becomes the binding, joining the pages together at the centre of the spine-margin. The individual pages themselves are only symmetrical to a point. Because we read words left to right, this affects the text in various subtle ways, but most profoundly at the beginning and ending of paragraphs. It is commonly stated that symmetrical setting tends to be static whilst asymmetrical setting tends to be active. Similarly, symmetry equals unity and asymmetry equals variety. Such theories are too simplistic. Good typography is that which is appropriate for its purpose and is produced with due care, both to the arrangement of disparate parts and to details. Theories which pre-empt appropriate solutions should be treated with caution.

If text is set *ranged left* to form a straight vertical at the left edge of the text area with a ragged edge to the right – as in this book – the word spaces can remain constant, unchanged. If the text is *justified* – straight vertical edges left and right of the text area – the word spacing will have to be adjusted. In either case, the interword spacings should, as far as possible, remain constant in their size. This, of course, is easy to achieve with ranged-left setting, but it is a skillful and time-consuming activity if the setting is justified (see page 92).

In ranged-left setting, the aim with the ragged line endings should be to achieve a 'natural' ripple. It should not, at any time, be apparent to the reader that the line endings are anything other than natural conclusions. Perversely, to achieve this, ragged line endings often need considerable adjustment. However, if they appear forced in any way – for example, lines too similar in length, achieved by having to use rather more hyphenated words than is preferable – the attention of the reader will be diverted from the text to typographic mannerisms. Equally, the ragged edge cannot be ignored in the hope that this will result in a 'natural' ragged line. Regular patterns appearing in the line endings, or any particularly short (or apparently long) line will distract the reader and will therefore require adjustment.

A common problem specific to ranged-left setting is that of very short (single or two character) words at the end of a line which itself is longer than the lines above and below. Such a situation can isolate the very short word from the main text. This phenomenon is made worse if the word preceding the very short word ends in line with the last words on the lines above and below (see below). This creates a vertical white 'river' and only serves to emphasise the isolation of the short word. In such cases (and even where the situation is not as grave as that just described) small words, particularly I, and a, unless at the end of a line which is between two longer lines, should be carried over to the following line.

Unfortunately, text looks just as bad having three or more lines beginning with the same or similar short word (again, causing a white vertical 'river') as they do at the end of the line. Judicious manoeuvring is required where such circumstances arise.

Exactly the same problems can happen in justified setting. The solutions are very much the same except that in justified setting dropping a short word down to the next line will have to be weighed against the effect upon the general evenness of word spacing.

Except where used for headings or, perhaps, in relation to illustrated material, flush-right (ragged left) settings should to be avoided, since the starting position of each line is unpredictable and, therefore, adversely affects reading efficiency. Where ranged-right setting is necessary reading will be made easier with fewer words per line.

There is a general rule that sans serif faces look better ranged left, whilst serifed faces are best justified. I cannot think of any reason for this other than habit; ranged left being an arrangement augmented in the 20th century which coincided with the rise in popularity of the sans serif.

we | like best what
we | already know and
we | like least that which
we | don't recognise.

we like best what | we
already know and | we
like least all that
cannot be easily
understood.

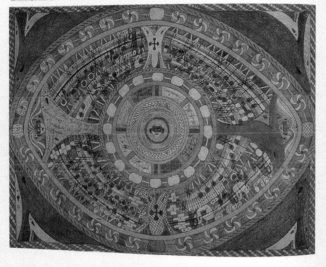

> Although Wölfli was not active as an artist before the onset of his illness, he must be viewed as an artist who happened to become afflicted with a psychosis. The illness did not awaken any creative capacities that were not already part of his personality. His social origins, however—his life of great poverty and social regimentation as an orphan, hireling and labourer—never permitted him even to think of becoming an artist. His entire life story proved as fateful as his illness and internment.

Opposite page
The isolation of short words that extend beyond the line endings of the previous and the following lines causes the ragged edge to appear particularly untidy. However, when rectifying such problems rivers must be avoided at the left side of the column.

This page
This is one of an eclectic series of large-format books published by Phaidon. *Raw Creation* was designed by Phil Baines. New paragraphs, indicated with a ¶ are set in a column under the position where the previous paragraph ends. Quotations within the body of the text are set in a dramatically increased size and run the full width of the gridded text area. Horizontal rules escort the eye to the foredge of the page where the 'footnotes' are positioned to run vertically.

PEARL FIGURES.

F1-5—5½ Set. 7 Unit. ·1173	12-5—5½ Set. ·1200	F18-5—5½ Set. ·1295	26-5—5½ Set. ·1173

RUBY FIGURES.

F29-5½—5½ Set. ·1218	F1-5½—6½ Set. 7 Unit. ·1240	12-5½—6½ Set. ·1240	16-5½—6½ Set. ·1240

F35-5½—6½ Set. 7 Unit. ·1103	F36-5½—6½ Set. 7 Unit. ·1316	F38-5½—6½ Set. 9 Unit. ·1105

F39-5½—6½ Set. 9 Unit. ·1325	F48-5½—6½ Set. 18 Unit.

Decimal Figures give Line of Face.

Tabular and tabled layout

All tables, unlike textual layout, work on two axes – vertical and horizontal, but they don't all present information in the same way. In a statistical table, for instance, the reader may need to compare one number against another, whereas in a timetable the need is to identify a particular route-number, time, interim halts, or termination. These considerations will dictate the direction in which the table is read.

Exceptions are tables such as those which provide distances between cities; the answer being where the two axes meet. But most tables have a bias in one direction. It helps the reader if this bias is emphasised, perhaps by the use of fine rules.

Tables do not have to be in the same typeface as the surrounding text. If, as is often the case, the table contains a lot of numbers then a typeface should be chosen with clear, open numerals. In tabular work, where numerals will be read in continuous lines or columns, and particularly if the type size is small, it might be preferable to use lining numerals which will provide a clearer horizontal axis.

Wherever possible, always present tabular material vertically; it is annoying for the reader to have to turn the document through 90 degrees to read a table. Also, avoid allowing a table to run over to the next page.

Balance Sheet

		24 June 1945	24 June 1946	
Permanent Expenditure				
		12 676	164 838	Freehold Properties (as valued by Mes ... completion, plus additions at cost)
		3 868 404	3 868 404	Leasehold Properties (as valued by Me ... completion, plus additions at cost; ...
		42 000	35 000	Artesian Wells & Water Treatment P ... less amount written off)
		5 335	4 793	Air Raid Shelters (at cost less recoveri ...
		128 714	128 714	Property Suspense Account (Balance a ...
		90 000	89 502	Contributions under War Damage Act ...
		4 147 129	4 291 251	**Total Permanent Expenditure**
Loan Capital				
	233 055		229 335	5% First Mortgage Debenture Stock (...
	309 789		303 165	4% First Mortgage Debenture Stock (...
	500 000		500 000	4% First [1945] Mortgage Debenture ...
	671 827		665 169	5% 'B' Mortgage Debenture Stock (re ...
	1 714 671		1 697 669	Total Mortgage Debenture Stocks
	1 225 405		1 342 634	Mortgages & Loans secured on specific ...
	2 940 076		3 040 303	**Total Loan Capital**
	74 182		78 700	Premiums on Mortgage Redemption F ...
		2 865 894	2 961 603	
		1 281 235	1 329 648	**Permanent Expenditure less Loan** ...
		16 670	19 504	Leasehold Redemption Fund *deducted* ...
		1 264 565	1 310 144	
		6 235	6 201	Furniture, Fixtures etc (at cost less de ...
		48 000	48 002	Investments in Subsidiary Companies (...
		1 318 800	1 364 347	
Current Assets				
	110 220		19 005	Cash at Bankers & in hand
			20 000	Tax Reserve Certificates
	84 286		93 412	Debtors (including estimated amount ...
			498	Amount due from Subsidiary Company ...
	9 945		8 730	Stocks
	15 986		18 542	Rates etc in advance
	220 437		160 187	**Total Current Assets**
Current Liabilities & Provisions				
	26 043		23 395	Accrued Interest on Mortgage Debent ...
	128 000		100 960	Taxation on Revenue to date
	102 662		87 706	Creditors, Specific Provisions & Accru ...
	41 474		49 586	Amounts due to Subsidiary Companies ...
	100 000		100 810	Provision for Repairs, Redecorations & ...
	398 179		362 457	**Total Current Liabilities & Provis** ... uncompleted building)
		177 742	202 270	**Excess of Current Liabilities & Pr** ...
		£1 141 058	£1 162 077	**Net Balance representing Shareho** ...
Capital fully paid				
		500 000	500 000	6% Cumulative Preference Stock (div ...
		100 000	100 000	6% Cumulative Second Preference Sto ...
				6% Cumulative Second Preference Sha ...
		400 775	400 775	Ordinary Stock
				Ordinary Shares of £1 each
		1 000 775	1 000 775	**Total Capital**
		140 283	161 302	**Revenue Account Balance**
		£1 141 058	£1 162 077	

Report of the Auditors to the Me ...

We have audited the above Balance S ...
have required. In our opinion such ...
correct view of the state of the Con ...
explanations given us & as shown by th ...

Revenue House, 7/8 Poultry, London ...
19 September, 1946

Opposite page
An early Monotype catalogue, circa 1920s.

This page
Anthony Froshaug. Financial accounts for Associated London Properties, 1945–46. Froshaug experienced considerable difficulty, and not a little resentment, when presenting his precisely annotated type specifications to the British Printing Trade. Both this, and its hand-rendered type specification on tracing paper (a virtual copy of the final, printed version) are held by the *St Bride Printing Library*.

Paragraphs

The start of a new paragraph is usually signalled by indenting the first line by one em. If the text is set to a wide measure – and particularly if the lines are closely set – then a slightly wider indent might be preferred.

To indicate a new paragraph, it is often not a clear enough signal to rely on the remaining line of space following the last word of the previous paragraph since, occasionally, such spaces do not occur. This is the case with both justified and ranged-left settings. It is, of course, easy, particularly with ranged-left setting, for the typographer to make the necessary adjustments to the text to manufacture such spaces, but even so, if a non-indented paragraph begins at the top of a new page, doubts as to whether it is a new paragraph or not will cause the reader to turn back and check the last line of the previous page. The likelihood of this being a regular problem decreases as the average word-count per full line increases.

There *are* alternatives. If an unbroken text is preferred then the paragraph mark (¶) can be used, allowing the text to flow continuously. (Other ideographs can be used if preferred. See page 54.) However, a page with no obvious break, particularly a large area of text, might present a daunting, rather uninviting, prospect to the reader. Alternatively, paragraphs can be separated by one clear line space. This should be reserved for situations where the line length is shorter. (Indents within narrower ranged-left settings can give the text the particularly untidy appearance of being ragged at *both* edges.) One-line spaces suggest a longer pause and separate the text into a series of shorter 'bite-size' lengths, and so ought to be reserved, perhaps, for text of a more technical nature.

Again, this arrangement can occasionally create doubts as to whether the start of a new sentence at the start of a new column is also the start of a new paragraph. In this book, any paragraph that cannot be fitted, complete, into a column is transferred, whole, to the next. But separating paragraphs by anything less than a full line creates problems of a different kind, leading to text columns of uneven depth; non-alignment on facing pages.

The exception to this rule concerns supporting texts, such as captions and reference material. These items are usually set in a smaller type size than the main text and consequently the line-lengths are normally shorter. In such material there may be a need to differentiate between captions and paragraphs within captions. At small sizes and short line lengths, indents of one em or similar are often not distinctive enough to signal a new paragraph, and, as already stated, can look untidy in short-lined, ranged left setting. Alternatively, one-line spaces might be reserved for distinguishing between captions. In such circumstances, a small amount of additional leading will be sufficient to signal a new paragraph without losing the overall shape of the text.

If an indented paragraph begins with a quote-mark, then the width of the indent will need to be reduced slightly to make the indent appear, visually, of the same value as all other indents. There is, of course, no need to indent the first line of the first paragraph after a main heading or any sub-heading.

CALL FOR ENTRIES

The competition: The Type Directors Club is an international organization founded in 1946 whose members include design professionals, typographic designers, and typophiles. This year will be TDC's forty-eighth open Call for Entries in its international competition which recognizes excellence in the use of typography, calligraphy, handlettering and other letterforms. All entries will be judged by a panel of distinguished designers in January 2002. Winning works will be exhibited in six traveling shows and published in *Typography 23*, the hardbound, all-color competition annual designed by design: m|w. The annual is published by Hearst Books International and sold worldwide.

TDC48 JURY

Peter Bain is principal of Incipit in Brooklyn, New York, a firm specializing in typeface design, logotypes, custom lettering and typographics. He served for many years as type director of the ad agency Saatchi & Saachi.
Mirko Ilić, a native of Croatia, established his graphic design, 3-D computer graphics and motion picture title studio in New York City, 1995.
Sarah Nelson has been a designer at Werner Design Werks in Minneapolis since 1995, working in areas from book design to corporate ID programs.
Marion English Powers is a design director of Slaughter Hanson in Birmingham, Alabama, a firm serving national and international clients with a major emphasizes on non-profit organizations.

George Tscherny, designer, teacher, typographer, former president of the AIGA and member of the Art Directors Hall of Fame is a native of Hungary. He heads his independent design office in New York City.
Kurt Weidemann, teacher, graphic and type designer (ITC Weidemann) was a student of Ernst Schneidler and became professor at Stuttgart's Academy of Fine Arts in 1963. Since 1991 he teaches at the College of Design, Karlsruhe, Germany.
Allison Muench Williams, founded the New York City based design : m|w with partner J. Phillips Williams in 1993. The firm is the designer of TDC48 Call for Entries and of the upcoming *Typography 23*.

Opposite page
**Call for entries from the Type Directors Club
(New York). An A2 poster which delivers
its information as the poster is unfolded.
The information throughout was written
so that it was appropriate for each
paragraph to begin with the first word
or phrase printed red.**

This page
**Paragraphs indicated by hanging the first
line. Plenty of space, of course, must be
allowed between columns, but on a page
such as this, with generous proportions of
white space, such demands are comfortably
met. However, it can be problematic when
the second word of a new paragraph aligns
with the left side of the column of text,
effectively isolating the first word. From
Typography: Macro- +Micro- Aesthetics,
written and designed by Willi Kunz,
published by Verlag Niggli AG, 2000.**

22

A case for Univers

In connection with my work, I am often asked why I prefer
Univers not only to serif typefaces but also to other sans
serifs such as Futura, Gill, or Helvetica.

My own preference for Univers begins – but does not end –
with its still-contemporary form and its comprehensive
series of fonts. In the early 20th century, the vehement and
animated debate between proponents and opponents of
the new sans serif type required typographers to take
a stand for one side or the other. Today, the issue of serifs
versus sans serif is no longer of aesthetic relevance
or ideological interest: the decision to use one face or the
other is better made on the basis of functionality and
appropriateness.

Traditionalists argue that serif type is more readable than
sans serif. While this may be so with lengthy text,
readability is in most cases less a function of the presence
of serifs in the typeface than of other factors: namely
type size, weight, and slant; line length and interline
space; paper, printing, and reading conditions. In fact, the
most important determinant of legibility (clarity and
efficiency in reading) and readability (pleasure and
interest in reading) is not the particular typeface but the
arrangement and structure of information.

Throughout my professional career, I have worked with
many sans serif typefaces; among them all I have found
Univers uniquely versatile. Univers has neither the
rigid forms of Helvetica nor the geometric constructions of
Futura; unlike Gill and many other sans serif faces it
comprises a series complete in terms of weights as well
as widths. Univers, moreover, is quietly refined in
its visual details; nothing extraneous detracts from the
essential form of individual letters. The upper case letters,
which are only slightly heavier than lower "read" dis-
tinctly but unobtrusively in lengthy texts.

Univers was created in the early 1950s by Adrian Frutiger,
a Swiss type designer with a profound knowledge of the
history of type and print technology. The first typeface
ever conceived as a complete series, Univers consists of
21 fonts, with Univers 55 serving as the primary font

from which the other 20 were developed. Univers 55
manifests all the characteristics of a good text typeface. Its
large x-height with short ascenders and descenders
makes the font compact yet readable in small point sizes.

Univers was designed as a matrix with 55 at the center: to
the left are expanded fonts, to the right condensed; above
light, below bold. Each font is identified by a two-digit
number. The first digit indicates weight, the second slant;
roman is indicated by odd numbers, italics by even.
Inherent in this matrix of 21 fonts are countless possibili-
ties for visual contrast in typographic design.

Since the introduction of desktop publishing, several Univers
fonts were deliberately altered in their conversion to
digital form by software manufacturers. In particular, the
desktop versions of Univers 47, 57, and 67 are consid-
erably wider than their originals, consequently weakening
the contrasts between different widths. Nevertheless,
Univers remains, in my opinion, unequalled for its com-
pleteness, versatility, and aesthetic distinction. Especially
in the late 20th century when novelty is unhesitatingly
embraced and typefaces can be created on a whim,
it is hard to imagine a typeface so thoroughly conceived
and executed as Univers.

Univers, of course, is not the only typeface suitable for
use in typographic design. Variety is necessary – and
desirable. Choosing a typeface is a process of elimination
based on whether the macro- and microaesthetic qualities
of the typeface are appropriate to the purpose of the
communication and its context of use. Even after carefully
considering all of these factors, though, a number of
typefaces might be suitable for any given problem.
Ultimately, the final choice of typeface is a question of
personal preference and taste.

All typefaces serve fundamentally the same purpose: to
communicate. The purpose behind the communication –
for example, to inform, to entertain, or to persuade – is
expressed, in part, by the typeface chosen. As the
communication objectives change, so might the typeface.

Depending on its context of use, different criteria must be
applied when selecting a typeface. When used in display
size on a poster, typefaces are evaluated on purely
aesthetic criteria: how the qualities of the letterforms, in
that particular size, interact for that particular set of words.

III.4

rekening maakt en fouten die te wijten zijn aan drift? Maakt men die laatste dan niet uit eigen beweging? Jawel, maar men moet ze allebei vermijden. Men is het er trouwens over eens dat onberedeneerde fouten net zo menselijk zijn als andere, en bijgevolg zijn ook handelingen die voortkomen uit drift en begeerte eigen aan de mens. Het is dus absurd te beweren dat men die handelingen tegen zijn zin verricht.

1111 b

4 VOORTREFFELIJKHEID VAN KARAKTER VERONDERSTELT EEN KEUZE

PROHAIRESIS

Hiermee hebben wij gespecificeerd wat het is spontaan en uit eigen beweging of opzettelijk, en tegen zijn zin of onopzettelijk te handelen. Het volgende punt van bespreking is de bewuste keuze.[8] Naar men immers aanneemt is er niets dat nauwer samenhangt met voortreffelijkheid en vormt zij een nog betere toetssteen van iemands karakter dan zijn daden.

1111 b 5

Welnu, het is duidelijk dat men uit eigen beweging handelt als men een keuze maakt. Toch vallen die twee begrippen niet samen: het begrip 'uit eigen beweging' is ruimer. Ook kinderen en dieren kunnen namelijk uit eigen beweging handelen, maar ze kunnen geen keuzen maken. En van handelingen die men in een plotselinge opwelling verricht kunnen we wel zeggen dat men ze uit eigen beweging verricht maar niet dat ze berusten op een bewuste keuze.

1111 b 10

Er zijn mensen die keuze identificeren met begeerte, drift, wens of een bepaald soort mening, maar die lijken het niet bij het rechte eind te hebben. Redeloze wezens hebben immers wel begeerten en driften maar niet het vermogen keuzen te maken. En een onbeheerst mens[9] doet wat hij begeert maar niet wat hij kiest; een beheerst mens daarentegen doet wat hij kiest en niet wat hij begeert. Verder kan men het tegendeel kiezen van wat men begeert, maar men kan niet op een en hetzelfde ogenblik het tegendeel begeren van wat men begeert. En begeerte heeft betrekking op wat aangenaam en onaangenaam is, een keuze noch op het een noch op het ander.

1111 b 15

Nog minder is een keuze te identificeren met een drift. Wat men uit drift doet, dat weet men, is allerminst het resultaat van een keuze.

onthuld aan oningewijden. 6 Volgens Euripides (*Medea* 1077-1079 en *Hippolytus* 380-383) handelt de mens niet verkeerd uit onwetendheid, maar omdat hij aan zijn passies weerloos is overgeleverd. Zijn irrationele neigingen zijn sterker dan zijn rationele overwegingen. 7 Zie Aristoteles, *Ethica Eudemia* 1223 a 29-36. Men kan het argument aanvullen als volgt. Handelingen die een aangenaam gevoel geven verricht men graag. Handelingen die beantwoorden aan iemands begeerte geven een aangenaam gevoel. Dus handelingen die beantwoorden aan iemands begeerte verricht ▶

TEAL TRIGGS due to increased dynamic range, raise the volume above average: PLAY IT LOUD

As a professional body, the Society has and must maintain a watchful eye on the Assessment Scheme's educational content and its industrial relevance. The Scheme has an international reputation for the standard it maintains and industry recognises it as an exemplar of quality. There has been change, and there will continue to be changes in working practice and technical innovations together with shifts in trends and culture. They must all be recognised so that the educational policy of the Society matches the needs of both the student and their future employer.

New Consumer Paradigm (1)

TECHNOLOGY HAS BECOME HIP (2)

Advocates of new technology tells us that 'education is entering a new era' (3). Computers are firmly established in every classroom, from early pre-school learning centres to higher education institutions. Students are now rising through the educational ranks with a high degree of computer literacy. Meanwhile, tutors find it increasingly difficult to keep up with the latest software developments. Recently in the *Times Higher Educational Supplement*, Chris Hutchison warned us that while we are being seduced by 'glorious technologies' in educational environments, we must also take time to think through the 'social and pedagogic implications.' (4) Computers have redefined traditional working relationships and standard teaching practices. In this period of transition thoughtful educators have raised difficult questions: should they teach ABOUT COMPUTERS, OR THROUGH COMPUTERS, OR BY THE WAY OF COMPUTERS (5)

In certain ways the computer has become a 'natural' extension of the physical self. We appear to be plugged in permanently with the mouse as an extension of our hand, the keyboard our fingers, and the screen, our eyes. The next logical, if fanciful, step is the virtual realm where the screen is accessible to total sensorial interaction. 'Virtual classrooms' with online electronic resources are not as distant as we might think. In the United States increasing numbers of university professors deliver classes on the Internet. For example. The World Lecture Hall web site housed at the University of Texas at Austin provides links to a wide range of courses ranging from Advertising Design Inquiry, Internetting Skills to Cyberspace Composition. Each course provides access to specialist tutors from all over the country who 'hand-out' course syllabi, assignments, and lecture notes, as well as provide online tutorials and examinations. Courses on the Internet related specifically to art and design are currently under development by academics in Germany and the United Kingdom as part of the Erasmus (Socrates) programme. 'Deliberations' is a new site devoted to teaching and learning issues in art and design for tutors who are interested in developing their teaching skill base in the non-virtual world. Online access means they can engage actively with educators from Middlesex University to discuss art and design teaching methods and learning strategies

Temporal Ghetto (6)

A GOOD PIECE OF TECHNOLOGY DREAMS OF THE DAY WHEN IT WILL BE REPLACED BY A NEWER PIECE OF TECHNOLOGY. THIS IS ONE DEFINITION OF PROGRESS (7)

Technology is ephemeral, but determining and defining forces of the 'machine age' have given way to a 'post-machine' age where technology has supported a new 'information culture based upon instant communication services' (8). Conventional forms of communication technology have included the telegraph, telephone, and more recently the fax machine. Entry into the digital computer domain has created new devices. As each new device is superseded, the way in which people think about, send and receive information is reassessed. As designers grasp increasingly more sophisticated and highly complex systems and structures, new ways of representing ideas and information, either through text or image, must be found which are appropriate to that medium (9)

1 New Consumer Paradigm is advertising speak on the Internet for 'market'

2 Clifford Stoll, *Silicon snake oil: second thoughts on the information highway*, Ten Books 1995, p.xx

3 Chris Hortanewon, 'Surves in the chartered circle' *Times Higher Educational Supplement* 22 April 1996, p.iv

4 ibid.

5 Theodore Roszak *The cult of information: the folklore of computers and the true art of thinking* Lutterworth Press, Cambridge 1986, p.50

6 Computer slang for the particular mental space entered into while stuck in the past

7 Douglas Coupland *Microserfs* Flamingo, New York 1995, p.179

8 Margaret Dewitzer *Multimedia concepts: art and artists in the age of electronic media* Prentice Hall, Englewood Cliffs 1992, p.76

9 Alan Kay argues in 'The initiative is Not the Answer' *Wired* May 1994, pp.76–77, that we ...NEED A BETTER SENSE OF HOW TO TRANSCEND THE PSYCHOLOGICAL AND SOCIAL LIMITATIONS OF BEING HUMAN in order for change to be positive

While the computer has enabled a greater freedom to explore conventional forms of communication and visual expression, the digital realm has opened up new possibilities. Interactive design and the structure of new information and communication networks (eg the Internet, e-mail and discussion groups) presents new conceptual and practical opportunities for graphic designers and typographers. Within these networks, information has become a valuable commodity (10). This is especially true within the international corporate realm. As information increases in value, so too do the designers who are trained to create new visual digital landscapes.

The greatest scope for developing visual design would appear at the moment to lie in developing new and appropriate visual languages for screen-based media. There is also great scope for experimenting with new communication models. Some critics proclaim that the digital computer will bring us to the 'end of print' while others compare its importance to the advent of the printing press. The visual and verbal language employed by designers for use on the computer does not necessarily belong in either the print or digital worlds; the language is conceptual - perhaps a meta-language. The way we think about and represent ideas and information is fundamental. It is the application of this language to the 'new' computer medium that is still fluid. Computers may allow rapid access to information, but this is no substitute for the creation of ideas. This is where educators can make this their greatest contribution, or as Theodore Roszak explains, the role of educators is to...TEACH YOUNG MINDS HOW TO DEAL WITH IDEAS: HOW TO EVALUATE THEM, EXTEND THEM, ADAPT THEM TO NEW USES... (11) When graphic design educators come to review their curricula, this component must remain in the foreground and receive proper emphasis. A balance must be achieved between developing ideas and the pragmatics of technical training if we are to achieve the desired result

Chip Jewellery (12)

Numerous heated debates questioning the computer's function within communication, typography and graphic design production have arisen. Despite increasing sophistication, some still argue simplistically and dogmatically that 'creativity emerges out of technology'. Others who are more sober advocates see the computer as an integrated 'tool' of the design process. Legibility and readability, visual aesthetic, function vs decoration, designers as authors, are all issues which evoke great passion and are some great distance from resolution. Whatever the discipline, the computer is recognised as a standard and accepted object of every graphic design studio and, for the moment, every design educational institution

10 The notion that information is a new and valuable economic consideration is discussed by a number of authors including Theodore Roszak

11 Theodore Roszak *The cult of information*, p.50

12 Computer jargon for old computers destined to be scrapped or turned into decorative ornaments

Opposite page
It is not necessary to indent the first line of the first paragraph but in the design of this text, the indented first paragraph aligns with the 'indented' chapter title. Designers: Rudo Hartman and Den Haag. The book is *Aristoteles,* the typeface *Aldus,* published by Historische Uitgeverij, Groningen, 1999.

This page
TypoGraphic, designed by Phil Baines, 1996. Each paragraph of the text starts with a new column. The strong vertical line indicates the beginning of a new article. The paragraph top left is, therefore, the last paragraph of the previous article. The full point was omitted from the last sentence of each paragraph.

Alignment

Textual setting

The shape of certain type characters means that when trying to create the visual effect of lines of text all starting and, perhaps, finishing on a vertical edge, positional adjustments sometimes need to be made.

Characters such as A, T, W and Y are usually pre-kerned by the type designer to stand a little more to the left at the start of a line (or whenever a space precedes them). In normal text setting this should be sufficient. Other characters, however, will need individual attention. Punctuation, such as dashes and quote marks, occupy so little of the space they are allocated that when they appear at the beginning of a line they present the visual equivalent of an indent. In such circumstances these need to be 'hung'; that is, repositioned so that they partly overhang the main column of text. The extent to which they hang depends upon the character. The aim is to achieve the illusion of a straight edge (see below). If the hang is obvious – when the page of text is viewed as a whole – then it has been over-hung! If the line still appears indented then it is under-hung!

With justified setting, the same requirement for optical alignment also occurs at the right-hand edge, except that there are far more 'problem' characters. Hyphens and dashes, full points, commas and quote marks all need to hang slightly outside the right-hand side of the column if the text is required to visually align. Such adjustments are time-consuming. The typographer is bound to ask; is this really necessary? The aim is to make everything – including the edges of columns of text – look unexceptional. If no-one notices – the task has been successful. However, a jagged column edge, which is intended to appear straight, will certainly make the column of text appear untidy, uncomfortable and therefore intrusive.

The general public can be remarkably forgiving in matters concerning textual layout, and are, perhaps, becoming more so as information media continue to fragment. But, with most texts, and in the majority of circumstances, the typographer's task is to present text in its most fluent and unobtrusively readable form.

Display setting

Exactly the same rules of alignment apply to display setting as to textual setting, except that, due to larger sizes, the adjustments are all the more imperative. The nature of display material and where and how it is used, however, offer many more opportunities. Alignments are not restricted to left and/or right margins, but can be created from the vertical strokes within the characters themselves or positioned to align with other elements. The edges of photographs or illustrations or prominent forms within images themselves can be used to position and align display text.

These will need to be 'hung'; that is, positioned so that they partly over-hang the main column of text.

This page
Visual alignment accomplished by 'hanging' the cap T and the quote mark.

Opposite
John Cage, American composer and philosopher, delivers his lectures as a recital rather than a speech, using, for example, pitch, rhythms and (famously) silences to punctuate his statements. When this, the first book of his lectures, entitled *Silence,* **was published, each transcript of each lecture was typographically arranged to suggest the way Cage delivered it. In this case, the alignments running vertically provide a visual account of its rhythms and its silences. 'Seeing' the lecture in this way on the page, provides a clear rendition of its structure that might not have been perceived by the audience. Typographer (surprisingly) is not credited. Published by Calder and Boyars (London), 1968.**

This lecture was printed in Incontri Musicali, *August 1959. There are four measures in each line and twelve lines in each unit of the rhythmic structure. There are forty-eight such units, each having forty-eight measures. The whole is divided into five large parts, in the proportion 7, 6, 14, 14, 7. The forty-eight measures of each unit are likewise so divided. The text is printed in four columns to facilitate a rhythmic reading. Each line is to be read across the page from left to right, not down the columns in sequence. This should not be done in an artificial manner (which might result from an attempt to be too strictly faithful to the position of the words on the page), but with the* rubato *which one uses in everyday speech.*

LECTURE ON NOTHING

I am here , and there is nothing to say .

If among you are

those who wish to get somewhere , let them leave at

any moment . What we re–quire is

silence ; but what silence requires

 is that I go on talking .

Give any one thought

 a push : it falls down easily

; but the pusher and the pushed pro–duce that enter–

tainment called a dis–cussion .

 Shall we have one later ?

 ♍

Or , we could simply de–cide not to have a dis–

cussion . What ever you like . But

now there are silences and the

words make help make the

silences .

 I have nothing to say

 and I am saying it and that is

poetry as I need it .

 This space of time is organized

 We need not fear these silences, —

 ♍

Word breaks and hyphens

To maintain relatively close and even word spacing with justified lines of text, hyphenation is unavoidable. When text is ranged left, and particularly with fewer than the optimum number of words per line, it might be necessary to hyphenate on occasion in order to control the raggedness of the right-hand edge. Decisions concerning where to break words are the responsibility of the typographer. Breaking of words is certainly detrimental to the efficiency of reading and should be kept to a minimum. With this in mind, it should be noted that a longer line-length throughout the text will tend to generate fewer broken words.

There have been various methods of dividing words; by vowels or by consonants to name but two, but the one most popularly used today is by syllables; a syllable being a group of letters that together represent a sound. For example, com-pos-ing, de-light-ful. Character combinations which represent a complete sound, therefore, cannot be broken by a hyphen. For example, *ph* in hyphen, *ch* in machine, *th* in nothing, and *sh* in crashing. Many words cannot be hyphenated, such as thought, breathe, should, and preach, because they are made up of one syllable (or sound). Some specialised dictionaries such as the *Oxford Spelling Dictionary* include, word by word, the range and variety of permissible word-break hyphenations, such as per-m-i-s-sible.

For efficiency of reading, it is important that, wherever possible, the first part of any hyphenated word should be capable of clearly indicating to the reader what the whole word is *before* the eye arrives at the second part of the word. For example, happi-ness, not hap-piness, even though the conventional options offer hap-pi-ness. Also, it is preferable that the first part of the word ought not be a word in its own right. It is particularly disconcerting if the first part of the hyphenated word has a completely different sound and meaning from that of the completed word. For example, reap-pear.

Proper names, such as the names of people and of places, ought never to be divided. If at all possible, where a person's full (first and second) name is required, these ought not be split between lines. Initials and/honorifics such as Mr, Mrs, or Lady, certainly ought not be split from the subject's names.

All amounts described in numerals should not be broken, and, for the sake of clarity, neither should email addresses.

Hyphenation can be controlled on the computer to a degree under 'H&Js' where all default settings can be overruled. The minimum number of characters at either the beginning or the end of a line should be three. Word breaks such as flagrant-ly or read-er, are both dysfunctional and ugly.

Display words (headlines and heading etc), however, should never be broken. Even a subheading of two lines should not have a broken word on the first line; and if the second line is particularly short, a hyphenated first line will look even worse.

A broken word should never end a page, especially if it is the right-hand (verso) page.

More information about the other functions of the hyphen are on page 46.

Proofreading

Every project requires a minimum of two separate readings by a proofreader quite apart from those carried out by the author and/or typographer.

The first reading (equivalent to a galley proof) should be done from the original typescript or manuscript. The second reading is done from a high resolution print-out of the print-ready artwork (equivalent to a press proof). In this way, there is the distinct advantage that the same text is seen in two very different arrangements.

The first should be set out on A4 paper in a generous size of type to ensure punctuation and accents can be easily identified. There should be one line, interline spacing throughout (10/20pt) and generous side margins to provide plenty of space for the proofreader to indicate errors and prescribe corrections. If, at this stage, the errors are numerous, it is advisable to resubmit the corrected copy for a second reading before going to stage two. Correcting a text heavy with the proofreader's red markings is liable to create new errors.

The second reading is an opportunity to revise the corrected copy, but more specifically, to check that the text runs from text box to text box, page to page, in the correct order and that nothing has been 'lost' in the process. Additional material, often not available for the first reading, such as captions, reference material, pagination (page numbers) and so on, must also be checked for accuracy. Covers, headlines and opening sentences are notoriously prone to errors. A cover will be looked at many times by the designer, but rarely read.

Computers, of course, have spell-checks, and these are indeed helpful. But unfortunately, such a system disregards any genuine word, whether it is the right one or not and, of course, cannot inform the user of missing words. There is also the issue of national variations in spelling (colour – color). Besides, a good proofreader (especially if an ex-compositor/printer) will look for more than textual errors, and can provide sound advice concerning the typesetting, bad word-breaks, loose lines and general inconsistencies of style. I look forward to reading the comments of proofreaders, their objectivity can be refreshing, (particularly when a project has been ongoing for a considerable time) and often enlightening.

Corrections should be done in ink. A good practice is for the proofreader to use two colours – red for errors, and green for sub-editorial suggestions concerning issues of consistency, grammar or style, or reminders to check the spelling of unusual proper names, telephone numbers and email addresses.

The proofreader, having found errors and inconsistencies, must then indicate these errors within and around the copy in a way that can be understood by the persons who will directly correct the errors. For each correction or amendment to the text, two marks are made: a site-locational mark within the text area; and in the nearest margin adjacent to that site, the proofreader specifies the nature of the change to be made. The notation is rule-governed and bound by convention. Proofreading is the equivalent of quality control and quality assurance in the manufacturing and construction industries.

Proof correction marks

instruction to printer	textual mark	marginal mark
delete	point size	ℐ
delete and close up	point size	ℐ
delete and leave space	point size	#
leave as printed	point size	(stet)
insert new matter	size	point∧
change to cap letters	point size	CAPS
change to small caps	point size	s.c.
change to lowercase	POINT size	l.c.
change to bold	point size	bold
change to italics	point size	itals
underline	point size	insert rule
change to roman	point size	ROM
wrong font. Replace.	point size	w.f.
close up	point size	⌒
insert space	point size	#∧
reduce space	point size	less #
space between lines	point size	<3 pts #
transpose	used sizes point	TRS
move to the right	point size	⌐
indent one em	point size	□/
Take words (or letters) to the beginning of the following line	The phoenix and the Turtle	T.O.
raise (or lower)	point size	⊤
align vertically	point size	∥

instruction to printer	textual mark	marginal mark
figure or abbreviation to be spelt out in full	12 point twelve pt	Spell out
substitute separate letters	phœnix	oe/
use diphthong (or ligature)	manoeuvre	œ
no new paragraph	point of the pen. The hair line of the	RUN ON
begin new paragraph	point of the pen. The hair line of the	N.P.
insert punctuation mark indicated	point size	
substitute punctuation mark indicated	point size/	⊙/
insert em (or en) rule	point size	⌒/
insert parentheses or square brackets	point size	(/)
insert hyphen	point size	⊢⊣
insert single quotes (double quotes, apostrophe)	point size	
refer to appropriate authority	15 point Caslon	(?)
substitute superior character	boys girl-friends	
substitute inferior character	boys girl-friends	

Eye halve a spelling chequer
It came with my pea sea
It plainly marques four my revue
Miss steaks eye kin knot sea.
Eye strike a quay and type a word
And weight four it too say
Weather eye yam wrong or write
It shows me strait a weigh.
As soo as a mist ache is maid
It nose bee fore two long
And eye can put the era rite
Its rare lee ever wrong.
Eye have rune this poem threw it
I am shore yore pleased two no
its letter perfect awl the weigh
My chequer tolled me so.
Anon

Paper and Print

Introduction

Page numbers (folios) were first used in the early 16th century, within an average life-span of the invention of printing from moveable type. Printing had changed the way thoughts were conveyed, offering a more precise, controlled medium. It must have been reassuring for a 16th-century author, aware of the dying craft of hand-written manuscripts (often consisting of inaccurate copies of inaccurate copies) to know that a tightly reasoned argument, complete with annotations and cross-references (hence the need for page numbers) would appear, in one thousand distributed volumes, all exactly the same as that of the corrected galley-proofs. (A galley being an open-ended tray for holding type after it has been assembled into lines, then pages, and before it is put onto the press.)

This new combination of communication and precision encouraged a printing trade to use its own medium to spread knowledge about itself by publishing descriptions of its practices, its processes and materials. Such materials were eventually co-ordinated, enabling better interaction, improved creative opportunities and a more efficient use of processes. All of this, along with the thousands of resulting titles, provide us with a record of an illustrious history of an illustrious craft.

From the middle of the 15th century to the middle of the 20th century, printers' type was three-dimensional. The process of its manufacture, certainly until the middle of the 19th century, runs as follows. Each character was carved, at actual size, into one end of a hard, steel *punch*. This 'shaped end' was pressed into a *matrix* made of a softer metal which could be fitted into a hand-held mould. From this, in turn, three-dimensional metal type-characters were cast, using an alloy of lead, tin and antimony. These were then distributed in sets to their designated compartments within wooden trays (or *cases*). The capital letters were all stored in one case, the text letters in a second; hence *uppercase* and *lowercase*. When required, the metal characters and spacings would be hand-picked by the compositor, assembled line by line (composed), arranged into page or pages, and locked into a frame *(forme)* before being placed in a printing press where the surface of the secured type would be inked. Such an ink is stiff and tacky, not at all liquid.

The ink was applied with mushroom-shaped, leather-capped daubers. Inking rollers came later. The inked image was transferred to paper; the contact being achieved by just enough pressure applied to ensure that the whole of each character was printed with an even colour. The ink would present each character with a slight sheen, contrasting with the soft, matt, fibrous paper.

The Renaissance typographers designed and cut type that was robust enough to cope with the physical demands of letterpress printing. In the 18th century (or, typographically, *transitional*) period, Baskerville had to use the same printing techniques but adjusted the quality of his papers so that their firmer, smoother, less fibrous surface could allow the finer lines of his typeface to remain crisp and unbroken when pressed into the paper.

This trend continued. Papers became yet smoother and harder, inks were denser and darker, whilst printing itself was evolving into a more refined process in which the image of the type, rather than being pressed *into* the paper, needed no more than to 'kiss' the surface of the paper. Perfect for the finest of fine lines of the *Bodoni* or *Didot* (modern period) typefaces.

Since the middle of the 20th century, commercial printing has been largely dominated by *lithography*. Initially, this medium, in which the printing surface might be a moisture-retaining sandstone slab or, later, a zinc plate, lent itself to a rediscovery of freehand drawn lettering, because all 'print' areas had to be drawn and painted using a water-resistant ink and drawing stick made from stiffened grease: water repellent but ink-acceptant. When the whole, flat, printing surface is wetted, its water-repellent image remains dry and ink acceptant. The whole surface is rolled with ink but the wetted, non-image areas repel the application of ink. Thus the mutual antipathy of water and oil (stiffened grease) is exploited to make it possible to print images from a perfectly even surface. Each constituent colour requires its own stone or plate.

Later, a method of transferring the image onto zinc plates photographically was invented and perfected. To transfer textual material, proofs were generated by letterpress and the resulting image would be cut and pasted into position and photographed. This photographic image was then transferred via (same-size) film to thin, light-sensitive, zinc plates. This additional, rather crude, photographic process meant that printing was more economical but could only be detrimental to the appearance of type. However, the extreme robustness of the sans serif and slab serif faces resisted the worst aspects of *photolithography* better than most.

In the 1960s, phototypesetting dominated the typesetting trade. The text was generated via a keyboard, and eliminated the need to photograph images printed from type. These photomechanical and photo-electronic innovations effectually marked the end of letterpress printing which had survived, almost intact, for a remarkable 500 years. In direct comparison to letterpress, phototypesetting was at first somewhat crude. All sizes of type were generated from one size of typographical master-negatives instead of using an integrated set of negatives needed to accommodate the subtle adaptations to form required by changes in scale. Such adaptations had been the norm with letterpress typefaces. The number of photosetting fonts was relatively few and those that were available often lacked ligatures, non-lining numerals, small caps and many of the accented characters.

These problems had only just begun to be addressed when digital equipment arrived to replace photosetting. The 1960s are less celebrated for the conversion from metal to film, but rather more celebrated for the development of computers to drive the new generation of high-speed composing machines.

Whilst the subtleties of letterpress have certainly not been fully retained in the digital era, there have been genuine compensations for the typographer. The democratic potential of the personal computer has returned typography, for many, to that of a 'cottage industry', whilst printing, now minus typography, has expanded to the scale of 'heavy' industry. With expansion, have come the possible drawbacks of standardisation; and yet the industry continues to generate new processes, whilst its supporting industries provide new products. Presses, papers, inks, and bindings are all in a constant state of improvement. But these services need to be recognised and understood by the typographer if type is to be presented to its full potential. It goes without saying that a good working relationship with paper-merchants, printers and binders is essential.

The following pages describe, in outline, the key products and processes available.

This page above
When *Univers* was cut for phototypesetting the crotches in the angles and the reinforcements of the obtuse angles were exaggerated to prevent them rounding.

This page below
The negative disc for a Lumitype machine, (circa 1964) from which characters are exposed onto film positive by a light signal synchronised with the spinning disc.

Paper and boards

Paper and card can be thick or thin, rough or smooth, capable of being printed on one side or both sides, matt- or gloss-coated, and each with numerous variations in between. *Board* is the industrial term for card.

The weight or substance of all grades of paper and board is defined in terms of grams per square metre (GSM). This system relates to each ream of 500 sheets and measures the paper on its weight per square metre regardless of sheet dimensions. Weight, however, does not in itself provide any indication of the thickness of the paper nor its other physical properties: how it feels, bends, folds. These characteristics must be fully investigated before a final choice is made.

Similarly, weight and/or thickness do not indicate strength. This is dependent upon the quality and length of the fibres and how firmly they are intertwined (or bonded) together. An important point concerning fibres is that, in machine-made papers, the fibres tend to lie predominantly in one direction. Paper will always fold, bend or tear more easily in the same direction as the fibres than across them. In order for a bound document to handle well and the individual pages to flex correctly, it is preferable for the fibres to run vertically, head-to-foot down the page, parallel to the binding edge.

The thickness of the paper will, naturally, determine the thickness of the document and this will need to be identified, particularly if the document comprises more or fewer sheets than is usual, if only to confirm the width of the spine. The printer can calculate that width, but there is no better way of thoroughly understanding all the implications of weight, bulk, shape and proportions than making or commissioning a dummy copy, the equivalent of a production prototype, and holding that dummy 'document' in your hand.

The surface of the paper, regardless of weight, will influence the choice of typeface; a rough surface requiring a more rugged, and perhaps heavier weight of letter. A more porous paper will cause both type and image to 'spread'. Alternatively, a very smooth, firmer surface also needs careful attention because too much sheen can make type more difficult to read.

With paper, the tones of 'white' are infinite, and this can affect the appearance of the type. The whiter the paper, the greater the contrast with the type (assuming this is printed black). This contrast might initially suggest heightened clarity, but in fact the opposite can be the case. The heightened contrast can cause 'dazzle' as the reader's eye attempts to progress along a line of type. Contemporary versions of *Bodoni*, which, initially, might be considered ideal for smooth, high-white papers, need very careful adjustments because with modern printing techniques the 'thin' lines are usually much thinner than Bodoni ever achieved (or expected to achieve) using letterpress. Therefore, type printed onto a high-white paper may require additional leading, and adjustments to tracking values, to produce a more comfortable read. An off-white paper offers less contrast and therefore allows the type to 'sit' (or 'bed') in, rather than on, the surface of the paper. For continuous reading, or for any situation where smaller sizes of type are required, an off-white paper is usually preferred.

A printer will provide paper samples, or these can be obtained directly from the paper merchants themselves. Precisely specified dummies will often be made to your order by the larger paper merchants or binders/printers at no extra cost and this service must be utilised if the contribution of the paper to the project is to be judged with any certainty. If postal costs are entailed per copy, it would be wise to weigh the dummy so that mailing expenses can be included in the overall project costs.

In the UK and Europe, a standardised series of stock sizes (paper and board) are in use; known as A sizes (or International Paper Sizes or DIN sizes, from the German standards organisation Deutsche Industrie Normen). These standards relate to three series of standards, designated as A, B and C. A sizes are based upon a standard size sheet called A0, which is 841x1189mm. Half that is A1 and half of A1 is A2 and so on. B sizes are intended, in the main, for posters, wall-charts and similarly large-scale items, and range, usually, from B0 to B8. C series describes the sizes of envelopes and pockets designed to accommodate A series paper material.

A series (trimmed)

A0	841 x 1189mm
A1	594 x 841mm
A2	420 x 594mm
A3	297 x 420mm
A4	210 x 297mm
A5	148 x 210mm
A6	105 x 148mm
A7	74 x 105mm
A8	52 x 74mm

Two larger, (untrimmed) paper size ranges have been introduced to produce A-size *finished* items. The RA range is not well stocked but most paper merchants stock the SRA range. This larger size provides space for the printing machines to grip the paper and also to allow for bleed and trim. (*Bleed* describes that part of a printed image which extends beyond the *trimmed* edge of the pages. *Trim* refers to the edge-cutting of printed sheets *after* they have been folded to form pages; trimming at the head, tail, and foredge enables the pages to be opened relative to the spine). The larger sizes SRA and RA, within reason, can be used to provide a little additional width or height to an item should this be required.

RA0	860 x 1220mm
SRA0	900 x 1280mm

B series

B0	1000 x 1414mm
B1	707 x 1000mm
B2	500 x 707mm
B3	353 x 500mm
B4	250 x 353mm
B5	176 x 250mm
B6	125 x 176mm
B7	88 x 125mm
B8	62 x 88mm

C series (envelopes)

C4	229 x 324mm
C5	162 x 229mm
C5/6	110 x 220mm
DL	110 x 220mm with window or aperture
C6	114 x 162mm
C7	81 x 114mm
C8	57 x 81mm

This page above
This advertisement for the printing company Davis Delaney Incorporated appeared in the eighth *Graphic Arts Production Yearbook*. This book, typical of its time, was published in 1948 by the Colton Press in America and was intended to keep those in the printing industry aware of the latest technological and design developments. Like its British counterpart, it has a distinct, crusading flavour: keep ahead of the game! The line 'Eight out of eight' refers to the fact that Davis Delaney had printed all eight of the *Production Yearbooks* thus far.

This page below
In England, paper manufacturers realised very early that graphic designers were becoming a major influence upon the choice of paper. Wiggins Teape have a long and very distinguished reputation for the promotion of their papers; largely by direct mail, but also, as in this example, in specialist publications. This gate-fold spread appeared in *The Penrose Annual* (number 50) 1956.

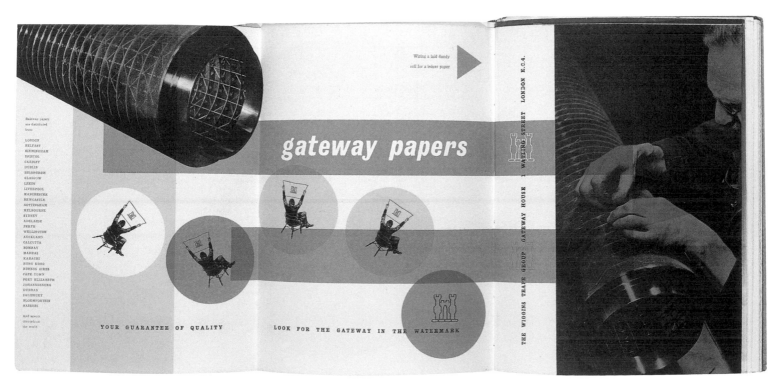

Print

Whilst the principles of the lithographic process have changed little since its initial expansion at the beginning of the 20th century, the presses have improved immensely in both speed and sophistication.

Offset-litho presses are designed to print large sheets of paper or board. There are also presses designed to print from input reels of paper and board. Sheet-fed presses are more adaptable whilst reel-fed web-offset machines, being considerably faster, are reserved for long-run work, with the major advantage of being able to deliver folded sections 'on-line' if required. Reel-fed machines are used to generate newspapers in standard tabloid or broadsheet formats. These are four-unit machines which print *both* sides of the reel simultaneously.

Sheet-fed presses are made in a range of sizes, but generally relate closely to the B range of ISO paper sizes – that is, slightly larger than the SRA paper size ranges. These presses are available as single-colour, two-colour and higher, multi-colour configurations, usually up to six-colour. Five-colour presswork will commonly be used for full-colour work (full-colour images being achieved via superimposed, colour-separated halftones printed in four colours: cyan, magenta, yellow and black, CMYK, the K standing for black *and* key) plus varnish. The use of varnish, which can be matt, smooth or gloss, can be beneficial where the ink coverage is high because it seals the ink, and in so doing, enables the print areas to resist finger marks. Matt sealer-varnishes are almost invisible in most situations. Gloss, on the other hand, is more commonly used as a 'spot varnish' to highlight words or images.

Alternatively, a five-unit press (or, of course, a single-unit press) can be set to carry a 'special'. These are inks which must be mixed having been specified by the typographer from a colour matching system such as the 'Pantone Range'. This comprises a small, basic range of colours from which a wide range of colours can be mixed. This is achieved by proportioning each constituent colour by weight. A specific colour can also be (theoretically) achieved using the full-colour process to superimpose tints of the four CMYK process colours. The system is based on specially produced tint-charts such as 'Focaltone'.

The results are not normally quite as satisfactory as those that can be attained using one 'special' colour. Also, because it requires four printings to achieve, it is unsuitable for text matter. Fluorescents and metallics are also classified as 'specials' and are bought in by the printer ready-mixed.

Because lithographic inks are translucent, there is the opportunity for an 'additional' third colour to be achieved by localised overprinting in two colours. For example, an overprinting of a green-printed area with orange ink generates a warm brown. Metallic inks are an exception because these are opaque. There are also a number of other specialist printing techniques:

Photogravure

Photogravure is a highly specialised printing process which is used world-wide for bulk-quantity, high-quality work such as large-circulation, full-colour weekly magazines; for full-colour consumer packaging; and for postage stamps. The underlying principles of photo-gravure can be traced back to such printmaking techniques as *aquatint* and *mezzotint*: the printing image comprises millions of tiny cells that are *recessed* into the flat or cylindrical printing surfaces photo-chemically. There is, today, growing use of computer-aided photo-electronic creation of photogravure printing cylinders. The printing action itself comprises repeated cycles of three operations: firstly, the cylinder is flooded with densely pigmented, liquid ink; secondly, the surface of the cylinder is wiped clear of ink and thirdly the cylinder is applied to the reel of paper, transferring the content of the cells to form the printed image.

Serigraphy

Serigraphy (silkscreen or screen-stencil printing) in a commercial context, has developed into a very diverse and versatile process. It is characterised by perfectly even, flat, opaque colours. It ranges from a simple flat-bed manual process, perfect for large size but small-run projects, to fully automated cylinder or rotary screen presses used for high-volume items such as packaging, point-of-sale displays, self-adhesive labels, scratch cards etc. A huge advantage of this process is that almost any material: metal, plastic, glass, fabrics (including T-shirts) can receive a typographic image via silkscreen.

Flexography

Flexography is now the dominant relief printing process, with ever increasing quality and speed. Digital technology has improved this high-speed rotary printing process with laser engraved rubber plates offering applications in flexible 3D packaging, plastic bags and reel-fed multiple labels.

Letterpress

Letterpress, as a commercial printing process, has long been superseded by other means. Cases of metal and wood type, composing stones, wood and metal furniture, proofing presses and platen and cylinder presses of various sizes can be bought very cheaply. Although metal type does wear out, letterpress materials and equipment were very well made to withstand robust use. If you have space, it remains a medium with huge creative potential for the typographer/author/publisher because the *whole* process – right through to the finished item – is under direct control. Because such a medium is rarely used for direct commercial purposes, the only constraint is the level of skill and commitment the typographer can bring to the project. To a readership used to high-volume, commercial lithographic standards, letterpress certainly still has the potential to produce a printed finish which is superior to all others. Recent successful developments, linking computer-generated texts directly to Monotype letterpress composing machines, have been made. These offer the typographer the opportunity to direct the textual setting on computer towards the output of galleys of Monotype. Such developments are, of course, only of value (and, I dare say, interest) to a small number of people for whom typography is rather more than a source of employment.

Inkjet printing

Inkjet printing was, initially, limited to printing serial or code numbers and sell-by dates on packaging products. It has now developed into a major print technology due largely to the establishment of its integral role in design studios as a means of providing full-colour proofs direct from the computer. The quality continues to improve and its industrial applications, particularly in large-scale graphics on textile stock (such as banners and flags) have already proved to be spectacular.

The composite colours are shown in the second and third rows. Six are dual combinations; one is a triple combination, and one is a quadruple. Exactly how the composite colours are arrived at is shown by the numbers, which refer to the key numbers of the pure colours in the top row. For example, 1 2 means that it is obtained by overprinting colour 2 on colour 1. Similarly, 1 2 3 4 means successive workings of colours 1 2 3 and 4. Note that the darkest shades are not necessarily obtained by the greatest number of overprintings; the choice of the colours is an important factor in this connection. Another factor which is every bit as important as the actual choice of the pure colours, as distinct from the composite colours, is the order of printing. If, to refer again to the colours on the opposite page, the Peacock Blue, 1, is printed over the Yellow, 3, a different shade will be obtained than were 3 to be printed over 1. A decision as to how many colours shall be used, and what they shall be, is therefore of little practical value if the printing order is not also fixed; and the selection of the colours and the determination of the printing sequence sometimes calls for ripe experience. All this is leading to one point, that it is desirable when planning a piece of water colour printing to execute very rough colour sketches to commence with, such sketches to embody the sales or other message it is desired to convey; for, after all, the process must be made to serve the purpose, and not the purpose the process. When these are felt to be right from a functional standpoint, they should be subjected

page 74

Described in the foreword as a 'work of reference' *The Print User's Handbook* of 1935 aimed to provide printers with 'new ideas and the latest technical information'. Much emphasis is placed upon new processes, inks and finishes although very little is mentioned about the production of artwork. The diagrams employed to explain a process tend to have an almost childish quality about them. At this time, the printing trade recognised that 'commercial artists', who had usually received an art training, were taking business away from them and books such as this would suggest the use of new products and new technologies as a means of fighting back.

This particular article, entitled 'Planning Print for Water Colours', describes the advantages of printing with water-based inks using rubber plates. The colours, which could only be printed flat (no tones) are particularly bright, almost fluorescent, but are neither water- nor light-proof!

Print finishing

Few sheet-printed projects are complete when they come off the press, having next to pass through other processes such as folding, creasing, binding and trimming for completion.

In the continuing drive towards automation in print-finishing and bindery operations, there has been significant growth in automative binding lines in which several operations are linked together. However, such in-line operations are only economical for larger runs.

Off-line finishing is preferable, both practically and economically, for the majority of work; allowing each part of the process to stand alone without restriction to its speed from other linked operations. With someone responsible for each stage of the process, there is a greater opportunity for the typographer to check the quality of the project as it progresses.

Film laminating is used extensively in packaging, and is commonly used on paperback books, to protect printed surfaces with a transparent layer of thin plastic. The reel of plastic has its outer end advanced into the laminating press so that it is roller-applied to each printed copy, sheet by sheet. Film-lamination keeps the printed image clean, creates a surface which can be wiped with a damp cloth if necessary, and has the curious effect of somehow sharpening colour-intensities. Laminates can be matt or gloss.

Three-dimensional products which are generated by printing processes include metal, plastic and card packaging. Metal boxes and canisters are normally printed by offset-lithography onto flat tin or aluminium sheets. The metallic surface needs to be printed with an all-over coating of white ink before it can be printed with any combinations of colour, image, and typography. The completed batch of printed sheets of metal is subsequently conveyed through a special oven, sheet by sheet. Thereafter, the sheets are die-cut into flat shapes which can be rolled and lipped to make the body and lid components of boxes and canisters. The die-cutting process can include the making of slots and tabs with which to lock edge to edge when flat shape is pressed into three-dimensional object.

Cartons for packaging and other three-dimensional objects, can be made from flat sheets of printed card. A heavy-duty clamshell platen-press can be fitted with two kinds of stiff metal strip. The two kinds vary in their edge-profile: a very sharp edge; or a rounded, blunt edge. The strips are seated into a thick base, normally plywood. The sharp strips cut out the silhouette of one or more card-printed cartons and, simultaneously, the blunt-edged strips impress the crease-folds needed to define the twelve edges of each finished carton. One printed sheet is fed into the clamshell at a time; the arrays of cutting and creasing strips might relate to four or eight or more printed carton-flats per printed sheet. Carton-assembly, including tab-gluing, normally combines manual and mechanised processes.

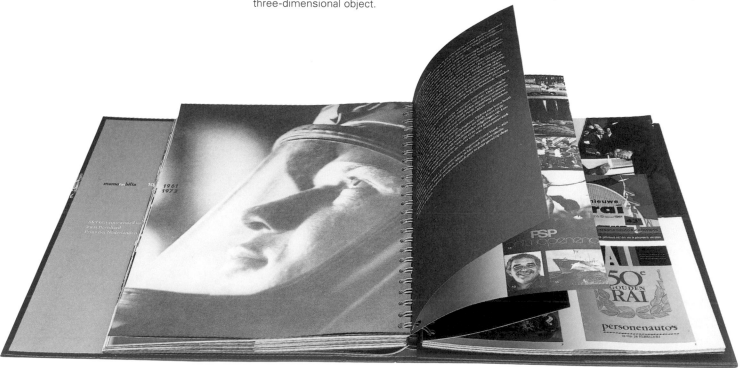

Benson Sedgwick

has the rare combination of engineering excellence & creative teamwork in fabrication technology.

For the engineer this teamwork means quality in the finished result, & the soul of the design never compromised.

Finite element
stress analysis
of vessel door.

Architectural feature
in polished aluminium.

Hygienic stainless
steel process plant.

Machining part of
air-ring assembly.

Sculpture fabrication
in stainless, alloy and
carbon steels, with full
CAD and QA back up.
Overhead cranage
throughout up to 15T.

Benson Sedgwick Engineering Ltd.

Benson Sedgwick Engineering Ltd.

Gloria (detail)
Commissioned to celebrate
the Centenary of the car, 1996
Courtesy of Robert Erskine ARB.

Opposite page
A large-format brochure designed by Darren Hughs, David Jury and Kelvyn Smith for an engineering company which, as well as building industrial projects also specialises in constructing large-scale public sculptures. The physical nature of letterpress (and the short print run required) made it a positive option for this particular project. The darker (narrower) pages carry photographic images and are printed offset lithography. Spiral bound with a wraparound, matt-laminated cover. Letterpress printing by Kelvyn Smith.

This page
This catalogue for an exhibition about the history of the motor car was designed by UNA (Amsterdam). It is in the form of a ring binder with pages of various size, weight and surface, specifically chosen to suit the particular information they carry.

Binding

The necessity that all visual aspects of any printed document require meticulous design should not need stating. However, non-visual, tactile qualities, including surface textures, implications of scale in relation to where and how the document will be read, weight and bulk of papers and boards, and methods of binding are equally important to the reader, the end-user.

The techniques of manual bookbinding produce very strong books and, if the materials used are worthy of this method of construction, should last for centuries. Bindings 200 or 300 years old are common enough in antiquarian bookshops to be cheap to buy. Such binding methods are too slow and costly for general use today but the overall structural process, although automated, seeks to achieve a comparable working result. The automation of the binding process has left in its wake a trail of small, 'cottage'-scale companies specialising in unusual and specifically designed binding and box-making. Because the work is largely hand-made, the only limit to creative endeavour is the budget. But since such small units often carry small overheads, the cost of their expert services is often surprisingly low.

The following list provides, in outline, an introduction to the standard binding techniques. These can, and should, be combined or extended to suit specific needs.

Sewn and glued
Sewn and glued is the best method of binding a document that consists of more than one section of pages; a section being a number of pages printed on a single sheet. Firstly the constituent sheets are folded. The number of folds depends on the number of pages printed per sheet. One fold generates four pages, two folds eight pages et cetera up to (in exceptional circumstances) as many as 128 pages per section. The arrangement and the number of pages on a sheet (called its imposition scheme) is necessary both for binding purposes and for economy of printing. Naturally, the higher the number of pages per sheet, the more economical the printing costs will be. However, when the flat sheets are eventually folded, the number of folds required will affect how the pages behave when bound.

The aim must be to ensure that every page turns in the same way, and for the centre of each section not to be signalled by a reluctance to allow the reader to turn the next page! Thirty-two page sections are normally the maximum number, although sixteen is preferred. Weight, bulk and size of page will, inevitably, determine this.

Each folded section is sewn together by cotton stitching that passes through the back (or spine) fold and through tapes which run across the width of the whole spine. The stacked sections, secured to the tapes, are coated across their spine-edge with flexible glue. This helps to fix the sections together, keeps the book in shape and, with a soft-backed book, allows the cover to be drawn onto the sticky spine before the book is trimmed. If the book has a hard cover, then the text pages only are trimmed before end-papers, which cover the inside covers, are attached to the very first, and the very last page of the set of text sections. These are used to firmly join the book to its cover.

Wire stitching
Wire stitching (or saddle-stitching) is the simplest method of binding slimmer documents. The maximum number of pages suitable for this method of binding depends, again, on the weight, thickness and size of the pages. The lighter and thinner the paper, the higher number of pages can be incorporated. The aim is to have a document that lies flat and, when opened, does not simply fall open at the centre spread.

Perfect binding

Perfect (or unsewn) binding is often used for thicker magazines, cheap paperbacks and other bulky work such as annually updated editions of directories or timetables. However, this method should be reserved for documents intended to have a short life-span or, if absolutely necessary, where economy is a prime consideration. Perfect binding is, in fact, a set of saddle-sewn sections whose bound edges are trimmed away so that the firmly clamped stack of constituent sections of the book is a firmly clamped stack of page-sheets! The spine-edge of the clamped stack is roughened and glued. The cover is then drawn on to be bonded to the glue along the spine.

Initially, the glue is flexible but over a relatively short length of time (sometimes only months!) it will dry and become brittle and prone to break if the reader attempts to fully open the book. Since the glue alone holds the pages in place by their edges, when it breaks, the pages simply fall out. Ergonomically, such binding is unacceptable because it resists being opened and cannot be laid flat without fear of irretrievable damage. Books need to be capable of relatively heavy handling, designed to be 'working documents', bound and arranged to be consulted and revisited on numerous occasions over (at the very least) a lifetime.

Plastic comb

Plastic comb and spiral wire bindings represent a wide range of similar products initially designed for shorter runs of, typically, in-house printed material. However, because these are largely manual operations there is the opportunity to use different papers, cards, and plastic sheets which can be positioned anywhere within each copy, and cut and folded as much as the budget will allow. Spiral binding has the disadvantage of not allowing precise alignment between left and right-hand pages, but proprietary systems, such as Wiro-O, set the wire so that page alignment is maintained.

Combs and spirals can be hidden with wrap-around covers and inside flaps which provide the document with a spine upon which to print a title. Documents bound in this way also have the advantage of opening perfectly flat and staying flat. Which is why this method is ideal for prescriptive texts such as operative's manuals and cookery recipes. An allowance must be made for the loss of margin at the binding edge.

Opposite page left
This method of stitching is called coptic binding and has the advantage of allowing the pages to lie flat when opened. This specially commissioned sketchbook includes trace, graph and cartridge paper in each section. The covers are made from birch ply and drilled to allow the white lining thread to pass through. Designed and made by Jayne Knowles.

Opposite page right
Two 32-page A6 books bound using an elastic band into a double-hinged cover. Designed by Struktur, 2002.

This page
A series of posters that are also the catalogue for an exhibition called *Inside Cover*. The posters are held in a smooth, plastic cover held by press-studs and the names of the artists are printed in twenty colours on the 'spine' of each poster. Designed by SAS.

Electronic Writing Systems

Introduction
Hypertext and hypermedia

Introduction

Speculation about a doubtful future for print (and of the book in particular) is not new. Like printing in the 15th century, the computer today is a technology that appears to challenge the traditional definition of the book. The initial hopes that printing would liberate human communication have been largely realised, and many consider hypertext as being capable of taking those same democratic possibilities an important, dramatic step further.

But some commentators are dubious about how realistic these expectations are, largely because hypertext is so different from the physical aspect of print. Gutenberg designed and printed his 42-line Bible to function as an artifact in a society that valued artifacts. In comparison, the computer is often accused of inherently isolating writing from its traditions which have been, and still are, enhanced by the activity of printing itself.

Although the nature of the computer undoubtedly provides 'electronic writing' with a unique flexibility and interactivity, the one thing it cannot do, and should not try to do, is imitate print. There is no sense of permanence, or stillness about electronic writing systems. But within these 'limitations' (which, of course, are described by many as 'advantages') there is a very broad range of possibilities.

The biggest problem is that whilst the printing and electronic systems exist side by side (and, in fact, have provided mutual support) comparisons will continue to be made. The most common comparison concerns readability. Assumptions about the physical size and clarity of the computer screen are constantly made and yet it is impossible to make predictions about the social or cultural influence of this technology. We cannot know, for instance, whether readers in the year 2005 or 2025 will come to prefer the computer screen (if that is what it still is) to the printed book. Certainly, cultural choices keep printed books and similar materials in use today. It is a fact that, for many purposes, print *could* be eliminated immediately – at least in the industrialised world – but readers are not prepared, so far, to replace their books with computers.

But in the history of writing, some techniques *have* been superseded by others. The book practically replaced the scroll in late antiquity. Parchment replaced papyrus in the early Middle Ages. But it is more common for a newer technology to replace one major function, leaving the previous technology to consolidate other functions. Printing replaced hand-written books but it did not make handwriting obsolete. Electronic technology has not, in any way, taken over the function of print. Rather, it appears to have replaced many functions of the fax machine and some functions of the telephone. The computer (and the text message facility on the mobile phone) is used primarily as an alternative medium for verbal communication. This is emphasised by the popular tendency to use 'spell as they sound' contractions: wot r u trying 2 say? Like the typewriter, and the word-processor, like the fax machine and email, each new medium provides both the meaning and the appearance of words with new possibilities, and these have influenced, and will continue to influence, both literature and typography.

For the present, it is enough to observe that there is nothing in the economics of publishing as a whole or in the usage of printed material to suggest books are in any danger of obsolescence – even in the long term.

There has, however, without a doubt, been a digital revolution. The ingredients that work together to break down the perceived limitations of the book are, by now, well established. They include, among others, the immense possibilities for archiving, scanning and updating in real time, the convenience of connecting together key words with others, rapid access via the internet to the best sources, wherever their location worldwide and the rapid exchange of commentaries in electric forums. It will be noted, that all of these involve extended reading; the comparison of diverse texts and viewpoints and exchange of ideas. The most common description is that this new 'material landscape' gives those who live in it the impression of being far more immersed, collectively, in the space of a never-ending book.[1]

But there are substantial implications regarding the replacement of a major communication medium which are often underestimated. Vaunted predictions coupled with limited utility have already diminished enthusiasm for the potential of hypertext and multimedia. There have also been political ramifications. Libraries have had their acquisitions budgets cut and education, for a considerable period, has had whole budgets cut in the name of alternatives that still do not exist.[2] The proclamation that the 'library without walls' now exists looks like an opportunistic move by budget cutters rather than a reasonable, if mistaken, prediction.

A graphic plan displaying the architecture of the website designed by SAS, London, for Bourjois, a French cosmetics company. The Bourjois website is enormous but this graphic map provides a clear overview of the site and the relationship of its disparate parts. In commercial terms, the website is required to focus on building brand awareness and conveying product information, so that consumers can find and recognise Bourjois products in the retail environment.

Hypertext and hypermedia

Before hypermedia, information typically required the collaboration of author, typographer, printer and publisher, who between them, refined and formalised its presentation. In contrast, words are circulated via the internet freely (in the democratic as well as the financial sense) as never before. In principle, this is the perfect medium for finding, reproducing and redistributing information. Issues concerning freedom of speech and the meaning and implications of 'liberty' have not been so vigorously debated since the late 15th century when the invention of moveable type provided the remarkable potential of every house to contain a book.

Unless we are reading a dictionary, encyclopedia or text-book, we normally start reading a document at the beginning and continue in normal order to the end. The fact that the computer is not limited to presenting information in serial mode was recognised very early in the development of computer science. Because of this, typographers designing for hypermedia often enthuse about hypertext systems lending themselves to innovative forms of information presentation as if it were impossible to open *any* book at *any* page other than page one.

However, in a hypertext system, not only 'pages', but 'documents' can be accessed from any point and linked together by either the originating author or the reader, who, importantly, can intervene to become, in effect, associate author. The question of 'originality' can become problematic (and interesting!). Hypertext is fundamentally an 'intertextual system',[3] offering the potential to redefine the relationship between author and reader and the nature of writing. This is because the text is presented as an evolving structure. Unlike print, which provides permanence and a physical context for the text, electronic writing is a radically unstable and impermanent form, a form in which the text exists only from moment to moment. The reader joins with the author in building the text because linkages, regardless of where, why and by whom they are made, affect, or create new, alternative meanings.

Traditionally, the author is someone who generates and collates a package of ideas so that the reader is able to comprehend a specific message. Hypertext, however, places the emphasis on writing as a never-ending *process* rather than as an *object* that might provide the 'final word' on a given subject. Without the means to control the outcome the role of both the author and the typographer is seriously compromised.

Opposite page
www.noodlebox.com presents a series
of rooms, each offering different visual
sequences involving organic or
geometric patterns.

This page above
www.yugop.com. Initial pages play on
the concept of old and new technologies.
The ambiguous keyboard has closer links to
the typewriter than the computer, although
when the type appears it is pure digital
in nature.

At a second level this site offers a line of
thought which can be taken in the direction
the reader prefers. MONO*crafts

Opposite and this page below
www.typographic56.co.uk. This is a
website designed in 2000 to accompany
the publication of (the conventionally
printed) *TypoGraphic 56*. Designed by
Nicky Gibson, Richard Kwok Wah Ho
and Mike Reid at DeepEnd, London.

Language

Introduction

Among the many ways to understand typography, its technical and aesthetic aspects tend to take precedence. Its invention, development and the improvement of its most effective, instrumental resources are the result of the typographer's process of understanding and optimising typography.

However, there is a growing interest in typography which is not directed at the issues of physical and aesthetic optimalisation of information, but towards issues of individual and collective use (and misuse) of typography. In such cases – the work of linguists, psychologists, philosophers and sociologists, for example – it is the human collective which lies at the centre of interest. That research into the role of typography within the wider context of communication should be of interest to typographers should not need justification (except to say that to ignore such developments is dangerously isolationist). Everything continues to change and develop, and the mediums typographers use are attracting others, with very different viewpoints, to look at the nature of type, what it does, how, to whom, and why. The role of the typographer and the function of our communication systems are under renewed scrutiny and the parameters being used for these valuable investigations need to be appreciated.

In the early part of the 20th century, the printing industry ignored the changing role of typography required by a growing mass-communication market, and consequently, saw typography snatched away and handed to the graphic designer. Today, the computer and the necessary software required for the making of typography is not the sole preserve of the graphic designer/typographer. Humanities, media studies, and other major, growing areas of study are using precisely the same equipment to study and even to generate material that has, for the last fifty years, been the responsibility of the typographer.

Language is a central feature of typography and yet, formally, it plays little or no part within the specialist education of most graphic designers. Instead, for the typographer, the craft of writing (or, at least, the ability to recognise and appreciate it) is usually acquired entirely separately from that of their initial, specialised, visual education. It seems, at the very least, a little perverse for typographers to perform their craft of making type readable without ever concerning themselves formally with the nature of how the words themselves communicate. This chapter introduces the primary concepts concerning language as a spoken and aural system, and its links with visual language systems.

It is presumed that language was initiated in face-to-face situations. In which case, direct communication would be limited to the distance the human voice could carry until a system of writing was developed. Writing – the development of language in a *visible* form – not only allowed the 'message' to be received over a greater geographic distance but also over a greater distance in time.

The development of written language is normally associated with the need to make records of transactions or agreements of various kinds. Such records were, initially, iconic; the number of notches cut into a stick might represent the number of objects stored or swapped. If a number of different objects or substances were involved then it might be felt necessary to differentiate, and so, for instance, a notch might be 'wavy' so that it could represent a liquid. Such marks evolved to form the basis of Chinese ideograms, or, in Egypt, hieroglyphic images. An example might be the image of the ox's head (which initially 'stood for ox') which, eventually, became the letter aleph, alpha and then a.

This is a process of considerable abstraction, so much so that, alphabetic writing, once established, has required very little adaptation ever since. All present alphabetic scripts, from the Middle East and on to Europe, are refinements of those initial steps, from Egyptian hieroglyphic representation to the Phoenician alphabet (and from there to Greek, or Sanskrit or Arabic).

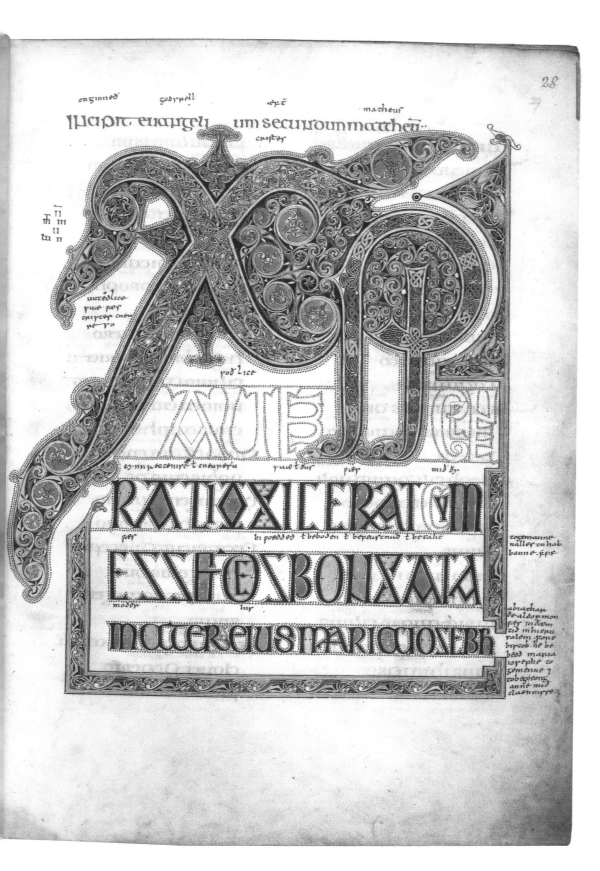

The *Lindisfarne Gospels* was made about the year AD698 in the island abbey of Lindisfarne off the north-east coast of England. This is the opening page of St John's Gospel. The script was written by Eadfrith, bishop of the island, and the tiny interlinear translation in Anglo-Saxon was added almost three centuries later by Aldred, provost of Chester-le-Street. *The British Library*

Latin survived as the language of the written word in Europe for more than a thousand years and, of course, it was possible for educated people to read Latin texts in addition to their native spoken language. However, from about the 9th century onwards, books began to be written in local texts representing local dialects. The *Lindisfarne Gospels* (see page 133) for instance, written in Latin at about AD700, had an Anglo-Saxon translation written between the Latin lines in the 10th century.

The invention of printing from moveable type not only hastened the demise of Latin as the standard language of learning but also hastened the demise of regional variations of other European languages within national boundaries. The English language, for instance, was a hybrid of many cultures, and it was not until a little after the invention of printing that, what might be termed 'standard' English, began to be established.

The concept of an 'ideal' or fixed mode of communicating is comparatively recent. In the Middle Ages, people from different parts of the British Isles would have had considerable difficulties communicating verbally. Scribes wrote their manuscripts in the 'universal' language of Latin or in a local dialect using spellings that reflected their own, regional pronunciation. The mix of Celtic, Anglo-Saxon, Viking, Norman-French et al, which produced a particularly rich and varied language, was made all the more so by writers such as Chaucer and Shakespeare. William Caxton and his successor, Wynkyn de Worde, were important because by setting up the first printing press in Britain (in 1476) their books marked the start of a standard orthography for the written form of English.

With the gradual establishment of a 'standard' English language and a 'standard' printed form, the concept of localised deviation being inferior was quickly accepted. The establishment of a rigorous standard was eventually achieved in the 18th century by Samuel Johnson with the publication of his highly influential *Dictionary*, and in the United States in the 19th century by Noah Webster.

Language

The structure of a language is the grammar of a language and is made up of three elements; phonology (sound patterns), syntax (arrangement), and semantics (meaning).

The sounds of language, apart from the onomatopoeic words such as *crash, bang, wallop* have no meaning in themselves. The word 'red' is a purely arbitrary sound-sign, the meaning of which must be learned. Such sounds develop within communities and provide languages appropriate to quite specific cultural and physical needs. Because of this, national languages become a valuable social archive as well as a current resource which need to be constantly updated to reflect local and sub-cultural idiosyncrasies.

The nature of language, with its infinitely variable elements, seems to positively encourage creativity. We invent new sounds and make up new words which continue to increase and enrich national languages, whilst the international nature of mass communication ensures that many 'new' words are capable of crossing all national barriers. When travelling abroad, a common understanding that transcends language barriers, no matter how mundane, always brings delight.

And, of course, the display of 'delight' (or any other appropriate reaction) is very much a part of the communication process. The human face seems to be unique in its ability to display such a wide variety of expressions. In fact, the whole body, and particularly the hands, support verbal communication with gestures, which again, often reflect local idiosyncrasies. There is also the range and variety of vocalisations: just imagine how many meanings a phrase such as 'How interesting' can be given simply by varying the nuance of the voice.

To ensure that the intended message is communicated without fear of misunderstanding, facial expressions are, on occasions, formalised for ritual situations in many tribal communities. This symbolism of facial expression is commonly used as a visual shorthand and has been incorporated into signage systems as well as visual language aids, such as the Bliss and LoCoS systems. But most systems which purport to provide anything approaching a 'language' must resort, eventually, to codes. Like the abstract word *red*, the meaning of a circle with a diagonal line through it must be learned, relative to its associated signs, allowing the set of signs 'to be read' situationally with relative ease regardless of national boundaries.

'Typographic' (printed) languages have been more stable than the spoken word due to the role of formality and tradition within the process of authorship, type composition, and proof-reading. The indefinite length of time that a recorded 'arrangement' survives in its printed form is also an important factor. The value of printed matter – be it in the form of magazines, catalogues, books, directories or a supermarket checkout receipt – is that printed matter can be checked and interpreted free of its original context. Of course, for others, a better understanding of 'context' will be the reason for scrutinising such printed material.

The spoken word is, generally, less formal. Dialogues involving interaction (speaker and listener) are notoriously difficult to 'control'. This, of course, is also their value; offering the creative, thinking process in its improvised form. Whilst someone might be seen and heard to be overcome by emotion and struggling for the right words, 'print', generally, has always tried to disguise the effort required. This paragraph, like every other in this book, has been rewritten several times with the aim to provide you, the reader, with a polished and finished result, free of extraneous distractions.

Formality provides a quiet, undisturbed arrangement. This is very much a product of tradition; of doing things in a certain way – the same way – regardless. It is also significant that the process of devising and producing printed material involved a number of people since this reliance on others encouraged a more conservative (less individual) approach to the way type was chosen, arranged and applied.

However, the recent democratisation created by computer technology, has radically opened up the design process, making the formal 'rules' of typography initially appear somewhat irrelevant. The privacy of the computer certainly encourages a more individual, more immediate and improvised response. In many respects this is a wholly positive result as long as the requirements of the reader continue to be met.

Opposite page
LoCoS: In 1970, the Japanese graphic designer Yukio Ota, presented a graphic language to the Icograda Conference in Vienna. It borrows some of C K Bliss's principles and ideas and builds upon a life-time's day-to-day experience of Sino-Japanese notations. Ota named his system LoCoS (Lovers' Communication System). All the ideographs are constructed from 18 graphic components. When a LoCoS ideograph is placed at superscript level (top) above a verb it functions as an adverb. At subscript levels (bottom) beneath a noun, a LoCoS ideograph becomes an adjective. Thus the substantive *grief* or *sadness* can be positionally inflected into *sadly* or *sad*. The LoCoS rough-coding shown in this sketch can be reliably translated into a well-formed English sentence thus: the postman brought today a sad letter to my home.

This page
The meaning of road signs, as with any complex language, needs to be learned. However, once the few abstract elements that symbolise commands have been memorised, a wide range of varied information can be applied and understood, for the most part, quite easily. The key is consistency. For this reason, change is always resisted and so it is not surprising to note from this diagram that modifications to the appearance of our road signage system changed little between 1931 and 1963. The art editor of the journal *Designer* was Brian Grimbly. The diagram was designed by Anthony Froshaug, October 1963.

triangular head, very slightly tapered shaft, and no tail. This reduction of taper is completed in his designs for the Worboys committee, where the shaft has parallel sides, 120-123; the head also is increased in barb to the extent of a solid V. The Protocol forms seem much improved on the 1931 Geneva sign, which is rather weak in impact, but Kinneir's redrawing of the Protocol form tends to blur the head, and to be too large a figure for its circular ground.
The use of an arrow to indicate 'keep left/right round bollard or obstruction', 115, 119, 123, is

certainly clearer than the previous verbal signs used in Britain, 104 and 107, as well as being visible at greater distance.
A rough comparison of one aspect of legibility may be made by rapid blinking at the images: verbal signs generally suffer because their very wordiness leads to complication of outline.

The various signs used at the junction of a minor road with a major road show a remarkable divergence of opinion on their purpose. Geneva considered the inverted triangle, 303, as a warning

sign : the 1933 committee adapted a 'dead slow' sign, designed in 1928, which surmounted a rectangular plate with the warning sign of a triangle, inside the prohibitory circle. It decided that the concept underlying the new sign 'slow – major road ahead' was warning, and thus merely made changes in the message on the plate, 312. At the same time it recommended, when discussing the use of light signals, a 'halt' sign, only to be erected with the individual authorisation of the minister in special cases, which it did not categorise as a roadside traffic

sign, and which is therefore not illustrated here. The 1944 committee added the words 'at major road ahead' to this sign, categorised it as mandatory, 108, and, although this is not mentioned in the report, made the white plate T-shaped, so that the sign would be recognised, even when totally obscured by snow/It also inverted the encircled triangle, to conform somewhat with international practice, both here and on the 'slow' sign, 325. The Protocol, however, still considers the inverted triangle, 339, as a warning sign : Worboys is surely correct in

regarding the concept of 'give way' as mandatory, 126, but cowardly in adding wording, which can only be redundant on a sign which differs from all others in outline.

The Worboys sign for 'stop – police', 'stop – children', 'stop – weight check', 125, follows Protocol, 117, and Geneva, 102, in category and form.

The 1944 committee's temporary signs for alternating one way traffic, 110 and 111, are similar to the 1933 recommendations, 320 and

321, but are correctly categorised as mandatory, not as warning. There is no Worboys recommendation for the form of this sign, merely for an ancillary 'traffic control ahead' temporary warning to precede such signs.

There are no British analogies to the Protocol sign for mandatory cycle tracks, 118.

Signs giving definite instructions (prohibitory)
A general view of prohibitory signs shows the recommendations of the 1933 and 1944
captions continued overleaf

Writing

In the initial years of their education, children are actively encouraged to draw pictures alongside their written work. Teachers will comment upon these drawings as much as they do on the written work, although not in the same way. Writing might be criticised for being grammatically incorrect, misspelt, unclear and so on. Drawing, however, tends not to be 'corrected'. This is because it is seen as self expression, spontaneous, something that is innately personal, and as such, cannot be 'corrected'.

This situation does not last long. By the time children begin their secondary education at the age of eleven, drawing (outside arts and technology) has largely disappeared, both from the children's own written work and from the school text books they use. (The exception, interestingly, is foreign language-study textbooks.) Visual images are generally restricted to maps, diagrams or technical illustrations. This is despite the fact that newspapers, magazines, advertisements and many kinds of books involve a complex interplay of written text and photographed and drawn images. The ability to 'read' material of this kind is ignored because whilst most teachers can expound, in absolute terms, the virtues and values of written and oral language, they are, to all intents and purposes, visually illiterate. This state of affairs is clearly not about to change.

The cultural emphasis, then, is placed upon writing. Grammar is a set of rules which must be obeyed if one is to write (or speak) 'correctly'. These rules are enforced through education and through all kinds of written and unwritten sanctions. And yet, a small 'elite' group of experimenters, (authors, playwrights, script writers etc) are allowed to break them. Despite the emphasis on the 'mechanics' of written form in education, it is recognised and sanctioned that breaking rules remains necessary, supposedly to keep the possibility of change (progress) open. Interestingly, teaching the rules of writing is not perceived as standing in the way of creativity; whereas teaching the rules of visual communication is often perceived as inhibiting creativity. The grammar employed to write poems or fiction is, essentially, the same grammar used when writing letters, memos or reports.

For the typographer, of course, type *is* visual communication. Indeed, paradoxically, the sign of a literate young person is the ability to treat the reading of text *only* as a visual medium by not vocalising (reading aloud); not even the movement of the lips is allowed. Children who vocalise, or 'subvocalise' in this way, are regarded as 'less advanced'.

This page left
The arrangement of words can provide information about the physical well-being of the writer. John Cowper Powys, 1872–1963 was a writer of 'great baggy monsters of novels' (his own description!). Powys was troubled all his life by chronic gastric problems. When writing, he adopted an unusual writing position, intended to ease the pain and discomfort. He usually lay on a bed or couch propped up with pillows, his knees drawn up to his chest. He rested a board against his legs and wrote on a pad of paper held against it in an almost vertical position. Not wishing to move Powys would turn the book, sometimes three of four times until every part of the page was full. *National Library of Wales*

This page right
A 'visual' diary kept by Laura Jackson. Although a personal document, it has, almost instinctively, been organised in a way that invites being read. Jackson, a designer and an educator, uses formal conventions of communication as an aid to clarifying thought.

Opposite page
The thinking process recorded on paper, and certainly not produced to 'communicate' such thoughts. Here attempting not only to find the right words but also an appropriate tone of voice – an appropriate way of presenting the words. Geoffrey Dowding, from a collection of papers held by the *St Bride Printing Library* relating to his book *An Introduction to the History of Printing Types*.

10th June 54

Choice = The act of choosing; preferential determination between things proposed; selection, election.

TITLE.

DBU. p.227 has a chapter Headed "The Choice of Type"

The Choice of Type Faces

? On Choosing Type Faces — or ? "On Choosing Types". or The Choosing of Type Faces

Considerations governing the choice of Type Faces

Factors governing the choice of type faces
Factors affecting the choice of type faces

The Selection of Type Faces = Clowes chapter heading

The Choice of Type = Bigg's chapter heading in "The Use of Type"

On the choice of type faces "Paul Beaujon, Mono Record 1933

Notes on choosing a type face.
Notes on choosing type face

The Principle of Type Selection (chapter six - Stees)

Considerations affecting the choice of types

Notes on choosing type faces.

? Notes on the choice of type faces

Choosing a Type Face.

Notes on choosing a type faces

On choosing a type face

Some Factors governing the choice of type faces

THE CHOICE OF TYPE FACES

THE CHOICE OF TYPE FACES

Of course, Blunks u/fce like a talker.

Which type?
NOTES ON SOME OF THE FACTORS GOVERNING THE CHOICE OF TYPE FACES.

Some Factors governing the choice of type faces 10/1/55

Factors determining the choice of type

FACTORS GOVERNING THE CHOICE OF TYPE FACES

Decisive factors in the choice of type

FACTORS GOVERNING THE CHOICE OF TYPE FACES

Some Governing Principles in the choice of Type

Factors governing the choice of type faces 28/2/55 u/fce

Emery Walker p.67 my Thurs Book of Rules

FACTORS IN THE CHOICE OF TYPE FACES March 3rd 55

Factors which govern the choice of type faces

Factors which govern the choice of type faces

(Factor = circumstance, fact or influence contributing to a result)

Communication

Communication is not a subject in the normal (academic) sense of the word. It is, instead, a multidisciplinary area of study. Communication is certainly talking to one another, but it is also dress sense and hair style. What a psychologist or a sociologist would have to say on this subject will be very different to what a typographer might say.

Communication involves signs and codes. Signs are marks or actions and gestures that refer to something other than themselves; they signify something else. Codes (such as writing) are the systems into which signs are organised, determining a system (language) within which the signs relate to each other. Communication is central to the life of our culture and consequently, the study of communication involves the study of the culture with which it is integrated.

Typography is the craft of constructing codified signs, which, when 'deciphered' by the reader carry the meaning intended by the author. This recognition of meaning occurs when the reader brings his or her cultural experiences to bear upon the codes and signs (the text). It also involves some shared understanding (and opinions) of what the text is about. We have only to see how different newspapers report the same event to realise the importance of this understanding, this social outlook, which each paper shares with its readers. So, naturally, readers with differing social experiences might find different meanings in the same text.

A classic model of the communication process was that devised by Shannon and Weaver in 1949.[1] It presents a simple, linear process which has since generated many derivatives. The *information source* is seen as the idea providing the transmitter (author, teacher, film-director) with what message to send. This message is then codified via speech, writing or computer keyboard into letters and words. These might be received via school lessons, the worldwide web, email, radio, television, film or books.

The one term in the illustrated model not readily apparent is *noise*. Shannon and Weaver intended this to signify anything that might be added to the signal between its transmission and reception that, in any way, inhibits its ability to communicate to the receiver (reader). Shannon and Weaver were, in fact, working for the Bell Telephone Laboratories in the USA and, to them, *noise* meant 'interference' on the telephone lines. But in other circumstances this could be static in a radio signal, snow on a television screen, or poor printing in a book. One of the reasons this model remains a relevant point of reference is that 'noise', in fact, can be extended to mean any information (signal) received that was not transmitted by the source, and/or anything that makes the intended signal more difficult to decode accurately. Thus, an uncomfortable chair, poor light, impaired vision; all of these can be a source of *noise* to someone trying to read.

From the reader's viewpoint, uncertainty (or worse, confusion) is for the most part (although not exclusively) the result of poor typographic decisions and, therefore, construed as 'noise'. Harrison and Morris[2] identified five common reasons for uncertainty:

1 *Uncertainty of what is present*
This relates most directly to readability. The cause of this uncertainty may be ambiguous character design, character or word spacing, or poor printing. It could, of course, also be the result of poor lighting conditions or poor concentration on the part of the reader.

2 *Uncertainty of what is meant*
At one level each individual character (or symbol) 'means' or stands for something. But also, the typographer selects, for example, a typeface which communicates certain additional connotations. Appropriateness of typeface and arrangement to the content and meaning of the text is essential. Of course, it is possible that the typographer might consider it appropriate to provide alternative or even conflicting connotations.

3 *Uncertainty about organisation*
In complex information, where more than one reading (or decoding) sequence is possible the hierarchy of information must be clearly stated. Questions of what is first and what is most important and what can be skipped over are important factors. Print, of course, is generally a linear process, starting at the top left. But in a complex layout the typography must also guide, emphasise and organise. Again, it might be possible that the typographer considers it appropriate to arrange the text in such a way that the *reader* must decide the route to take.

4 *Uncertainty of preference*
Aesthetic responses were once thought to be the sole result of pleasant associations from the reader's past. Today, it is readily accepted that stimulation can be caused by arrangements and compositions which are complex, challenging and original. Although difficult to prove, experience suggests that this is most certainly true. Not surprisingly, it is certainly the case that some individuals also demonstrate a liking for that which is easy to read.

5 *Uncertainty of response*
How to interpret the information and, by inference, how to respond. At one level, information might contain explicit instructions: 'Cut out and send to…' On a more subtle level, a document might use a specific typographic treatment for one kind of information so that the reader will, in time, associate a similar typographic treatment with similar information elsewhere. Emotive responses, however, are dependent, somewhat, upon the reader's individual psychological state and social-cultural context.

source (eg idea)　　　transmitter (eg author)　　　receiver (eg reader)　　　destination

noise (eg interference)

NUMBER OF MALES AGED 14-64 IN GREAT BRITAIN

TABLE 1 Thousands

Mid-year	Armed Forces [1]	Whole-time Civil Defence	Industrial groups			Unem-ployed	Rest of male popula-tion [5]	Total male popula-tion aged 14-64
			Group I [3]	Group II [3]	Group III [4]			
1939 ...	477	80	2,600	4,688	5,798	1,043	1,324	16,010
1941 ...	3,271	324	3,140	4,264	4,116	158	704	15,977
1942 ...	3,785	304	3,285	4,154	3,553	103	750	15,934
1943 ...	4,284	253	3,305	4,040	3,093	76	870	15,921
1944 ...	4,502	225	3,210	4,059	2,900	71	943	15,910

[1] These figures, and also the total column, exclude prisoners and missing.
[2] Munitions industries, i.e., iron and steel, non-ferrous metals, shipbuilding, engineering, aircraft and vehicles, instruments, chemicals, explosives, etc.
[3] Agriculture, mining, National and Local Government, transport, shipping (including Merchant Navy), public utilities, food manufacture.
[4] Building, textiles, clothing, distribution, professional services, etc.
[5] Schoolboys, students, invalids (including war invalids), retired, etc.

How men were employed during World War II

Each figure stands for 1 million men

Opposite page
The Shannon and Weaver model of communication (From *The Mathematical Theory of Communication,* 1949)

This page left
Otto Neurath developed the system of graphic communication known as isotype, the specific purpose of 'transforming' data and statistics into clear and understandable information. This chart was produced by Marie Neurath from the table above.

The information load has been edited to present the message clearly. For example, only alternative years are shown, and the change of scale means fewer man-symbols. Isotype charts do not aim only to display statistics, they aim to show what the statistics say, and to provide visual impact to their information.

This page right
This series of four typographic treatments of a notice seen in a dentist's waiting room was first reproduced in Cal Swann's book; *Language and Typography,* Lund Humphries, 1991.

The original notice (approximately 40x60 cm) was drawn by the receptionist who probably extracted the wording from an official leaflet. Although the notice highlights three main points there are, in fact, six items of information.

1 False teeth should be examined every twelve months
2 Examination is free
3 False teeth should be replaced every five years
4 NHS dentures cost £8·75
5 Exceptions for OAP and low income groups
6 DHSS claim forms necessary

There are clearly issues concerning legibility and clarity of the message. The absorbency of the paper and the uneven lines make some of the letterforms appear bolder than others. But it is important to recognise that these characteristics are not wholly negative and that, in fact, the 'hand-drawn' localised nature of the notice provides an informal appearance.

The second and third examples demonstrate conventional typographic development aimed at making the information clearer. However, as Swann suggests, would it not be better to use a simple, friendly language and an informal hand?

ADVICE TO WEARERS OF FALSE TEETH.
1 HAVE YOUR FALSE TEETH EXAMINED AT LEAST EVERY 12 MONTHS. THIS SERVICE IS FREE.
2 FALSE TEETH SHOULD BE REPLACED AT LEAST EVERY 5 YEARS. AND PROLONGED WEARING 10 or 20 YEARS LEADS TO PROBLEMS LATER WHEN THE DENTURES ARE EVENTUALLY REPLACED.
3 NATIONAL HEALTH SERVICE DENTURES COST 8.75 BUT FOR PENSIONERS OR PEOPLE WITH LOW INCOME THIS IS OFTEN PAID BY THE MINISTRY OF SOCIAL SECURITY, AND FORMS ARE AVAILABLE FOR CLAIMING THIS.

ADVICE TO WEARERS OF FALSE TEETH
1) HAVE YOUR FALSE TEETH EXAMINED AT LEAST EVERY 12 MONTHS. THIS SERVICE IS FREE.
2) FALSE TEETH SHOULD BE REPLACED AT LEAST EVERY 5 YEARS. AND PROLONGED WEARING 10 OR 20 YEARS LEADS TO PROBLEMS LATER WHEN THE DENTURES ARE EVENTUALLY REPLACED.
3) NATIONAL HEALTH SERVICE DENTURES COST £8·75 BUT FOR PENSIONERS OR PEOPLE WITH LOW INCOME THIS IS OFTEN PAID BY THE MINISTRY OF SOCIAL SECURITY. AND FORMS ARE AVAILABLE FOR CLAIMING THIS.

Advice to wearers of false teeth

1) have your false teeth examined at least every 12 months. This service is **free**.

2) false teeth should be replaced at least every **5** years. and prolonged wearing 10 or 20 years leads to problems later when the dentures are eventually replaced.

3) national health service dentures cost **£8·75** but for pensioners or people with low income this is often **paid by** the ministry of social security and **claim forms** are available for claiming this

Do you wear false teeth?

Have them examined here soon – it's FREE!

Make sure you have new ones every 5 years at least, leaving it longer often causes problems.

NHS sets cost £8.75.

If you are an OAP, or on a low income, you may not have to pay (Claims at DHSS).

Information

The level of predictability (described as 'redundancy' by Shannon and Weaver) is a key factor in the successful communication of information. It may initially appear paradoxical to suggest that predictability is essential to the practical aspects of communication[3], and yet approximately 50% of the language we use on a daily basis is redundant. But whilst it is redundant it is, in fact, providing orientation and context for the unpredictable, the unknown elements.

The necessity of formality (or rules) in many circumstances has been stressed in relation to the use and arrangement of typographic material many times elsewhere in this book. With information itself, predictability provided by convention is essential for accurate decoding and provides a check enabling the identification of the unusual or unpredictable. The conventional is predictable and therefore easy to decode. It follows, therefore, that a writer who breaks from convention (breaks the rules) knows that, in so doing, the information will be made more difficult to understand and must, presumably, be happy with this consequence.

Predictability/convention also diminishes the influence of noise. The 'noisier' the presentation the more conventional the message must be if clarity is required. If a telephone line is distorting sound, we repeat words, or when asked to spell something we will say 'A for apple…'. Any information that has to function in a busy, bustling environment must be simple, repetitious and highly predictable. Alternatively, a message which can expect to have plenty of uninterrupted attention, such as that of a highly specialised journal, can be written (and designed) in a less predictable, more challenging way, in the certain knowledge that the reader will enjoy investing the extra intellectual effort necessary to comprehend. It follows that formal design helps to overcome the problems of transmitting difficult, less predictable information. If the intended audience is larger and more heterogeneous, then the formality of presentation is essential. Alternatively, if a rapport has been built between the author and/or typographer and the audience, it is quite possible that they might be reached with a less predictable, more challenging mode of presentation.

Of course, the medium chosen to deliver the message is also influential. 'Difficult' information in a book can be re-read as many times as is necessary, and at the reader's convenience. The same information delivered by speech would need to be slow and accurate because there is clearly a socially defined (if vague) limit as to how many times you can ask someone to repeat themself!

Structuring information according to an established pattern or convention is a standard method of decreasing the possibility of confusion. Such 'patterns' can offer an aesthetic aspect within the formality. In writing, for instance, the repeatable and therefore predictable patterns of rhythm and rhyme increase both the pleasure and the predictability of the words.

In typography, the grid achieves much the same qualities, encompassing and holding together all disparate parts of, for instance, a book, in a formal, prearranged manner. Understanding the structure and the hierarchy of the information provides the reader with access, ownership, and comfort. The more popular and widely accessible the information is, the more predictable it tends to be in both form and content. Mainstream pop music and television soap-operas are typical examples. However, the presentation of complex material in a highly predictable format will invite the accusation of 'dumbing down'. More demanding information, which, by definition, is less predictable, tends to be presented in a less formal manner. However, the context and orientation of literature, television, film and the fine arts, painting, sculpture etc, are always changing. Their possible longevity means that an audience can, over time, learn to understand and enjoy what was, initially, a 'difficult' subject presented in an appropriate, but 'difficult' manner. New conventions can, and are, learned and accepted all the time. Challenging 'norms' is essential to social and cultural development but where this is successfully achieved, inevitably 'redundancy' follows. Early reactions to the Surrealists were, understandably, hostile, and the Surrealists themselves went out of their way to ensure that their work would stimulate adverse reaction. Today, much of what they achieved has become a cliché; amusing in their rather obvious attempts to shock. Similarly, people who grew up in the Punk era are distraught to hear 'their' music being played on mainstream radio and even in supermarkets.

Opposite page
When information is essential it must be as conventional and as predictable as possible both in its position and in its appearance. London Underground.

This page
The preliminary pages of a book follow a formal pattern which have their roots in technological as well as commercial constraints of publishing. Page one, opposite the inside cover, is the half-title page. Commonly, a part of this page has to be used to glue a soft cover to the text pages. If the book is a hardback (case-bound) book then the half-title page is, often, in the same way, partially glued to the end-papers. Because of this, the half-title page often cannot lie flat, but lifts with the cover or the end-paper when the book is opened. For this reason, the half-title page tends to be given a rather cursory role.

Page two might be clear or used for the colophon. The colophon lists information such as the publisher's name and address, the year the book was published, the country it was printed in and, importantly, the ISBN number. It might also include the name of the designer/photographer/illustrator/researcher etc.

Page three is typically the title page. Before books were 'mass produced' this page would have acted as a temporary cover. The buyer would then have the book bound to his/her own specifications; normally in keeping with the rest of the 'library'.

Page four will be clear or, occasionally, carries a dedication. Page five might present a foreword or preface. The author will often include an expression of gratitude to various people or organisations who have been of help, and, if necessary, explain, for example, why certain aspects of the book might have been organised in a certain way. The contents pages follow, which, in turn, are followed by the introduction. This is normally written by a leading figure associated with the key subject of the book to add gravitas to the author's aims and to provide an overview of the subject in question. Only after this can the 'book', eventually, begin.

These opening spreads are taken from *TypoGraphic Writing*, published by the ISTD, 2001. Designed by David Jury.

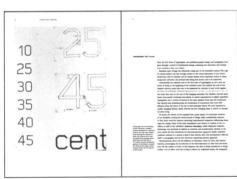

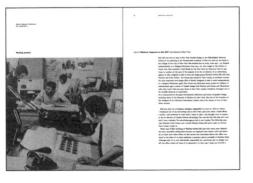

Rhetoric

Introduction

The term *rhetoric* is normally limited to the art of using language for the purpose of persuasion. It is almost a derogatory term, something artificial, superficial. But rhetoric was included in the medieval curriculum so that the student could be taught how to most effectively convey his thoughts to an audience or to a reader. Rhetoric was certainly a subject for the writer as much as the speaker. Rhetoric was combined with two other closely related subjects for study and practice: logic and grammar. Taken together, grammar, logic and rhetoric were dedicated to clear analysis; constructive formulation, and fluent, clear, direct communication.

The rules of typography represent tradition, and tradition, by definition, is predictability. In the past, predictability had two functions. It enabled compositors, proofreaders, and printers to know, without needing to ask, what everyone else was doing.[1] It streamlined training and production, made mistakes easier to recognise, and in so doing, guaranteed a level of quality at a predictable cost that, in turn, guaranteed a profit: 'Well-tried, well reasoned principles of text construction whose survival would depend on their effectiveness in practical situations'.[2]

Tradition also has certain important benefits for the reader. When the text looks familiar, there is nothing in the text itself to divert the reader's focused attention from the meanings of the author's words. Much of this book has been concerned with the activities of making type readable and in so doing has, inevitably, promoted the role of tradition (rules) as a part of the communication process. Eliminating typographic uncertainty allows the receiver to read 'automatically'. This does not, of course, mean mindless reading – quite the opposite – it means the reader can concentrate on what the *author* is 'saying' without distraction. Tradition reduces 'noise interference' to a minimum.

Tradition requires time and a stable working methodology to be established. To the layman there has probably been very little discernible change in the design and arrangement of type in the 500 years between the initial demise of blackletter and the invention of digital technology. And yet, for a brief period after the invention of moveable type, printers such as Gutenberg, Plantin and Manutius must have been aware that they were amongst the most progressive artisans of their day. In a largely preliterate world, they swiftly embedded the written word into a universal structure and gave it a state of permanence. The types and the arrangements they developed continue to be models for most typographic endeavour today. Typography is still based, either through adherence to, or rejection of, the basic principles established during that epoch-making period.

By the late 15th century, the standards had been set. It is easy to imagine that because there had been so little discernible change over such a long period of time that rhetoric played little or no part in the process of making and printing books. It has been suggested that 'design' without rhetoric is all but impossible.[3] If rhetoric crept into the printer's work, it is tempting to imagine it did so quite innocently and without intent. However, within the hushed and sober domain of the printer's workshop the precise placement of, for example, a decorative device on a title page might have been the result of painstaking deliberation. Such refined activities might only be recognised by fellow printers. It is clear that rhetoric cannot be measured by the amount of personal effort the typographer gives a project or by the user's ability to recognise its presence. A major part of the craft of typography, as this book has reiterated, is making text easy to read; 'normal', which means keeping the effort afforded to its design *hidden;* something incomprehensible to a typographer who has been educated to believe that the function of the designer is to be the arbiter and innovator of change.

The new Church of England Prayer Book; *Common Worship*, designed by Derek Birdsall (and John Morgan) in 2000. In an extended review of this book, Robin Kinross wrote,'…to impose design would seem wrong on such a book. Rather, the book should be allowed to design itself. This is the old credo and one with which the designers of this new work have long been familiar.' *Baseline* No 33, 2001.

This spread is from the index, that section of a book which might be considered to be the most self-effacing part of, what is, a self-effacing book. And yet, even here, it is clear that this is a contemporary book which claims integrity for its subject through the strength and grace of its distinctive design.

Creativity

What students have in mind when they (inevitably) describe themselves as 'creative' is someone who challenges the status quo. This is, at least in part, to do with the notion of 'status'. To set out to design 'change' is also to crave attention. Unfortunately, the concerns that initially lead many into design – human, political, social, aesthetic, practical – are, too often, replaced by design in its most intrusive (and dispensable) form. Also, there has been comparatively little persuasive public discussion concerning design (let alone typography) as a social or cultural activity. Without this debate, how can the 'commercial world' recognise the potential responsibilities and the creative role of design? But times *are* changing. During the last twenty years, design has generated public interest, and although a high proportion of this has tended to be critical in nature, at least opinions are being formed and expressed. Design is slowly establishing itself as an intellectual discipline equivalent to other such disciplines. When parity has been established, the status that some designers crave will be forthcoming.

To be applied effectively, it is generally accepted that creativity needs to be incorporated into a range of expertise. Design companies are fully aware of the necessity of acquiring the 'right mix' of abilities and attitudes, and yet, attempts to establish what, exactly, is creativity, can prove elusive. In studies of leading artists and scientists, it was found that the only characteristic that stood out in common among individuals was a willingness to work hard and work long hours. Such a characteristic is, of course, likely to contribute to success in most areas, but at least it questions the oft-repeated cliché that 'creativity' offers an easy alternative to hard work.

What characterises creativity is a mixture of rational and intuitive processes which may lead to originality. Here, we need to distinguish between creativity and originality. Originality might be no more than the rearrangement of existing elements into new patterns. Originality, in itself, is vacuous since a 'solution', to be original, need only be different. A *creative* solution may have varying degrees of originality but it must always be *useful*.

To be creative the designer must have time to think. Too often, 'time to think' is considered a luxury. And yet, without sufficient time, novelty, not creativity, tends to be the result. When pressure is caused by volume of work, there is a tendency for the typographer to switch to 'automatic'. This is unfortunate but also inevitable. In education, typographers (like all designers) are encouraged to think creatively and, of course, are given the time and the circumstances to do so. But when the commercial world cannot allow this, switching to 'automatic' is the only alternative. It is then that the typographer has to fall back onto the essential 'rules', the tradition, the orthodoxy of how type works. Substantial anecdotal evidence describes how the compositor achieved the 'traditional' appearance of type; honed to varying degrees of finish depending upon how much time could be allowed. All of which, of course, was dictated by how much the customer was willing to pay. Working at speed over prolonged periods establishes clear parameters of what is 'automatic' and what is rhetoric.

Typographers are particularly prone to staleness because they solve their problems with the same, specific, ingredients. As habits are formed, there is less likelihood of attaining a creative solution. Not surprisingly, it is often the newcomer who displays the greatest creativity, suggesting that typographers, should be both knowledgeable about their subject and, at the same time, capable of seeing the familiar afresh. However, it must be repeated that the act of *looking* at a page of text is very different from *reading* a page of text. A critical appraisal cannot, finally, be made only by looking. Whilst aesthetic considerations often appear to be paramount, it is the intimate level of intellectual engagement – reading – where the final, and the most important appraisal is made; and this judgement is generally *not* made by the designer.

However, reading and readability is not, by any means, the *only* function or criterion, of typography. Elements which distract also have a role to play in communication. In typographic terms this requirement is most clearly identified in the use of *display* type, designed to divert the viewer from whatever else they might be doing and, instead, persuade them to start reading. But also, on a more subtle level, there is little doubt that visual attraction, either through the sophisticated use of pre-arranged signals or by a poignant arrangement of text, can encourage a potential reader to invest time (and perhaps money) in wanting to read more.

Every piece of printed matter must clearly convey the reason for its existence, why it is appearing *now* and why it looks the way it does. Without this information, it will be ignored because it is superfluous to requirements. The traditional requirement, that there should be a connection or coherence between purpose, content and form, remains an essential criterion. At the same time, there is so much more that is possible; print is cheaper and more versatile, and digital technology offers endless options. But these new possibilities *also* require high standards, and certainly cannot be used to mask low standards!

The role of the typographer is often described as a 'form-giver'. Before form can be prescribed, there must be a mutual understanding between all involved of the social values of the project and to whom, as precisely as possible, it is directed and why. At the early stages of any project there are many options. The process of elimination, achieved by the relentless adherence to the needs of the message, and of the reader, will continue until there remain only the essential ingredients. If the form loses contact with the message then that form will degenerate into decoration. It will become form about form. A vacuous exercise, the only purpose of which can be to impress other, vacuous typographers.

Whilst textual typography requires anonymity, the purpose of generating printed text is never to remain anonymous. If printed matter is to exist, it must be made into something, an object that will attract the attention of those whose attention is sought. In short, it must solicit. But the means of attraction must not sacrifice the message. A lack of relevance – empty rhetoric – will inevitably be betrayed by superfluous design.

For the typographer, the very intention to record thought on paper affects the thinking process. Typography invites rational thought, controlled and directed communication. Consciously or unconsciously, it aims to create and preserve social links, which, by accumulation, eventually make up a whole social structure. The format, the proportions, and the planning, not only of a page but also of the whole document, affects the very intelligibility which comprises the psychological impact as well as the direct meaning of the text.

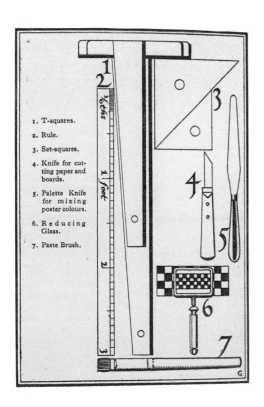

1. T-squares.
2. Rule.
3. Set-squares.
4. Knife for cutting paper and boards.
5. Palette Knife for mixing poster colours.
6. Reducing Glass.
7. Paste Brush.

This page left
An illustration captioned 'tools of the trade', from Fowler's Publicity, published by Publicity Publications, New York, 1900.

'The advertisement designer needs, fortunately, very few materials and tools with which to ply his trade. His equipment is much the same as that of an illustrator, with the addition of a small number of odd things* which will help him in his dealing with his work without loss of time.'
*These included type-specimen books and a telephone '…a great time saver'.

This page above
An advertisement for a company specialising in typography which appeared in the first edition of *Typographica*.

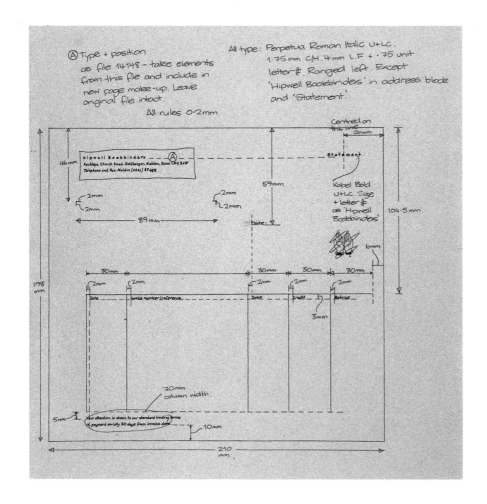

This page above
All the components which make up the 'finished' advertisement were available as Letraset dry-transfer products. Letraset aimed to democratise typography 25 years before the computer.

This page left
Prior to the personal computer, typographers had to produce a 'type specification' that was capable of communicating all the information required for the typesetter to produce precisely what was required. Such documents were very time-consuming and a rigorous test of the typographer's ability to rationalise information. Silk Pearce, circa 1991.

Opposite page above
Since each issue of *TypoGraphic* is designed by a different, invited designer it is interesting to see how differently each designer interprets common aspects such as contents (illustrated here) or the colophon, subscriptions and back issues, or, of course, the cover. These two examples are by Nick Bell (1998) and Cartlidge Levene (1997).

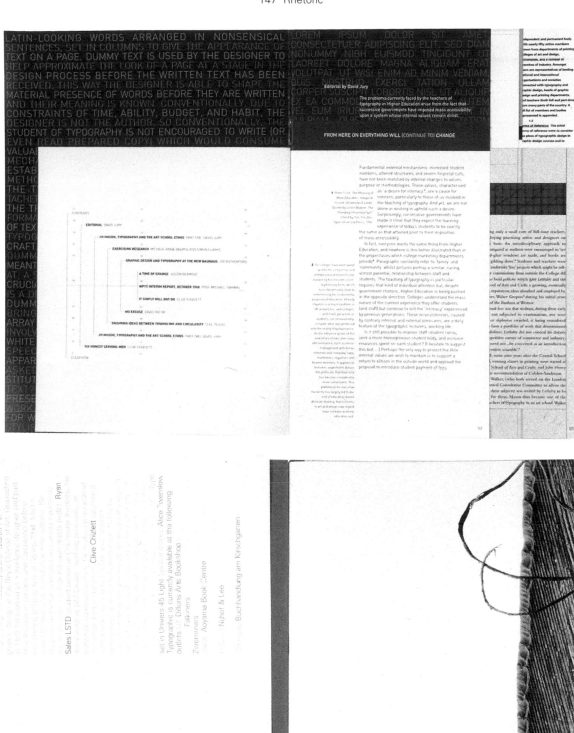

Typographer and technology

Since the beginning of the 19th century, creeping 'automation' has changed the way type is made and composed. As the role of typography diversified, it was required to play a less subservient part in a communication 'business' which increasingly demanded a more overt, more 'creative' approach to its design and application.

For 'creative' we might insert 'commercial art' in which typographic 'expression' might be characterised by the word *hot* depicted engulfed in flames or the word *cold* with icicles hanging from it! The fact that the vast majority of printed matter had maintained, for such a long period, a predictable, pre-meditated pattern and structure, made it remarkably easy for the commercial artist to find ways of attracting attention and comment. Many in the print trade considered 'attracting attention' (eg doing everything *wrong*) to be the *only* thing they need (or even could) do. Beatrice Warde called them 'Flashy little stylists'[4]. Not surprisingly, printers retreated from the inane activities of the commercial artist. Others, however, decided to make a genuine challenge.

The Bauhaus typographers also wished to distance themselves from the frippery of commercial art but were equally determined to reject what they saw as the redundancy of traditional function. They achieved this by redefining 'functionalism', equating it to the efficiency of the mechanised process, and went on to construct type from the simplest possible geometric elements. They admired the aesthetic of the industrial product and, believing sans serif to be the 'simplest' type form, declared it, therefore, to be *the* modern type form. The role of technology, and its perceived potential to improve the general quality of life, became a point of reference for all technical, economic, functional and aesthetic requirements of typography. Naturally, this meant breaking all the rules, or 'recipes' as Max Bill later (in 1946) described them, their sole purpose, he suggested, being to provide a security blanket for the typographer. 'We have happily freed ourselves from the schema of the Renaissance and do not wish to go back to it. Rather, we wish to make the most of liberation and all its possibilities.'[5]

These comments were made by Max Bill in response to a lecture, *Constants in Typography*, given by Jan Tschichold in which he had criticised the work of *The New Typography* (between 1925 and 1933) and in so doing, criticised both the typography of Max Bill, the Bauhaus, and his own earlier work. Following Max Bill's article, Tschichold replied in a passionate counter-article[6] in which he defended traditional typography, describing it as being organic, easily understood and free of extraneous dogma. Having added that he too was no friend of 'Olde Worlde' typography, Tschichold argued that the work of a 100 per cent 'modern' designer (as opposed to Max Bill's 'modernist' designer) was far more individualistic, ambitious and intelligent.

As 'modern production' overtook the printing industry, the establishment of the typographer's independent role was cemented. Bill, Tschichold and Paul Renner had all played major roles in articulating the role of the designer in the 1920s. In Britain, the same period could also be viewed as a 'golden age' for typography, although its design and application were based upon ideas quite opposite to those held in Germany. Stanley Morison, Typographic Advisor at the Lanston Monotype Corporation (and later, Typographic Advisor to *The Times*) provided *New Traditionalism*[7] with a summary of its philosophy in his extended essay *First Principles of Typography* in 1930[8]. In this text, Morison argued for the inviolability of governing typographic values such as convention, reason and comprehension. This essay is also notable for its lack of comment concerning the work of the modernists in Germany. Morison believed that the experiments of the Bauhaus typographers had little to do with typography since they were making an art out of something that should be a service.

New Traditionalism had its roots in the work of William Morris's Kelmscott Press and the Arts and Crafts Movement and in their concerns about the political and social implications of increasing mechanisation in the 19th century. Morris had been instrumental in the appointment in 1896 of the architect W R Lethaby as head of the Central School of Arts and Crafts in London. The influence of this school was far reaching, and certainly the lack of barriers between specialist areas of study later became a major aspect of the teaching philosophy at the Bauhaus.

Lethaby summed up his philosophy thus, '…usually, the best method of designing has been to improve on an existing model… a perfect table or chair or book has to be very well bred'.[9] Although this reforming movement sustained itself upon historical revivalism (whilst the Bauhaus claimed to embrace the future) New Traditionalism nevertheless produced two of the most influential typefaces of the 20th century: Eric Gill's *Gill Sans* in 1927 and Edward Johnston's typeface for the London Underground Railway signage system. Conceived in 1913, and drawn between 1915 and 1916, this alphabet was based upon Renaissance humanistic letterforms and yet the final result was a sans serif (also see pages 28 and 61).

Eric Gill had been a student at Johnston's calligraphy classes at the Central School of Arts and Crafts. Already a sculptor and stone letter-cutter, Gill certainly belonged to the New Traditionalism of Morris, Lethaby and Johnston, but was also something of a maverick. Like his Arts and Crafts colleagues he poured scorn upon industrialisation and capitalism at every opportunity, and yet found ways to form partnerships (albeit on his own terms) with the 'enemy' when it suited. In 1925 Gill was asked by Morison to draw an alphabet that could be reproduced as printing types for Monotype composition. Morison had been particularly interested in the idea of going back to the stone-cut or engraved letterforms as a model for type design, sensing that something had been lost in the mechanised process of producing letterforms. The result was *Perpetua*. Shortly after, Gill became fully engaged in the drawing and production of what would be *Gill Sans*.

For Morison, *Gill Sans* was his concurrence with modernism. He had been aware of the burgeoning production of sans serif typefaces in Germany. But, in contrast, he did not indulge in grandiose rhetoric about the 'spirit of the age'.

TO BE A PRINTER:
Brooke Crutchley

SINGLE WORDS:
Jeremy Tankard

Typographic [form / space] design does visually [content / integrity / culture / confirmation / belief / faith] what [contrast / theatre / order / rhythm] intonation [movement / simplicity] does audibly; [complexity / interest] it [visibility / structure] emphasises the [colour / weight] important, subordinates [time / reason] the [freedom / sound] less important, [feel / pitch] so [decoration / communication] clarifying [beauty / point] the [consideration / purpose] [architecture / illumination] message.

how to embody

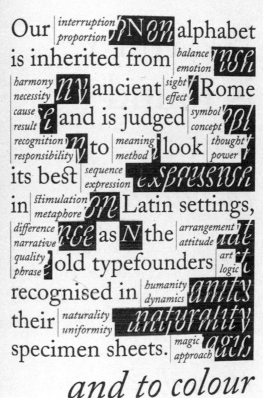

Our [interruption / proportion] alphabet is inherited from [harmony / necessity / cause / result / recognition / responsibility] ancient [balance / emotion / sight / effect] Rome and is judged [symbol / concept / meaning / method / thought / power] to look its best [sequence / expression] in [stimulation / metaphore] Latin settings, [difference / narrative / quality / phrase] as the [arrangement / attitude / art / logic] old typefounders recognised in [humanity / dynamics] their [naturality / uniformity] specimen sheets. [magic / approach]

So is it correct to use the Latin Forms for the English language?

and to colour

20

21

This book, *Re Approaches*, was edited and printed by Jeremy Tankard as a student in his final year at the Royal College of Art, 1992. It is a distillation of annotated notes from his sketchbooks and note books of the time. The arrangement of each spread is an attempt to capture the spirit of the original, hand-written notes. In this case, the words are from Brooke Crutchley's *To be a Printer* with additional, individual words interspersed. Tankard limited himself throughout to the use of Adobe *Caslon*.

At this time, and until the introduction of computer technology, typographic work required the typographer (now, increasingly, a graphic designer working independently of the printer or typesetter) to make a *type specification (see page 148)*. This was normally a drawn 'plan' indicating in detail precise descriptions (or instructions) of typefaces and their spatial and positional relationships which had to be interpreted by the compositor. The 'type spec' was, by default, a test of the typographer's competence, a demonstration of typographic knowledge. This was a period of bitter frustration for the printing trade, marking the de-skilling of the compositor and exasperation 'for the typographer. As Stanley Rice remarked, the designer does not need to specify everything in detail, [whilst] the designer, who leaves a lot to the compositor, may seem very competent without having much right to'.[10] For many involved in the printing industry, the type specification was the final humiliation before the computer finally, and comprehensively, took all remnants of typographic craft out of their hands. An invaluable legacy of this period, however, are the *Rules for Composition* written by Jan Tschichold when he was working in England for Penguin Books from 1940 to 1949.[11]

Developments in text composition and printing technology following photocomposition (discussed in Chapter 10) with the storage of letters as images in digital form radically altered the relationship of typographer and technology. The standards established in hot-metal composition and letterspacing no longer have any material necessity and can be modified or ignored. Nostalgia, however, is irrelevant. Technically, the standard of good quality hot-metal composition has been improved upon. Only the subtle, tactile quality of letterpress printing has not been replaced.

Technology, in its various forms, has *always* dominated typography but the digital revolution is different in that the whole of society is also tied into the same technology. And it is getting more complex. This complexity imbues technology with the suggestion of choice and creative opportunity. But this was not always the case. The initial pressure upon design studios to install computers came largely from clients rather than from designers themselves. Buyers of design were seeking a democratisation of the design process that would allow what they saw as a more 'flexible' working relationship. It is not surprising therefore, that initially many designers saw the computer as a very genuine threat to the integrity of their profession precisely because it appeared to eliminate the tacit, hands-on activity which many considered as defining the design process.

However, it is the computer which, today, defines the design process. For this reason alone it might prove beneficial to spend less time thinking about how to make the computer do something and, instead, try to imagine using hands and head. This is not easy. Designers have invested huge amounts of time learning how to utilise the computer and so to consider alternative methods might seem perverse. In fact, for those typographers locked into a larger commercial system, this might already appear to be impossible.

If the role of drawing within the process of design through making is re-assessed, the radical change the computer has brought to that same process can begin to be appreciated. Before computers, graphic design studios looked (and smelled) very different to those of today. Commonly, they would contain drawing tables with parallel motion used for drawing and planning, and larger, flat surfaces used for making.

Every studio would also have huge stocks of various papers and boards, drawers of dry-transfer lettering, heavy-duty knives, scalpels, various adhesives, tapes, paints, inks, brushes, expensive technical drawing sets and, of course, hundreds of pencils, crayons, markers and pens of various thicknesses. Craft skills were an integral part of the practice of design because a client presentation inevitably meant finding ways of 'mocking up' a piece of print by other means. Most design companies, regardless of size, preferred to keep much of this activity in-house because it was seen as an integral part of the creative process. Not surprisingly, evidence of craft-skills (including drawing) were considered to be an essential part of every design student's folder of work.

The use of such materials slowed down the pace of work, made the progress of projects a very open, and social point of reference. Evidence of the time spend on a project was clearly identifiable in the appearance and feel of the final 'proposal'. Many believed that the predominant role of drawing and craft in the production of a hand-made model gave it an added 'precious' quality that a client felt less inclined to question. Here, perhaps, lies the reason for the pressure upon design studios to 'democratise' their working methods.

Opposite page
A perfect example of the work environment everyone in the pre-digital era aspired to. Derek Birdsall, photographed in his Omnific studio in 1999.

Commercial values

In a specialised publishing environment, where there is a common focus on, and belief in, the integrity of the printed word, time to attend to typographic detail, revisions and proofing is recognised and built into a common system of work. However, other areas of design activity, by their very nature, behave in a very different way.

Craft is associated with the manipulation of physical materials; wood, metal, paper and ink. Unfortunately, the process of moving specks of coloured light on-screen does not have the same *cachet* and the future is committed to efficiency. A modernist society such as ours believes that things can only get better – which, of course, means more efficient. Unfortunately, the time gained by the speed of new technologies is not, by and large, being used in the service of good typography, seen by many to be inordinately time-consuming and therefore intrinsically inefficient (doing work that nobody notices). Typography is certainly the most vulnerable part of the graphic designer's craft. Time to discuss the merits of an idea is rare. It is even rarer for plans to be rethought, to change direction, to explore alternative ideas. It is only in exceptional cases that inspiration comes in a flash; it is far more common for it to grow from discussion, and from time to think, time to allow an idea to ripen. Time is in increasingly short supply and that leads to missed opportunities.

During the writing of this book I have listened to designers, who are well aware of the importance of typography, complaining of managers who have banned kerning in the studio saying '…if you want to work on typographic detail you must do it in your own time!' Meanwhile, for designers who don't know the difference, the minutiae of textual typography is an unnecessary exercise in restrictive conservatism; 'Why not, in this technologically driven age, leave it to the machine… that is what it was designed to do!'

The current digital revolution has provided total, independent control of typography to every graphic designer. However, the same technology is sitting on desks in every commercial business and organisation and this question is being asked more and more: 'do I employ a graphic designer or should I "design" it myself?' The impersonal anonymity of good textual typography has led to the conceit, in this epoch of typographic software, that we are *all* typographers! These are dangerous times. If the finer points of typography are not addressed, then what will be the difference between a graphic designer and a secretary, who is paid, perhaps, ten times less for doing the same job just as badly?

Typography is now something everybody does, although only typographers call it 'typography'. For everyone else it is now considered a very common, everyday practice – a manual task requiring virtually no thought whatsoever. Certainly not an achievement. Thus, the fundamental significance of 'typography' as an intellectual discipline and as a personal accomplishment, is something of a enigma. Perhaps it always has been, but whereas in the past typography and printing were genuinely mysterious (commonly referred to as 'the black art') today everyone has access to the same hard- and software. Even so, the full impact, the sheer scale of its role and application are hard to fully appreciate. Even typographers, when discussing typography, are *all* too prone to think only in terms of books, posters, and magazines, and to forget the millions of legal, commercial, religious and scientific documents that contribute to the rational structure that is our society.

Typography is so familiar, so matter of fact, that many fail even to acknowledge its existence. A book such as this, claiming typography to be a complex product (and which, here, has barely scratched the surface) will be considered absurd to many. In some ways, of course, this is the successful result of its 'invisible' application by generations of printers/typographers. But typography is so very much more than the achievement of a technology.

Whilst there is no reason why digital technologies should spell disaster for typography, people cannot be blamed for overlooking typographic refinements. Fine typography was never the *primary* purpose of writing and fine printing was never the *primary* purpose of typography. The proof of 'good' typography has nothing to do with technology; it can be judged only in the reading. Typography is a way of thinking, a rational attitude and a mental discipline. Only when thought is applied in an orderly and rational way, can articulate decisions be made concerning the many and varied physical and intellectual elements in which typography plays a part. Consideration of grammar, hierarchy of information, and editing as elementary tools is essential.

The study of typography cannot (and more and more *is* not) confined to any one special branch of learning. It calls for interdisciplinary co-operation between specialists in linguistics, communication, psychology, history, sociology, information technology, computer programming and media studies. Such co-operations will become the natural evolution of typography. A role for the typographer is certainly not a foregone conclusion.

References

1 Classification

References
1 Binding was a completely separate activity; books being bought as loose leaves, the title page serving as a temporary cover, and often bound in a style in keeping with the rest of the buyer's library.

2 Christopher De Hamel
The Book. A History of the Bible, Phaidon Press, 2001

3 Allan Haley
U/Lc No 14, November, 1987

Key texts
James Mosley
The Nymph and the Grot, St Bride Printing Library, 1999

Stanley Morison
Introduction to Sir Cyril Burt's *A Psychological Study of Typography*. Cambridge University Press, 1959

Sumner Stone
Hans Eduard Meier's Syntax-Antiqua
Fine Print, October 1979

Paul Beaujon (Beatrice Warde)
The Monotype Recorder, 1926

Robin Kinross
Modern Typography, Hyphen Press, 1992

Fred Smeijers
Counterpunch, Hyphen Press, 1996

Printing and the Mind of Man
Bridges and Sons Ltd and the Association of British Manufacturers of Printing Machinery Ltd. 1963

2 Function

References
1 'With regard to some freakish typefaces now in use, little need be said... Novelty there must be in this restless age but illegible and ugly types, popular as they may be for a time, soon pass away'. *Art and Practice of Printing*, (Volume 1), Sayers and Stuart, Pitman, 1949

Key texts
Peter Proto
Letraset International Typeface Competition results (article)
TypoGraphic Writing
Editor David Jury
International Society of Typographic Designers, 2001

Philip B Meggs and Roy McKelver
Revival of the Fittest
RC Publications, 2000

Walter Tracy
Letters of Credit
Gordon Fraser, 1986

Fine Print on Type
Edited by Charles Bigelow, Paul Hayden Duensing and Linnea Gentry, Lund Humphries, 1989

3 Standard Fonts

References
1 Clause: a single statment, a distinct part of a sentence
2 Adjunct: subordinant or incidental
3 Compound: consisting of several parts
4 Syllables: a unit of pronounciation, the least amount of speech

Key texts
Gerrit Noordzij
Letterletter, Hartley & Marks, 2000

Walter Tracy
Letters of Credit, Gordon Fraser, 1986

Karel Martins
Printed matter, Hyphen Press, 1996

4 Extended Fonts

Key texts
Hart's Rules for Compositors and Readers 39th edition, Oxford University Press, 1983

International Organisation for Standardisation
(Volumes 1 and 2) 1989

F Howard Collins
Author's and Printer's Dictionary
Oxford University Press, 1956

5 Legibility

References
1 Sir Cyril Burt
A Psychological Study of Typography,
Cambridge University Press, 1959

2 Miles A Tinker
Bases for Effective Reading, University of Minnesota Press, 1965

3 G W Ovink
Legibility, atmosphere-value and forms of printing types
A W Sitjthoff's Uitgeversmaatschappi N.V. 1938

4 Herbert Spencer
The Visible Word, Lund Humphries, 1968

5 Harold F Hutchinson
Research on Bus Blinds, *Design* magazine No 152, 1961

6 A W Christie and K S Rutley
...And on Road Signs, *Design* magazine No 152, 1961

7 Peter Barker and June Fraser
Sign Design Guide, JMU and Sign Design Society, 2000

Key texts
The A.Typ.I Legibility Research Committee
(Initial report. No named author) *Journal of Typographic Research*, 1968

Richard H Wiggins
Effects of three typographical variables on speed reading
Journal of Typographic Research, 1967

TypoGraphic Writing
Giovanni Lussi, Editor David Jury, International Society of Typographic Designers, 2001

6 Readability

References
1 Miles A Tinker
Bases for Effective Reading, University of Minesota Press, 1968

2 Wim Crouwel
Introduction to TypoGraphic Writing
Editor David Jury, International Society of Typographic Designers

3 R Barthes
The Death of the Author, Fontana, 1977

4 J Derrida
Signature event context, Glyph 1, pages 172–197. 1977

5 U Eco
The Role of the Reader, Hutchinson, 1979

6 Michael Forrester
Psychology of Language (chapter 9) Sage, 1997

7 Ralph Fabrizio, Gilbert Teal
Readability as a function of the straightness of right-hand
margins *Journal of Typographic Research*, 1967

Key texts
Walter Tracy
Letters of Credit, Gordon Fraser, 1986

Donald Paterson, Miles A Tinker
How to make type readable, Harper and Brothers, 1949

D Starch
Principles of Advertising (Chapter 25: Layout and Typography)
A W Shaw and Co (Chicago), 1923

7 Measurement

References
1 'ISO's case for reform was that in metal the range of
preferred sizes had to be a range of body sizes. However,
the physical body occurs exclusively in lead composition, while
a photocomposed [or digitised] character image is not tied to
any kind of body.... Type size should, therefore, no longer be
specified in terms of a dimension that does not indicate
the real size of type.'

Andrew Boag
What is the Point? *Print* magazine, 1994

Key texts
Warren Chappell and Robert Bringhurst
A Short History of the Printed Word, Hartley and Marks, 1999

Walter Tracy
Letters of Credit
Gordon Fraser, 1986

John Southward
Modern Printing (Volume 1)
Raithby, Lawrence & Company, 1924

8 Manipulating Space

References
1 Jan Tschichold
The Form of the Book, Lund Humphries, 1991

2 David Jury
Why Helvetica, *Eye*, July 2001
Quoting Nicky Barneby, Head of Typography
for the General Division at Penguin Books

Key texts
Walter Tracy
Letters of Credit, Gordon Fraser, 1986

David Kindersley
LoGoS: Letterspacing with a computer
TypoGraphic Writing, page 174, Editor David Jury ISTD, 2001

David Kindersley
Optical letter spacing, Cardozo Kindersley, 2001

Anthony Froshaug
The field of the majuscule
TypoGraphic Writing, page 166, Editor David Jury ISTD, 2001

Geoffrey Dowding
Finer Points in the Spacing and Arrangement
Wace and Company, 1954

9 Manipulating Type

Key texts
Emil Ruder
Typography, Hastings House, 1981

Walter Tracy
The Typographic Scene, Gordon Fraser, 1988

Suzanne West
Working with Style, Watson Guptill, 1990

Ernest Turner
The Shocking History of Advertising, Penguin Books, 1952

David Crystal (editor)
The Cambridge Encyclopedia of Language
Cambridge University Press, 1987

Marks for Copy Preparation and Proof Correction, BS 5261
British Standards Institution, 1976

The Oxford Dictionary for Writers and Editors
Oxford University Press, edition 2000

H W Fowler (revised E Gowers)
Modern English Usage, Clarendon Press, 1968

Roget's Thesaurus, Penguin Reference Books, current edition

Horace Hart
Rules for Compositors and Readers at the University Press
Oxford University Press, 1904 and current edition

Judith Butcher
Typescripts, Proofs and Indexes
Cambridge University Press, 1980

10 Paper and Print

Key texts
Alan Bartram
Making Books, The British Library and Oak Knoll Press, 1999

Printing and the Mind of Man
F W Bridges & Sons Ltd and the Association of British
Manufacturers of Printing Machinery Ltd

John Dreyfus
Into Print, The British Library, 1994

The Monotype Recorder
One Hundred Years of Type Making (New series, No 10) 1997

Lawrence W Wallis
Typomania, Lund Humphries, 1993

11 Electronic Writing Systems

References
1 Patrick Bazin
The Future of the Book Edited by Geoffrey Nunberg
University of California Press, 1996

2 Ibid

3 G P Landlow
*Hypertext: The convergence of contemporary
critical theory and technology*
Johns Hopkins University Press, 1992

Key texts
Marshall McLuhan
The Guttenberg Galaxy
Routledge, 1971

Marshall McLuhan
Understanding Media
MIT Press, 1994

Michael A Forrester
Psychology of Language
Sage Publications, 1997

Paul Levinson
The Soft Edge
Routledge, 1997

12 Language

References
1 Shannon and Weaver
The Mathematical Theory of Communication
University of Illinois Press, 1949

2 Randle Harrison and Clyde D J Morris
Communication Theory and Typographic Research
Journal of Typographic Research, July 1969

3 John Fiske
Introduction to Communication Studies, Routledge, 1990

Key texts
Michael A Forrester
Psychology of Language, Sage Publications, 1997

Karel Martens
Printed Matter/drukwerk, Hyphen Press, 1996

Tomás Maldonado
Notes on Communication, Uppercase 5, 1961

Cal Swann
Language and Typography, Lund Humphries, 1991

13 Rhetoric

References
1 Robert Waller
Quoted by Paul Stiffin 'Instructing the Printer'
Typography Papers
Department of typography and graphic communication,
University of Reading, 1996

2 Brooke Crutchley
Design and Production: A Cambridge Experience
Scholarly Publishing, July 1976

3 Gui Bonsiepe
Persuasive Communication:
Towards a Visual Rhetoric, Uppercase 5, 1961

4 Beatrice Warde
The pencil draws a vicious circle
The Crystal Goblet
The Sylvan Press, 1955

5 Both articles, by Max Bill and Jan Tschichold, are
reproduced (in English) in *Typography Papers* No 4,
Department of typography and graphic communication,
University of Reading, 2000

6 Ibid

7 New Traditionalism: This term was used by René Hague, who,
with the son-in-law of Eric Gill, ran the Hague & Gill Press, in a
short text entitled *Reason and Typography* (1936): 'There is only
one sort of hope, and that is in establishing a new tradition, but
not a new academicism, in keeping everything plain, trying not
to remember the —teenth century (filling in whatever is the
fashionable number) when you are struggling with a newspaper
in a tube. Printing will have to be judged as printing and not as
an advertisement or fine art.' *Typography* No 1. 1936

8 Stanley Morison
The First Principles of Typography
Cambridge University Press, 1967

9 W R Lethaby
Art and Workmanship
The Imprint No 1, January 1913

10 Stanley Rice
Book Design: Systematic Aspects
New York: Bowker, 1978

11 Tschichold's *Rules of Composition* are reproduced in *Jan
Tschichold: Typographer*, by Ruari McLean. It is interesting to
compare with the current Penguin book *Rules for Composition*
by Nicky Barneby, Head of Typography at Penguin Books, and
reproduced in *TypoGraphic* 58, published by the International
Society of Typographic Designers (ISTD) 2002.

Acknowledgement

I wish to record my gratitude to Clive Chizlett for all the advice and invaluable assistance I have received during the preparation of this book. I would also like to state my indebtedness to Cal Swann's book *Language and Typography*, the essence of which was the central premise of this book.

Lastly, I must thank the staff of the St Bride Printing Library, London, and particularly Nigel Roach, for their expert advice and generous cooperation. Naturally, all opinions expressed, and any errors or emissions, are entirely the responsibility of the author.

Index

* Indicates subject is illustrated.
 Typefaces are gathered under that title.